SOURCES AND DO[
HISTORY OF

H. W. JANSON, *Editor*

LAST DAY AT
TYLER'S BUILDING.

POWERS'
Greek Slave

The Exhibition of this World Renowned Statue,

Over which Poets have grown sublime, and Orators eloquent, will
CLOSE THIS EVENING, AUG. 1st. ☞ By special request.

NONE BUT LADIES AND FAMILIES WILL BE ADMITTED DURING THE AFTERNOON OF EACH DAY.

THE SUBJECT IS A

GRECIAN MAIDEN,

Made captive by the Turks, and exposed for sale in the Bazaar of Constanti-
nople. This statue is the property of Mr. Powers, and is the same one for-
merly exhibited in New York, and which has been on exhibition for several
years. The one at the World's Fair, which is pronounced

THE GEM OF THE WHOLE COLLECTION,

was made by Mr. Powers, from the same Model, for Capt. Grant, of the Royal
Navy, and has never been in America. Capt. Grant kindly placed it in the
American department of the Great Exhibition.

We hope, while all the world is admiring the Greek Slave in the Crystal
Palace, the citizens of this place will improve this opportunity to see it at their
own doors.

One writer says, the Greek Slave receives the most unqualified
admiration. Not one of all the

Fifty Thousand Daily Visitors !!

Leave the Exhibition without acknowledging the genius of our own Ameri-
can artist, Powers.

ADMISSION 25 CTS. PAMPHLETS 6¼ CTS.

Open from 9 A. M. till 9 P. M. Franklin Office, 132 Chapel Street.

American Art

1700 - 1960

SOURCES and DOCUMENTS

John W. McCoubrey
University of Pennsylvania

PRENTICE-HALL, INC.
Englewood Cliffs, New Jersey

Current printing (last digit):

30 29 28 27 26 25 24 23 22 21

PRENTICE-HALL INTERNATIONAL, INC., *London*
PRENTICE-HALL OF AUSTRALIA, PTY., LTD., *Sydney*
PRENTICE-HALL OF CANADA, LTD., *Toronto*
PRENTICE-HALL OF INDIA (PRIVATE) LTD., *New Delhi*
PRENTICE-HALL OF JAPAN, INC., *Tokyo*

Preface

It became immediately apparent in editing this anthology that the literature of American art would lend itself even less readily than our painting and sculpture to the classifications that usually guide students through the history of art from the late eighteenth century to the present. In America, democracy from the first produced an open society, and the pace of industrialization eventually produced the first truly modern one. The same forces worked against the establishment of an artistic tradition as it was known in Europe. Americans were too engaged by more pressing concerns to establish the schools and collections that are the institutions of a tradition or to foster with their patronage the continuous master-student relationships that are its living aspect. The major stylistic innovations from Neo-Classicism to Cubism, which mark the European artists' search for new certainties to supplant lost assurances, were supported by an abiding belief in the efficacy of style, revolutionary or otherwise, that is ultimately part of what tradition implies. American artists tried from various distances in time and place to absorb these bewildering changes—but established none of them here. What was learned was subtly changed and the contours of our art history blurred by a more unmediated confrontation of the American artist with his environment.

These selections have been arranged to conform in some way to the special circumstances of this history. The Colonial period, for example, is represented entirely by writings on the portrait, which in America, as nowhere else, was virtually the only vehicle for the painter's art. Both the advice of the venerable Gilbert Stuart and the diary of the obscure itinerant, James Guild, suggest that the matter-of-fact approach of our earliest face painters survived with the portrait's popularity in the early years of the Republic. But the artists' discontent with the limits put upon them by a public "entirely destitute of all just Ideas of the Arts" is the basic theme of Copley's letters from provincial Boston.

The reverence Copley had for "one of the most Noble Arts of the World," West's youthful ambitions in Philadelphia, and Durand's plaintive advertisement in New York are early signs of a determination to extend the range of our painting that sent generations of Americans abroad in search of the means to accomplish it. But younger, more ambitious painters, first Trumbull, then Allston and Morse, were more cruelly frustrated in their attempts to bring the grand style of history

painting to America. Their idealism, evident in Trumbull's letter to Jefferson, Allston's theoretical writing, and admitted in Morse's letter to Cooper as a possible cause of his failure as a painter, makes their disappointment particularly poignant. A hopeful democratization of history painting, which it is not capable of surviving, can be read in Dunlap's account of his peregrinations and in Rembrandt Peale's complex "simplification" of his *Court of Death.* Thus, a section that on English or European art might deal with the reestablishment of history painting and the introduction of the Neo-Classical style, appears from the documents on American art as a story of unfulfilled ambitions.

Allston's neo-platonism was beyond the powers of his or any American artist's ability. The transcendent style that it seems to have demanded would have been far ahead of its time, and even the less demanding classicism that our sculptors practiced came up, as is evident in the controversy over Greenough's Washington, against the hard-headed requirements of public taste. Emerson's *Thoughts on Art,* like Allston's *Lectures,* were aspects of romantic thinking, but Emerson's theories, particularly his assertions that nature, "the representation of the universal mind . . . tyrannizes over our works," parallels on a philosophical level what actually happened in our landscape painting, the major vehicle in American art of romantic sensibility.

The writings of Cole, Bryant, and Durand make it clear that our landscape painting represented a resolution of the conflict between an idealistic, religious disposition and a demand for the quiet observation of fact. The wilderness, as Cole put it, was a "fitting place to speak of God,' and particularly the American wilderness, which in its untamed wildness impressed Whittredge on his return from the tended forests of Europe, offered unspoiled evidence of Creation. With its religious connotation for those who wished to contemplate it, our landscape painting required of the less imaginative no special knowledge of history or style and could offer them at the very least the solace of a woodland view painted in an unassuming, more or less realistic style.

Three essays on our art dating from 1829, 1843, and 1864 appear together to give successive views of what it was thought we had accomplished and what we might yet achieve. Neal describes his astonishment at the progress of our painting despite the lack of institutions to promote it, while Greenough, in an eloquent appraisal of our position in the arts, sees in the absence of court patronage and what he called the "hot bed" culture of academies the promise of even greater progress. Jarves, though aware of obstacles in American Puritanism, finds hope in the promise of assimilating styles from abroad. All three are buoyant without being chauvinistic and typically more concerned that art should flourish here than with the precise styles it should adopt. With these essays appears a recollection of J. P. Morgan, whose generosity, like that

of many other American collectors of the late nineteenth century, eventually did much to justify the optimism of these earlier writers by bringing to America the treasures of the world's artistic heritage and making them available to the public.

The persistent strain of realism through much of our painting makes a section entitled simply "Realism" seem a rather questionable expedient, but the literature is less difficult to categorize for this purpose than the painting. Neal's early attack on borrowed styles in landscape painting only suggests the frequency of such commentary. Neal wrote just before American landscape painters had begun to look directly at nature, and the survival of the standards that they established is evident in James's disparagement of Moran's "geological eccentricities" and in Innes's rejection of Impressionism. It is fortunate that both Homer and Eakins left accounts of the motives that took Homer out of the studio into the open light of day and led Eakins to the sciences of anatomy, perspective, and photography to serve, like humanists before him, the ultimate dignity of the human figure. It is in the pattern of American art that neither Homer nor Eakins had major followers, but the spirit of Eakins continued in the work of the Eight whose aims are described by Robert Henri in terms he would have understood: freedom, independence, and integrity.

Garland's pioneering essay on Impressionism, because it is couched in terms the Eight stood for, is included in the section on realism, but it might as well have appeared as evidence of the first impact of the new European painting that almost all at once just after the turn of the century presented American artists with the perplexing results of twenty years of experiment. The Armory Show of 1913, which was the culmination of this invasion, was more influential on taste than upon practice. Its conception, set forth in the preface to its catalogue, reflects the investigative spirit of its founders and more distantly of Eakins. Kenyon Cox's review, incidentally, is the sole representative in this anthology of the academic establishment which had been forming since the 1880's, and it was the intransigency of Cox and those of his persuasion that made the spirit of revolt at last a necessity in American painting, both to the Eight and later to younger proponents of more radical modernism.

The documents from the end of the First World War to the recent past present our art in terms of two opposing forces. At one pole is Benton, who rejected the new European styles and painted, like many of his generation, specifically American subjects; at the other extreme is Calder who, at home on both sides of the Atlantic, seeks to express universal themes in his abstract sculpture. Between the two is the position of Davis whose sources of inspiration ranged from Bach to American chain-store fronts and gasoline stations. It is clear, however, that the isolation of much of our painting during the interwar years produced

the reaction expressed in one of the few manifestos of American art, the letter of Rothko and Gottlieb calling for universal themes drawn from the collective heritage of myth and symbol.

Abstract Expressionism was the first American contribution to the mainstream of western painting, and its rise marked the emergence of New York as the artistic capital of the West. Its internationalism stemmed from the reaction to American isolation signalled by Gottlieb and Rothko, and its derivations from Kandinsky and the Surrealists are part of its international credentials. The action painters' preoccupation with the act of painting, as described by Rosenberg, would seem to preclude the appearance of specific references to "the American Scene" (a term much in vogue in the thirties) from which they were in full flight. But the huge size of their canvasses, their boldness, and the immediacy of their impact upon the observer would appear to have owed much to the experience of America, and some of their most characteristic configurations were drawn from the storehouse of raw visual data peculiar to America. These characteristics have been more apparent to foreign critics like Gowing than to Americans who take this visual experience for granted. His persuasive article, the last in this book, may persuade some of us to agree with him that this painting is imbued with what he calls the material poetry of America and that its antecedents were "no more than half European."

The literature of our painting and sculpture has no counterparts to the influential doctrines of Winckelmann, the journals of Delacroix, or the manifestos that marked the major developments of European painting from Courbet's realism to Breton's Surrealism. It reflects rather a discontinuous, unsystematic development that makes the orderly presentation of its history difficult and the usual terminology awkward. But because of the problems the history of our art presents, these selections may be particularly helpful in giving, from close at hand, insights into the elusive characteristics of an art produced in a new society in a new place.

JOHN W. McCOUBREY

ACKNOWLEDGMENTS

In addition to the sources of articles acknowledged in citations throughout the text, the author wishes to give his thanks to Mr. Lloyd Goodrich of The Whitney Museum of American Art, New York; Mr. Joseph S. Trovato of Munson-Williams-Proctor Institute, Utica, New York; Miss Margaret Cogswell of the American Federation of Arts; and Mr. Wayne Andrews of the Archives of American Art, Detroit.

Contents

I

The
Portrait

SAMUEL WILLARD: TWO SERMONS

Seventeenth-century New England theocracy rejected all forms of religious painting. The vehemence of this conviction is clear in the two excerpts below from the Sermons of Samuel Willard (1640-1707), who was pastor of Old South Church in Boston (1678-1707) and, in the last decade of his life, Vice-President of Harvard College. These documents are reproduced here because they express in most concise form the attitude toward art which was generally felt in Protestant America outside of New England during the Colonial period and throughout much of the nineteenth century. This attitude was the cause of the narrow specialization in portraiture and the uneasiness of Americans with historical as well as religious painting. The testimony of later writers on art in America, which we will discuss later on, confirms the long-lasting impact of the ideas given here in their basic theological form.

Enquiry into the Divine Attributes, 1689

Hence how very unsuitable is it to represent the Divine Nature by any Corporeal similitude. I mean in Pictures or Images, of any visible and bodily substance, and that whether it be for civility or devotion, i.e., either merely as Ornamental, or as some pretend, to increase devout Affections in any; how is it possible rightly to shadow a Spirit? Whoever was able rightly to decipher the form or shape of a being which is invisible! It is folly to pretend to afford us the Portraiture of an Angel, but it is a madness and wickedness to offer at any Image or Representation of God: How many solemn cautions did God give His people against this by Moses, besides the express forbidding of it in the second Command; and God declares it to be a thing Idolatrous. For any to entertain or fancy any other Image of God, but those reverend impressions of His glorious Perfections that are engraven upon his heart, is highly to dishonour Him, and provoke Him to Jealousy.[1]

What Is Forbidden in the Second Commandment, 1701

First, this Command forbids the Worshipping of God by Images. This is expressly mentioned; and that in two Particulars.

1. The Making of them is prohibited. *Thou shalt not make.* And under a graven Image and Similitude is comprehended, every manner of Representation of God, whether in Statues or Pictures: For this general

[1] Samuel Willard, *A Compleat Body of Divinity in Two Hundred and Fifty Expository Lectures on the Assembly's Shorter Catechism* (Boston, 1726). Sermon XVII, "Enquiry into the Divine Attributes," April 23, 1689, p. 54.

3

Prohibition doth not respect things merely Civil, but only a Representation of the Deity, as we may gather from Deut. 4.15, 16. *Take ye therefore good heed unto yourselves (for ye saw no manner of similitude on the day that the Lord Spake unto you in Horeb, out of the midst of the fire). Lest ye corrupt yourselves, and make you a graven image, the similitude of any figure, the likeness of male or female.* Isai. 40.18, 19. *To whom then will ye liken God, or what likeness will ye compare unto him? The workman melteth a graven image, . . .*

2. The offering of Divine Worship to them or before them. *Thou shalt not bow,* And the latter is *exegetical* to the former. God reckons any religious bowing to an Image or Representation, to be a worshipping it. For although Idolaters have been so brutish, as to direct their Worship nextly and immediately to the Image, yea, the wise Heathens themselves were not so gross, as to acknowledge that they looked upon their Idols, to be real Deities in themselves, or terminate their Worship on them; but they conceived of a God, whom they represented by the image, through which they supposed him to communicate himself to them, and in which they adored him, hoping for a better Acceptance. The Egyptians, when they found good or benefit by any Creature, they worshipped God in it, not supposing that the thing itself was God, but that God communicated himself to them, by and through the Creature, and that they ought to worship him in it, and the Creature no further, then they supposed God to be in it. For this End also they made Images, or Portraitures of these and those Creatures, before which they paid their Devotions, and on which they imposed the Name of their God. And this is represented as sinful and superstitious, Rom. 1.21, 22, 23. *Because when they knew God, they glorified him not as God, neither were they thankful, but became vain in their imaginations, and their foolish heart was darkened. Professing themselves to be wise, they became fools: And changed the glory of the uncorruptible God, into an image made like to corruptible man, and to birds, and four-footed beasts, and creeping things.* Of this Nature was the Golden Calf, which Israel made in the Wilderness, in Imitation of the Egyptians, among whom they had lived and conversed. Nor did they suppose it to be God himself, but a Representation of him, and put his Name upon it, as we do of a Person on his Statue or Picture. Hence they kept the Feast to Jehovah, Exod. 32.5. *Tomorrow is a feast to the Lord.* Of the same Nature was *Jereboam's* Calves, which were erected at *Dan* and *Bethel*, to facilitate the People's Worship, and was surrogated in the room of the Ark, at the Temple in *Jerusalem*. Hence that Reason is given of the making of them, I Kin. 12.28. *Whereupon the king took counsel, and made two calves of gold, and said unto them, It is too much for you to go up to Jerusalem.* It is true, those are called Gods, in the Word of

God, and the worshipping of them is called Idolatry, yea, they are named Devils and their Service Devil-Worship. See, II Chron. 11.15. *And he ordained him priests for the high places, and for the devils, and for the calves which he had made.* Psal. 106.36, 37. *And they served their idols which were a snare unto them. Yea, they sacrificed their sons and their daughters unto devils.* Partly because the ignorant among them, were become so brutish in their Imaginations, as to terminate their Service on the Idol. Hence that Complaint, Isai. 44.19, 20. *And none considereth in his heart, neither is their knowledge nor understanding to say, I have burnt part of it in the fire, yea also I have baked bread upon the coals thereof: I have roasted flesh and eaten it, and shall I make the residue thereof an abomination?* Partly also, because God doth not account himself to be acknowledged as God, if his Laws of Worship be neglected, and other Rules be invented in the room thereof, Acts 17.24, 25. And by this, the horrible Idolatry of the Church of Rome is manifested. Nor will all their Evasions, and copious Distinctions, excuse them from the Guilt of it. False Worship is supposed to be paid to a God that will accept of it, which must be a false God, for the true God abhors it.[1]

JAMES LOGAN: LETTER TO DR. WILLIAM LOGAN ON GUSTAVUS HESSELIUS, 1733

Characteristic of the Colonial attitude toward portraiture are these remarks by James Logan (1674-1751), who was at various times secretary to William Penn, mayor, jurist, and botanist. The Swedish painter in question is Gustavus Hesselius (1682-1755), one of several painters trained abroad who came to the Colonies in the early eighteenth century to seek their fortunes. At the time of Logan's writing in 1733 Hesselius was the chief portraitist in the Philadelphia area, but apparently his professional qualifications failed to awe his sitters.

We have a Swedish painter here, no bad hand, who generally does Justice to the men, especially to their blemishes, which he never fails showing in the fullest light, but is remarked for never having done any to ye fair sex, and therefore very few care to sitt to him. Nothing on earth could prevail with my spouse to sitt at all, or to have hers taken by any man, and our girls—believing the Originals have but little from nature to recommend them, would scarce be willing to have that little

[1] Samuel Willard, *A Compleat Body of Divinity* . . . , Sermon LI, "What Is Forbidden in the Second Commandment," January 13, 1701, pp. 621-622.

(if any) ill treated by a Pencil the Graces never favour'd, and therefore I doubt we cannot make you the most proper Return for so obliging a Present.[1]

MATHER BYLES: TO MR. SMIBERT ON THE SIGHT OF HIS PICTURES, 1730

Like Hesselius in Philadelphia, John Smibert (1688-1751) represented in Boston a continuation of the European portrait tradition. His painting rooms in Boston, with casts and copies after the masters he brought from London, became the closest thing to a painting school in the Colonies. These verses by Mather Byles, here quoted from a London newspaper, probably first appeared in a lost edition of the Boston Gazette. *Unlike Logan's brusque report on Hesselius, they reveal an almost sensuous response to Smibert's pictures and suggest a softening of the Puritan distrust of painting as well as the pride and delight Smibert's modest competence brought to the artistically impoverished citizenry of Colonial Boston.*

To Mr. Smibert
on the sight of his Pictures

Ages our Land a barbarous Desert stood,
And Savage Nations howled in every Wood;
No laureled Art o'er the rude Region smiled,
Nor blest Religion dawned amidst the Wild;
Dullness and Tyranny, confederate, reigned,
And Ignorance her gloomy State maintained.
 An hundred Journeys now the Earth has run
In annual circles round the central Sun,
Since the first Ship the unpolished Letters bore
Through the wide Ocean, to the barbarous shore.
Then infant Science made its early Proof,
Honest, sincere, though unadorned and rough,
Still, through a cloud, the rugged Stranger shone,
Politeness, and the softer Arts unknown.
No heavenly Pencil the free Stroke could give,
Nor the warm Canvas felt its Colors live.
No moving Rhetorick raised the ravished Soul,
Flourished in flames or heard its Thunders roll;
Rough, horrid verse, harsh, grated through the Ear,
And jarring Discords tore the tortured Air.
Solid, and grave, and plain the Country stood,
Inelegant, and rigorously good.
 Each Year succeeding the rude Rust devours,

1 James Logan, Letter to Dr. William Logan, May 31, 1733, *Logan Letter Books*, Vol. IV, p. 331, Pennsylvania Historical Society, Philadelphia.

And softer Arts lead on the following Hours;
The tuneful nine begin to touch the Lyre,
And flowing Pencils light the living Fire.
In the fair Page new Beauties learn to shine,
The Thoughts to brighten, and the Stile refine;
Till the great Year the finished Period brought,
A *Smibert* painted and a —— wrote.
 Thy Fame, O *Smibert,* shall the Muse rehearse,
And sing her Sister-Art in softer Verse.
 'Tis yours, Great Master, in just Lines to trace
The rising Prospect, or the lovely Face,
In the Fair Round to swell the glowing cheek,
Give Thought to Shades, and bid the Colors speak.
Touched by thy Hand, how *Sylvia's* Charms engage,
And *Flavia's* Features smile through every Age!
In *Clio's* Face the attentive Gazer spies
Minerva's reasoning Brow, and azure Eyes;
Thy blush, *Belinda,* future hearts shall warm,
And *Celia* shine in *Citherea's* form.
In hoary majesty, see *Sewall* here;
Fixed strong in thought there Byfield's Lines appear;
Here in full Beauty blooms the charming maid,
Here Roman ruins nod their awful Head:
Here gloting monks their amorous rights debate,
The *Italian* master sits in easy state,
Vandike and *Rubens* show their Rival Forms,
And studious *Mascarene* asserts his Arms.
 But cease, fond Muse, nor the rude Lays prolong,
A thousand Wonders must remain unsung;
Crowds of new Beings lift their dawning Heads,
In conscious Forms, and animated Shades.
What Sounds can speak, to every Figure just,
The breathing Statue, and the living Bust?
 Landskips how gay! arise in every Light,
And fresh Creations rush upon the Sight.
Through fairy Scenes the roving Fancy strays,
Lost in the endless visionary Maze.
 Still, wondrous Artist, let thy Pencil flow.
Still warm with Life, thy blended Colors glow,
Raise the ripe Blush, bid the quick Eyeballs roll,
And call forth every Passion of the Soul.
Let thy soft Shades in mimic Figures play,
Steal on the Heart, and call the mind away.
Yet, *Smibert,* on the kindred muse attend,
And let the Painter prove the Poet's Friend.
In the same Studies nature we pursue,
I the Description touch, the Picture you;
The same gay scenes our beauteous Works adorn
The flamy Evening, or the rosy Morn:
Now, with bold hand, we strike the strong Design,
Mature in Thought now soften every line,

Now, unrestrained, in freer Airs surprise,
And sudden at our Word new Worlds arise;
In generous Passion let our Breasts conspire,
As is the Fancy's, be the Friendships' Fire;
Alike our Labor, and alike our Flame,
'Tis thine to raise the Shape, and mine the Name.[1]

ADVERTISEMENTS OF ABRAHAM DELANOY AND JOHN DURAND, 1768, 1771

Advertisements such as these from New York newspapers, although often all that is known of some of our earlier painters, frequently suggest their fortune. Abraham Delanoy (c. 1740-1789) was the first American on record to try to capitalize on his study in London with Benjamin West. The second advertisement suggests the outcome of this venture, and Dunlap states that the painter ended his life poor, consumptive, and dependent upon sign painting for his livelihood. John Durand (active 1767-1782), who painted provincial, linear portraits of considerable charm, also ran touching appeals extolling the noble and ennobling aspects of his profession which were so little recognized in a land where no "expressions of the passions" and very few "subjects of antient and modern history" were painted or owned.

To the Publick. Likenesses Painted for a reasonable Price, by A. Delanoy, Jun., who has been Taught by the celebrated Mr. Benjamin West, in London. N. B. Is to be spoke with opposite Mr. Dirck Schuyler's, at his Fathers.[2]

* * *

The following Articles, to be sold very cheap, at wholesale or retail, by Abraham Delanoy, Jun. At his House in the main Street, between Burling's-Slip and the Fly Market, opposite Mr. Brevoort's Store of Tin Ware, and next Door to Dr. Bard, Jun., *viz.:*

Old Madeira, Teneriff and sweet wines, claret, wine bitters; Jamaica spirits and Antigua rum, brandy, Geneva, Molasses; vinegar, sweet oil, raisins, currants, and figs, citron, sugar candy, sugar almonds and do. in the shell, prunes and prunelloes; Teas and Spices of all

[1] Mather Byles, "To Mr. Smibert on the Sight of His Pictures," *Daily Courant*, London, April 14, 1730. In H. W. Foote, *John Smibert* (Cambridge: Harvard University Press, 1950), pp. 54-55.

[2] *N. Y. Gazette* and the *Weekly Mercury*, January 7, 1771. This and the two following items are in W. Kelby, *Notes on American Artists* (New York: New York Historical Society, 1922), p. 8.

Sorts, best Chocolate and Coffee; double and single refined loaf sugar, best and low priced muscovado sugars; rice, black and Cayenne pepper, Durham and New York flour mustard, fine salt and alum, castile soap, snuff, pipes; pickles in cags fit for exportation, a small quantity of quince, peach and Holland plum sweet meats, fresh imported, Cheshire and Gloucestershire cheese; paper, quills, ink, and ink powder, sealing wax and wafers; best White Chapel needles, Scotch threads, and pins, empty twelve bottle cases, and so forth. Most kinds of Painting done as usual, at reasonable rates.[1]

* * *

The Subscriber having from his infancy endeavored to qualify himself in the art of historical painting, humbly hopes for that encouragement from the gentlemen and ladies of this city and province, that so elegant and entertaining an art has always obtained from people of the most improved minds and best taste and judgment, in all polite nations in every age. And although he is sensible that to excel (in this branch of painting especially) requires a more ample fund of universal and accurate knowledge than he can pretend to in geometry, geography, perspective, anatomy, expression of the passions, antient and modern history, &c., &c., yet he hopes, from the good nature and indulgence of the gentlemen and ladies who employ him, that his humble attempts in which his best endeavors will not be wanting, will meet with acceptance, and give satisfaction; and he proposes to work at as cheap rates as any person in America.

To such gentlemen and ladies as have thought but little upon this subject and might only regard painting as a superfluous ornament, I would just observe, that history painting, besides being extremely ornamental has many important uses. It presents to our view some of the most interesting scenes recorded in ancient or modern history, gives us more lively and perfect ideas of the things represented, than we could receive from a historical account of them, and frequently recalls to our memory a long train of events with which those representations were connected. They show us a proper expression of the passions excited by every event, and have an effect, the very same in kind (but stronger) than a fine historical description of the same passage would have upon a judicious reader. Men who have distinguished themselves for the good of their country and mankind may be set before our eyes as examples, and to give us their silent lessons—and besides, every judicious friend and visitant shares with us in the advantage and improvement, and increases its value to ourselves.[2]

[1] *N. Y. Journal,* or the *General Advertiser,* June 20, 1771.
[2] John Durand, *The New York Journal,* April 7, 1768.

JOHN SINGLETON COPLEY: CORRESPONDENCE, 1766-1767

The letters below reflect a critical phase in the career of John Singleton Copley (1738-1815), the most gifted of our native-born Colonial portraitists. In them one finds the beginning of his resolve to leave Boston for study abroad and some of the doubts that beset him before he finally sailed, never to return, in 1774. The pictures he sent to London via Captain R. G. Bruce were the famous Boy with a Squirrel, shown in 1766 at an exhibition of the Society of Artists, and a Little Girl, subsequently lost, which followed in 1767. The paintings were generally well received in London, but the criticism that they were too "liney," opaque, and lacking in "Due Subordination of the Parts," only strengthened Copley's discontent with the provincial city of his birth.

Captain R. G. Bruce to Copley

LONDON, 4TH AUGUST, 1766

DEAR COPLEY,

Don't imagine I have forgot or neglected your Interest by my long Silence. I have delayed writing to You ever since the Exhibition, in order to forward the inclosed Letter from Mr. West, which he has from time to time promised me, but which his extreme Application to his Art has hitherto prevented his finishing.

What he says will be much more conclusive to You than anything from me. I have only to add the general Opinions which were pronounced on your Picture when it was exhibited. It was universally allowed to be the best Picture of its kind that appeared on that occasion, but the sentiments of Mr. Reynolds, will, I suppose, weigh more with You than those of other Critics. He says of it, "that in any Collection of Painting it will pass for an excellent Picture, but considering the Disadvantages" I told him "you had labored under, that *it was a very wonderful Performance.*" "That it exceeded any Portrait that Mr. West ever drew." "That he did not know one Painter at home, who had all the Advantages that Europe could give them, that could equal it, and that if you are capable of producing such a Piece by the mere Efforts of your own Genius, with the advantages of the Example and Instruction which you could have in Europe, You would be a valuable Acquisition to the Art, and one of the first Painters in the World,

provided you could receive these Aids before it was too late in Life, and before your Manner and Taste were corrupted or fixed by working in your little way at Boston. He condemns your working either in Crayons or Water Colors." Don't imagine I flatter You. I only repeat Mr. Reynolds' words, which are confirmed by the public Voice. He, indeed, is a mere Enthusiast when he speaks of You. At the same time he found Faults. He observed a little Hardness in the Drawing, Coldness in the Shades, An over minuteness, all which Example would correct. "But still," he added, *it is a wonderful Picture* to be sent by a Young Man who was never out of New England, and had only some bad Copies to study." I have begged of Mr. West to be copious in his Criticisms and Advices to You. Mr. Reynolds would have also wrote to You himself but his time is too valuable. The Picture is at his House where I shall leave it till I have your Directions how to dispose of it. I could sell it to advantage, but it is thought more for your Interest to keep it as a Specimen. You are greatly obliged to Lord Cardross, a Friend of mine, to whom I first sent it. He showed it to the most eminent Conniseurs, then gave it to Mr. Reynolds, who sent it with his own Pictures to the Exhibition. You are best Judge of your own Affairs, and whether you can with propriety accomplish a Trip for a few Years to Europe. Should you take that Resolution, I believe I may venture to assure You, that You will meet with much Encouragement and Patronage. Should it be in my little power to be of the least use to You, you may command me to the utmost. I am already very happy in having contributed to make your Merit so far known to the World, and hope it has laid the Foundation of your being the great Man Mr. Reynolds prognosticates.

I am obliged to write this in a very great hurry as I set out tomorrow on a Visit to Scotland. Pray remember me to my old Acquaintances at Boston. I have wrote to Mr. Scollay and Mrs. Melville. You have already my Direction, and I shall expect to hear from You. Perhaps I may see you in Boston next Year, but that at present is uncertain.

I had almost forgot to tell You, that in case you don't appear yourself, the Friends of your Art wish that you will paint another Picture to exhibit next Year, and Mr. West has promised to point out a Subject to You. Should you do so, send it to Mr. West who seems sincerely disposed to be your Friend. Mr. Reynolds is too busy and too great a Man to be active for You, though he is also much disposed to serve You.

I have now a Favor to beg of You in turn, which is, that you will make me a Copy of my Picture I left with Mrs. Melville. I hope

this will find You and your Family well—And either in Europe or America assure yourself of my sincere Friendship while I am

R. G. BRUCE

Benjamin West to Copley

LONDON, AUGUST 4TH, 1766

SIR,

On Seeing a Picture painted by you and meeting with Captain Bruce, I take the liberty of writing to you. The great Honor the Picture has gained you here in the art of Painting I dare say must have been made known to You Long before this Time, and as You have made So great a Progr[e]ss in the art I am Persuaded You are the more desirous of hearing the remarks that might have been made by those of the Profession, and as I am here in the Midst of the Painting world have the greater opportunity of hearing them. Your Picture first fell into Mr. Reynolds' hands to have it Put into the Exhibition as the Performance of a Young American: he was Greatly Struck with the Piece, and it was first Concluded to have been Painted by one Mr. Wright, a young man that has just made his appearance in the art in a surprising Degree of Merit. As Your Name was not given with the Picture it was Concluded a mistake, but before the Exhibition opened the Particulars were received from Capt. Bruce. While it was Exhibited to View the Criticism was, that at first Sight the Picture struck the Eye as being too liney, which was judged to have arose from there being so much neatness in the lines, which indeed as far as I was Capable of judging was somewhat the Case. For I very well know from endeavoring at great Correctness in one's outline it is apt to Produce a Poverty in the look of one's work. Whenever great Desition [decision] is attended to the lines are apt to be too fine and edgey. This is a thing in works of great Painter[s] I have remark[ed] has been strictly avoided, and have given Correctness in a breadth of outline, which is finishing out into the Canvas by no determined line when Closely examined; though when seen at a short distance, as when one looks at a Picture, shall appear with the greatest Beauty and freedom. For in nature everything is Round, or at least Partakes the most of that form which makes it impossible that Nature, when seen in a light and shade, can ever appear liney.

As we have every April an Exhibition where our works is exhibited to the Public, I advise you to Paint a Picture of a half figure or two in one Piece, of a Boy and Girl, or any other subject you may fancy. And be sure take your Subjects from Nature as you did in your

last Piece, and don't trust any resemblance of anything to fancy, except the dispositions of the figures and the adjustments of Draperies, So as to make an agreeable whole. For in this Consists the work of fancy and Test [taste].

If you should do anything of this kind, I beg you may send it to me, when you may be sure it shall have the greatest justice done it. Let it be Painted in oil, and make it a rule to Paint in that way as much as Possible, for Oil Painting has the superiority over all other Painting. As I am from America, and know the little Opportunities is to be had there in the way of Painting, made the inducement the more in writing to you in this manner, and as you have got to that length in the art that nothing is wanting to Perfect you now but a Sight of what has been done by the great Masters, and if you Could make a visit to Europe for this Purpose for three or four years, you would find yourself then in Possession of what will be highly valuable. If ever you should make a visit to Europe you may depend on my friendship in any way that's in my Power to Serve.

Your Friend and Humble Servant,

B. West

Copley to Benjamin West

BOSTON, NOVR. 12, 1766

SIR:

Your kind favor of Augst. 4, 1766, came to hand. It gave me great pleasure to receive without reserve Your Criticisms on the Picture I sent to the Exhibition. Mr. Powell informed me of Your intention of writing, and the handsome things You was pleased to say in praise of that little performance, which has increased my estimation of it, and demands my thanks which previous to the receipt of Your favor I acknowledged in a letter forwarded by Mr. Powell. It was remarked the Picture was too lined. This I confess I was conscious of myself and think with You that it is the natural result of too great precision in the outline, which in my next Picture I will endeavor to avoid, and perhaps should not have fallen into it in that, had I not felt too great timerity at presenting a Picture to the inspection of the first artists in the World, and where it was to come into competition with such masterly performances as generally appear in that Collection. In my last I promised to send another piece. The subject You have since pointed out, but I fear it will not be in my power to comply with Your design, the time being too short for the execution of two figures, not having it in my power to spend all my time on it, and the Days short and weather cold, and I

must ship it by the middle of Feby. at farthest, otherwise it will come too late for the exhibition. But I shall do something near what you propose. Your c[a]utioning me against doing anything from fancy I take very kind, being sensible of the necessity of attending to Nature as the fountain head of all perfection, and the works of the great Masters as so many guides that lead to the more perfect imitation of her, pointing out to us in what she is to be copied, and where we should deviate from her. In this Country as You rightly observe there are no examples of Art, except what is to [be] met with in a few prints indifferently executed, from which it is not possible to learn much, and must greatly enhance the Value of free and unreserved Criticism made with judgment and Candor.

It would give me inexpressible pleasure to make a trip to Europe, where I should see those fair examples of art that have stood so long the admiration of all the world. The Paintings, Sculptors and Basso Releivos that adorn Italy, and which You have had the pleasure of making Your Studies from would, I am sure, animate my pencil, and enable me to acquire that bold free and graceful style of Painting that will, if ever, come much slower from the mere dictates of Nature, which has hither to been my only instructor. I was almost tempted the last year to take a tour to Philadelphia, and that chiefly to see some of Your Pictures, which I am informed are there. I think myself peculiarly unlucky in Living in a place into which there has not been one portrait brought that is worthy to be called a Picture within my memory, which leaves me at a great loss to guess the style that You, Mr. Reynolds, and the other Artists practice. I shall be glad when you write next you will be more explicit on the article of Crayons, and why You dis[ap]prove the use of them, for I think my best portraits done in that way. And be kind enough to inform me what Count Algarotti means by the five points that he recommends for amusement and to assist the invention of postures, and whether any prints after Corregios or Titianos are to be purchased. I fear I shall tire Your patience and make you repent your writing to one who makes so many requests in one letter.

But I shall be exceedingly glad to know in general what the present state of Painting in Italy is, whether the Living Masters are excellent as the Dead have been. It is not possible my curiosity can be satisfied in this by anybody but Yourself, not having any correspondence with any whose judgment is sufficient to satisfy me. I have been painting the head of a Dissenting Clergyman and his friends are desirous to subscribe for it to be scraped in mezzotinto in the common size of 14 inches by ten, but I cannot give them the terms till I know the price. I shall take it kind if when you see any artist that You approve You mention it to him, and Let me know. I have seen a well

executed print by Mr. Pether of a Jew Rabbi. If You think him a good hand, be kind enough to desire him to let me know by a few lines (as soon as convenient) his terms, as the portrait waits only for that in my hands, and I shall send it immediately with the money to defray the expense when I know what it is.

I am Sir with all Sinceri[t]y Your friend and Humble Sert.

J:S:COPLEY

Benjamin West to Copley

LONDON, JUNE 20TH, 1767

SIR:

Don't impute the long Omission of my not writing to you [to] any forgetfulness or want of that Friendship I first Showed on seeing your works. My having been so much engaged in the Study of my Business, in particular that of history Painting, which demands the greatest Care and intelligence in History imaginable, has so entirely Prevented my taking up the Pen to answer your Several Agreeable favors, and the reception of your Picture of the Little Girl you Sent for the exhibition. It came safe to hand in good time. And as I am Persuaded you must be much interested in regard to the reception it met with from the artists and Public opinion in General, I as a Friend Take this opportunity to Communicate it to you.

In regard to the Artists they Somewhat differ in Opinion from Each Other, Some Saying they thought your First Picture was the Best, others Say the last is Superior (which I think [it] is as a Picture in point of Execution, though not So in Subject). But of those I shall give this of Mr. Reynolds when he saw it he was not so much Pleased with it as he was with the first Picture you Exhibited, that he thought you had not managed the general Effect of it so Pleasing as the other. This is what the Artists in General have Criticized, and the Coloring of the Shadows of the flesh wants transparency. Those are thing[s] in General that have Struck them. I Can't say but the Above remarks have some justness in them, for the Picture being at my house some time gave me an opportunity of Examining it with more Exactness.

The General Effect as Mr. Reynolds justly Observes is not quite so agreeable in this as in the other; which arises from Each Part of the Picture being Equal in Strength of Coloring and finishing, Each Making too much a Picture of its self, without that Due Subordination to the Principle Parts, viz., the head and hands. For one may Observe in the great works of Van dyke, who is the Prince of Portrait Painter[s],

how he has managed by light and shadow and the Color of Draperies made the face and hands appear almost a Deception. For in Portrait Painting those are the Parts of Most Consequence, and of Course ought to be the most distinguished. There is in Historical Painting this Same attention to be Paid. For if the Principle Characters are Suffered to Stand in the Crowd, and not distinguished by light and shadow, or made Conspicuous by some Piece of art, So that the Eye is first Caught by the Head Character of the History, and So on to the next as he bears Proportion to the head Character, if this is not observed the whole is Confusion and loses that dignity we So much admire in Great works. Your Picture is in Possession of Drawing to a Correctness that is very Surprising, and of Coloring very Brilliant, though this Brilliancy is Somewhat misapplied, as for instance, the Gown too bright for the flesh, which overcame it in Brilliancy. This made them Criticize the Shadows of the Flesh without knowing from whence this defect arose; and so in like manner the dog and Carpet too Conspicuous for Accessory things, and a little want of Propriety in the Back Ground, which Should have been Some Modern ornament, as the Girl was in a Modern dress and modern Cherce [skirt?]. The Back Ground Should have had a look of this time. These are Criticisms I should not make was not your Pictures very nigh upon a footing with the first artists who now Paints, and my being sensible that Observations of this nature in a friendly way to a man of Your Talents must not be Disagreeable. I with the greater Freedom give them, As it is by this assistance the art is raised to its height. I hope I shall have the Pleasure of Seeing you in Europe, where you will have an opportunity of Contemplating the great Productions of art, and feel from them what words Cannot Express. For this is a Source the want of which (I am sensible of) Cannot be had in Ameri[c]a; and if you should Ever Come to London my house is at Your Service, or if you should incline to go for Italy, if you think letters from me Can be of any Service, these are much at your Service. And be assured I am with greatest Friendship, Your Most obedient Humble Servant

BENJN WEST

PS. I have Spoke to Several of our Mezzotinto Scrapers, and their Prices for a Plate after a Picture of that Size is from fifteen Guineas to Twenty Guineas. There are Scrapers of a less Price than that, but they are rather indifferent. I hope you will favor us with a Picture the next Exhibition. Enclosed I Send you a Copy of our Royal Charter and list of fellows, amongst whom you are Chosen one. The next which will be printed your name is to be inserted.

Copley to [Captain R. G. Bruce?] *

[1767?]

But What shall I do at the end of that time (for prudence bids us to Consider the future as well as the present). Why I must either return to America, and Bury all my improvements among people entirely destitute of all just Ideas of the Arts, and without any addition of Reputation to what I have already gained. For the favorable receptions my Pictures have met with at home has made them think I could get a better Living at home than I can here, which has been of service to me, but should I be disappointed, it would be quite the reverse. It would rather lessen than increase their opinion of my Works which I ought by all prudent methods strive to avoid. Or I should set down in London in a way perhaps less advantageous than what I am in at present, and I cannot think of purchasing fame at so dear a rate. I shall find myself much better off than I am in my present situation. (I would be here understood to speak of the profits of the art only, for as I have not any fortune, and an easy income is a necessary thing to promote the art. It ought to be considered, and Painters cannot Live on Art only, though I could hardly Live without it). But As it is not possible for me, Who never was in Europe, to settle sufficiently in my mind those points, I must rely on Your Friendship and Mr. West to inform me. I have wrote You and Mr. West in the plainest and most unreserved manner what the difficulties are, and doubt not Your friendship and prudence will lead You to give all Due weight to the objections I have proposed; and if You think they are still sufficient to keep me in this Country, I shall strive to content myself where I am. I have been the more particular in this Letter Least the other should have miscarried, and doubt not You will write me answer as soon as possible, and prevail on Mr. West to Lay aside the pencil to remove my Doubts, for You cannot but know a state of uncertainty in affairs of consequence (as these are to me,) are very perplexing and disagreeable. Beside if Your Answer [be] such as to favor my going, you know I have a Real Estate which I must dispose of, and a Great Deal of Business to settle, which must take up much time and will detain me another Year, unless I can hear soon from You.

Copley to [West or Captain R. G. Bruce?]

[1767?]

I observe the Criticisms made on my last picture were not the same as those made on the first. I hope I have not in this as in the

* A fragment of the letter.

last by striving to avoid one error fallen into another. I shall be sorry if I have. However it must take its fate. Perhaps You may blame me for not taking anoth[e]r subject that would have afforded me more time, but subjects are not so easily procured in this place. A taste of painting is too much Wanting to afford any kind of helps; and was it not for preserving the resembla[n]ce of particular persons, painting would not be known in the plac[e]. The people generally regard it no more than any other useful trade, as they sometimes term it, like that of a Carpenter tailor or shoemaker, not as one of the most noble Arts in the World. Which is not a little Mortifying to me. While the Arts are so disregarded I can hope for nothing, eith[e]r to encourage or assist me in my studies but what I receive from a thousand Leagues Distance, and be my improvements what they will, I shall not be benefitted by them in this country, neither in point of fortune or fame. This is what I wrote at large in my last letter Dated [] as the only reason that discourages me from going to Europe, least after going I shall not find myself so good an artist, as to merit that encouragement that would make it worth my while. It would by no means be [] to go th[e]re to improve myself, and then return to America; but if I could make it worth my [while] to stay there, I would remove with Moth[e]r and Broth[e]r, who I am bound by all the ties of Duty and Affe[c]tion not to Desert as Long as I live. My income in this Country is about three hundred Guineas a Year, out of which I have been able to Lay up as much as would carry me through and support me handsomely for a Couple of Years with a family.[1]

CRITICAL COMMENT ON GILBERT STUART IN LONDON, 1787-1805

The anonymous passages below are comments drawn from London periodicals on the painting of Gilbert Stuart (1755-1828). Although two of them were written after Stuart's return to America, they all appear to have been based on personal contact with the painter or his work. Stuart's own remarks here quoted reflect his distrust of critical and pictorial fashion, and although Stuart mastered the English portrait techniques to such a degree that one of his pictures, Gentleman Skating *(Washington, National Gallery of Art), was exhibited in the nineteenth century as a Gainsborough, he is praised for his visual accuracy and*

[1] "Letters and Papers of John Singleton Copley and Peter Pelham," *Collections of the Massachusetts Historical Society*, No. 71 (1914), pp. 41-45, 51-52, 56-58, 64-66.

psychological insight. Note too that, like Hesselius, he is held to be no "favorite portrait painter with the ladies."

Stuart. The Vandyck of the Time

In the most arduous and valuable achievements of portrait painting, *identity* and *duration,* Stuart takes the lead of every competitor.

Those who wish to redress themselves of accident, and, independent of time and place as far as eyesight goes and eye service, to have before them the glowing fidelity of friendship or of love, may here secure the perpetual presence of the charm they wish.

Not only skin deep, and skimming superficially over complexion and contour, Stuart dives deep—less deep only than Sir Joshua, more deep than every other pencil—Stuart dives deep into *mind,* and brings up with him a conspicuous draught of character and characteristic thought—all as sensible to feeling and to sight as the most palpable projections in any feature of a face.[1]

* * *

When we speak of him as the most accurate painter we mean to say, that having a very correct eye he gave the human figure exactly as he saw it, without any attempt to dignify or elevate the character; and was so exact in depicting its lineaments that one may almost say of him what Hogarth said of another artist, "that he never deviates into grace," and from all which we may fairly infer that he was never a favorite portrait painter with the ladies. He was, however, so well grounded in his profession that had not his eccentricities led him to quit this country he would have corrected his errors and figured very high in his art.[2]

* * *

Stuart was accustomed to say that though it was *rather* more difficult to paint a picture than to discover its defects, yet he did not think it probable that among twelve men who might be deemed competent to form a jury to approve or condemn a portrait of his, one would be found who would judge of it fairly; because (added he) they will not try it by the test of nature by which it was painted.

The admirers of Vandyck will say the portrait wants air. The followers of Romney will say it wants squareness. Those who adore Sir Joshua Reynolds will decry it as destitute of taste; and the imitators of Rembrandt will object to its wanting breadth in the shadows. He

[1] *World* (London), March, 1787. This and the following two items on Stuart are in W. T. Whitley, *Gilbert Stuart* (Cambridge: Harvard University Press, 1932), pp. 56-58.

[2] *Monthly Magazine* (London), 1805.

that makes Mr. Gainsborough his idol will say it has too decided an outline; while admirers of Mr. West may perhaps object to the outline being uncertain and ambiguous.

With respect to my brother artists (continued he) I am apprehensive that many of them paint by laws that bear a strong resemblance to those by which these critics judge, and the consequence appears in their productions; where neither the excellencies nor errors are original but are the result of their succeeding or failing in their imitation of the manner of that master whom they have made their leading model.

To illustrate this we will suppose A, E, I, O, U, to be five painters. A is a blockhead; E a person of some capabilities; I a person of still superior attainments; O has attained a high rank in the art, and deserves a high character but is still deficient in some particulars. We will suppose that U is perfection itself, yet it is the more probable that his inferior, whom we have classed under the letter O, will be looked up to and followed; but admitting that the perfect artist whom we have classed under the letter U is admired and imitated, yet with all his superiority of ability he hides nature instead of displaying it to the man who implicitly follows and copies him.[1]

MATTHEW JOUETT: NOTES FROM CONVERSATIONS ON PAINTING WITH GILBERT STUART, 1816

These observations of Gilbert Stuart were jotted down by a young portraitist, Matthew Jouett (1787-1827). The conversation between painters turned, as might be expected, to practical matters, and of particular significance is that the methods of painting Stuart describes are those by which he sought likeness alone, not style or superficial elegance. There are no appeals by the aging painter to the nobility of his calling or to the lofty aims of the grand manner. In this respect Stuart remained close to the journeyman's approach to painting which characterized our earliest practitioners of the art, an approach which the younger and more educated painters, Trumbull, Allston, and Morse, had already abandoned for a more idealistic one.

Notes Taken by M. H. Jouett while in Boston
from Conve[r]sations on painting with Gilbert Stuart Esqr.

Rude Hints and observations, from repeated Conversation with Gilbert Stuart Esqr. In the months of July, August, September and Oct. 1816 under whose patronage and care I was for the time, and

[1] *Monthly Magazine* (London), 1804.

that his singular facility in conversation and powers of illustration may suffer no detriment, I hereby do acknowledge that but in two pages have I given his words: to wit on pages 1 and 5 and upon the subject of light and flesh. Nor have I maintained the order in which he treated the subjects.

Equal color upon equal surfaces produce equal effects. That in the commencement of all portraits the first idea is an indistinct mass of light and shadows, or the character of the person as seen in the heel of the evening in the grey of the morning, or at a distance too great to discriminate features with exactness. That in every object, there is one light, one shadow, and one reflection, and that 'tis from a judicious entering into and departing from either of them that mark the harmony of a painting. That there are three grand stages in a head as in an argument or plot of any sort: a beginning, middle, and end: and to arrive at each of these perfect stages, should be the aim of the painter. Illustrated in three heads shown in a double mirror, or two mirrors, where you perceive the effects of distance upon face.

That too much light destroys as too little hides the colors, and that the true and perfect image of man is to be seen only in a misty or hazy atmosphere. Darkness hides and light destroys color, and this illustrated in a comparative view of the climates of those countries where the best colorists have lived, for instance in the foggy climates of Germany, or Holland and about Florence and Venice: compared to that of Rome and Paris, where good coloring has never obtained. England on the contrary owing to this in part has produced some good colorists. Where there's too much light there will be too much flesh in the shadows —where too little not enough flesh in the lights—both extremes are dangerous. Look at the climate for the first fault. Drawing outlines without the brush, like a man learning the notes without a fiddle, or learning the notes on a violin without a bow: In his portraits 'tis all spirited drawing and yet no outline. Illustrated in the story of a tracing of Sir B. West's picture where the traced outline would not give any idea of the painting. Criticism upon Vanderlyn's coloring, like putrid veal a little blowed with green flies. The eye ought to be accustomed to distances and directions from point to point. More important, to give a prominent admeasurement of distances than a set of mincing curves. Keeping of the very highest importance to good coloring, to effect which one should set a good way from his easel and early accustom themselves to look at the subject and not at the features. A ludicrous criticism upon mincing painters who paint all the features correctly but so detached that when bought to be the same job look like new lives convicts and preache[r]s and so forth, all huddled up together and all out of place because there's no chain of inter[e]st to connect them. That

fitness is a very main and almost essential to a tolerable picture. Consult truth rather than fancy; and without reason to systematize and control the fervor of the imagination our paintings will be like our dreams when they come to be examined coolly and philosophically—fancy without reason and good taste like declamation without sense, or a fine voice and good words and fine gestures without common reason or common arrangement.

Let everything be of a piece: Let not your Pharaohs be beef eating Aldermen nor your buff jerkins who unbutton after dinner lean Cassius. Ludicrous illustration of the want of fitness in Mr. [*blank in MS.*] whose Pharaoh was a jerkined alderman or Squire and his [*blank in MS.*]

Cry of the English School, sink your drapery Stuart and bring out the flesh; but no let Nature tell in every part of your painting and if you cannot do this throw by the brush. On the lightest parts of your linen drapery, let the light fall brilliantly, on the lightest parts of the flesh let your light fall same: the whitest drapery cannot blaze in a soft light, nor neither can it take away from the swe[e]tness of the flesh. Immense light makes all polished metals alike in the highest polish of gold and silver in a vertical sun 'tis a reflex of white only. On flesh it has likewise this partial effect and this will serve to illustrate what has before been observed with respect to too much light.

* * *

Avoid by all means, parallel lines whether they be parallel straight or parallel curve lines. His extreme judgment and taste, evinced in a slight alteration of a small lock of hair that was a little parallel with the ear—Mrs. Shaw's portrait.

Miss Pickering's portrait. In this he had to lose the line of the far side of the robe to prevent a too long parallel with the front edge of the trimming: Whenever a picture is offensive: and the cause does not at once strike, bethink yourself to look out for parallel lines. These not unfrequently offend when not seen—that is when not separately examined. Straight lines to be avoided to do away the effects of straight lines in a limb or the side of the nose or face recourse must be had to indenting so as to give rest to the eye, but as there are no straight lines in nature, so this precaution becomes of little avail. One of the principal reasons of the dignity of his heads, his great practice in his youth upon heads of the nobility of England and Ireland. *Reflection of mine*: In painting great public characters be sure to have them elevated above you—this opens the countenance and gives a grandeur to the figure. Another advantage in having your sitters elevated when the pictures

are hung the same view seems to be had of them, that is by giving an elevation to the sitter you suit the picture to the height in hanging, and the perspective is agreeable. His method of flinging in Marbled pillars. See Buckminister's head. Of making back grounds, badgers tools, its use to be remembered. Vandyke's brown to be used with success in Backgrounds. He uses no ultramarine: but keeps it by him. Ludicrous account of his blueing West's head with ultra. Burnt sienna to be used in making out the composition of a picture, and in gold lace. In his head of Washington, no Burnt sienna. Dark Shadows umber and lake or vermillion and black.

Drawing the brush up and down in painting monstrous, his charge to me while engaged on the woman's [?] head.

this the proper stroke, but no stroke either to be used [?] or avoided but the liny strokes. Suit the motions of the brush so as to get the effect and give the best shapes to things. To paint with great beauty and freedom endeavor to put down what you see. Without being at all curious as to the shape of your strokes, but the blotching plump round stroke seems to suit with this best and is to be recommended because of its appropriateness: this evil half positive and half timid precautionary instruction inten[d]ed to leave you room for experiment, and I thus note them that I may not forget to think and act for myself. One main ingredient to make a bold and lively painter. All this to be found under the head of decision.

* * *

The ingratitude of Copley to West and the good nature of Capt. Higgins in offering to loan an indiffer[ent] head of Copley for a study. Particular charge never to have the head higher colored than wish it at the finish. This is apt to give a heavy doughy effect. Never to glaze on the face, nowhere in fact unless you have such a body of color underneath the glaze as stand against all accidents, from picture cleaners. His head of Shaw, in proof of the first proposition. In this head he was feeble—less feeble—strong, very strong as regards both light and shadow. Even in the hair he observed his gradations of strength: in fine the wh[ol]e head was in constant keeping, from beginning to ending, and there was no part that did not receive his attention in every sitting. His strictures upon the balance of the human figure and his criticism on Trumbull's painting in London. They looked like they were painted with one eye (secret). He loves Trumbull and thinks highly of his talents. He says that Sully is very clever and ingenious, and had he

remained in London a year or two longer would have received immense advantages and been now at the very head of his profession. Whiteford's pun on the looking glass kept in the back of his chair. The looking glass one's best instructor. This should early be used least one gets to love one's faults too well to renounce them. To take out the oil from (yellow paint) stone [?] ochre when it works ropy [?] with your palette knife and a little water work it about on your palette and it will soon lose its clamminess and work short [?] and agreeably.

Never introduce an object in the shadow of your picture that you wish conspicuous as for instance a white dog as Fields once did, in the shadow of his master. But always so arrange the parts of the whole as to reflect with advantage one upon another. In a full length of Louis 16th is the same fault. There the silvery gray of the one side of his dress is thrown from the light and the black faces the light, whereas the opposite would have been the fairer treatment. Avoid all parallels whether of straight or curved lines. Nature abhors so much uniformity, and it looks like a contest in the parts of a picture to be so fronting and opposed to each other or as Mr. Stuart expresses "the parallels in a painting look like fighting against each other." But this point I have in another place touched.

The first thing to be sought for in a picture is the balance of the picture, then of the composition as a whole, then of the composition as individual groups, and lastly of the single figures. If these points are met by the artist, incorrect and false design is easily detected for the error will be seen; if you at first discover where it is not, you have gone a great way toward where it is. Whenever a great picture and indeed a picture is presented to you, Should you not understand the subject, before you undertake to develop its beauties be sure that you understand the foundation of it, the thing it is intended to represent, and the like, without a perfect knowledge of this it cannot be supposed that you can do either the artist's or your own skill justice. A subject may be treated in different ways, and the view of the artist may not be understood without fully understanding the whole subject. After understanding the subject you can determine at once the fit means, and go on to the composition design and lastly of the coloring of the picture, but as coloring is not so significant to us as drawing and as it partakes more of common mechanical employment, in a word as it is more closely allied to matter than intelligence, so 'tis of inferior importance to design. But even coloring is of great use, as without it a complete picture could not be given nor indeed could perfect expression be given without its aid, and for the simple reason that it forms a portion of the necessary thing. The liquid eye, the aged pale lip, the wan cheek of care and disease or the rosy

bloom of health and joy are as necessary in color as in line. Raphaelle who was a bad colorist, for his great invention, composition, expression, and Design has been called the Divine, whereas Titian [and] Corregio, who [were] the greatest colorists [enjoy] a reputation of limited extent.

Expression is often taken in too limited a view. There is such a thing as a general and at the same time individual expression in every picture of any size, and where a general, good expression prevails, 'tis of singular service in producing pleasing emotion, for the idea of an adaption to an end is an extremely pleasing one, and nothing can be of more singular service in this than the general expression. Individual expression or the expression of individual parts or objects as enforcing the whole is very desirable but this partial expression, when it fights against the general effect or character is of but little importance. It only serves to mock the chief design or intention of the artist.

Expression is but too generally understood to relate to living character. It belongs as much to inanimate as animate being and I take it for granted in landscape painting, the most pleasing expression may be given, and without the introduction of a single animate being. In architecture the more particularly. In short in all natu[re] whether of animate or inanimate there is abundance of character. Or why expands the soul at the sight of old trees and rocks swept over by the raging flood.

These things ought to [be] well considered. Whilst the artist is all attention to animate expression, he should by no means overlook that character, which is necessary to enforce animate express[ion] [and] give life to inanimate creatu[res].

When one has in view the painting of a picture he should in privacy, digest as well as practicable the subject and previous to his drawing a single figure he should have made in his mind the necessary selection of means. This falls under the head of invention in painting and is expressive of the same idea as invention in poetry, which means nothing more than the necessary materials out of which the picture or poem is to be formed. Whenever the materials are laid out, then the putting of them together in group or groups. But it is necessary to premise in the first place that one should never design his picture other than his imagination approves. It often happens that an attitude singularly *necessary and proper* is sacrificed to one that is more easy to the hand. No man can meet his fancy, but 'tis a general, good rule not [to] be contented to treat a subject but as it deserves.[1]

[1] Matthew Harris Jouett, "Notes on Painting from Conversations with Gilbert Stuart," in John Hill Morgan, *Gilbert Stuart and His Pupil*, (New York: New York Historical Society, 1939).

"control" of portraits

AMERICAN ACADEMY OF FINE ARTS: REMARKS ON PORTRAITS OF GEORGE WASHINGTON, 1824

First published as a pamphlet by the American Academy and sub-sequently printed in Atlantic Magazine, *these remarks reflect the flourishing trade in likenesses of George Washington. The diplomatic evasiveness of the listing stems from the Academy's desire to rescue these works from the overriding popularity of Stuart's* Lansdowne Washington. *More overtly the document provides some standards by which the work of "pitiful bunglers" might be judged and marks the emergence of a guardian professional body in the artistic affairs of the young republic.*

Remarks

We shall add a few remarks on the chief characteristics of those sculptured and painted portraits of Washington which were done from life by artists the most reputable for talents and which he actually sat for: premising with a few introductory reflections—

It was a wise decree of Alexander the Great that none should paint his portrait but Apelles, and none but Lysippus sculpture his likeness; we feel the want of such a regulation in the case of our Washington, whose countenance and person, as a man, were subjects for the finest pencil and the most skillful chisel. But we are cursed as a nation with the common. miserable representations of our Great Hero, and with the shocking counterfeits of his likeness by every pitiful bungler that lifts a tool or a brush, working solely from imagination without any authority for their representations and deceptions, and bolstered up by every kind of imposture.

The evil has arisen to such a height that it is necessary for something to be done to rectify the public sentiment on this point, now so warmly agitated, so as to undeceive posterity. For these reasons we have drawn up this list of artists who painted and sculptured from life, as far as is ascertained; and give the various circumstances under which they executed their likenesses, that the public may know where to find the true standard of what were genuine likenesses of Washington at the respective periods of life at which they were done, with a comparative view of those originals most worthy of confidence. These we necessarily limit to six of the best artists who took his likeness at those periods of life most interesting to us, and which at the time they were done met with the decided appreciation of the most competent judges; no one ever

imagining it necessary to procure a set of certificates as to their authenticity or genuineness for verisimilitude, with which spurious or imaginary compositions are bolstered up:—Therefore

(1) If we wish to behold the countenance of Washington in his best days we must look at the bust of Houdon; who gives the air of the head, and custom of the hair of the day, but with closed lips; in his best manner, and of whose competency to the task there can be no doubt.

(2) If we want to behold his complexion and expression of the eye with an averted aspect let us look at Pine's portrait in military uniform; the excellence of the painting and its correspondence with the other genuine originals speaks volumes as to its character.

(3) If we wish to behold Washington not only in his countenance but in the full display of the majesty and figure of the man, with eye averted, we shall find it in Trumbull's *brilliant* whole length.

(4) If we wish more particularly to see the graceful play of his lips in the act of speaking, and the peculiar expression of his mouth and chin at the same moment, we shall see it in Ceracchi's colossal bust.

(5) If we wish to behold Washington when he began to wane in his later years, and had lost his teeth, but with the full vivacity and vigour of eye, looking at the spectator, we must behold Robertson's; it is somewhat remarkable that only Robertson and Stuart make him look at the spectator.

(6) If we wish to see President Washington as delineated from the life in 1796 by one of the first portrait painters of the day, let us look at the original picture in the possession of the artist, G. Stuart, now in Boston. The head only is finished, the drapery has never been added.

This last, differing so essentially from all other portraits, has been the cause of all the dissension about Washington's likeness; although we have not the least doubt the artist gives us a true representation of the man when he sat to him; and thus we explain why we ought to receive all these originals as correct likenesses at the time they were taken, for it is impossible that one picture can represent him with all his teeth, without them, and with a new set of formidable ones, at the same time.

It is particularly requested that should any person be in possession of a well authenticated original likeness of Washington other than above specified he will be so good as to communicate it to the Secretary of the American Academy of Fine Arts, by letter or otherwise.[1]

AMERICAN ACADEMY OF FINE ARTS,
NEW YORK, SEPT. 20, 1824

[1] *Atlantic Magazine*, October, 1824, pp. 433-435.

JAMES GUILD: TRAVEL DIARY

Very little is known of James Guild's career. He was born in Hat-field, Massachusetts, in 1797. After adventures as a peddler, tinker, and itinerant portrait painter, he wound up in London, still an innocent, before a nude model for the first time "drawing her beautiful figure, perfectly naked." After some success in Europe and a period of residence in the West Indies, Guild died in New York in 1841. His diary tells of his early years and ends abruptly with the London experience mentioned above. Itinerant painters such as Guild were common in America, particularly in rural areas, from the Colonial period down to the Civil War when the rise of photography ended their days. Guild's diary, with its mixture of pride, rascality, and Yankee sharpness is a rare document of the vernacular in the history of American portrait painting.

Here I went to cutting profile likenesses. After I had been in town about two days, I was traveling on a back road and passing by a large white House where there were two young Ladies who had got on their old bonnets for washing. When they saw me, they thought to have a little fun with a stranger, for they thought they would never see me again, and they began to beckon and curtsey and bow and make all the mocking figures you could mention. All this time I stood with my mouth wide open and about half bent and made the appearance of a fool as much as I could. They seeing my posture concluded I was a fool as perhaps it is too true.

After they had mocked me enough, I thought I would let them know I was not so big a fool as they thought, for in order to get to the back room where they were, I had to go through a garden, and over the fence I jumped, and as hard as I could after them, and followed them into a parlor where sat Mrs. Semore. Then I was waited upon in the greatest politeness. By this time I had attended my deportment and was as polite as you please. No matter, Marm, about a seat, I only called because those young Ladies beckoned to me. I never have young Ladies beckon to me without I know their desires. One of the girls said I thought it was someone else. The other says I thought it was such an one, and their faces colored up, and I think they got punished enough for their impudence.

While I were here I bought me a diamond to cut glasses with and of the same man I cut profiles enough to pay for it. Then I went to Elbridge in Camelus. Here I stayed 5 weeks in cutting profiles. While I

was here, I sold my diamond for 300 frames to put likenesses in. While here I saw a young Lady who wanted I should give her my profile. O yes you may have my profile and welcome. The object was she thought if I gave her my likeness, I would give her my frame, also she being a little imprudent told one of my friends, and he told me. So when I offered it to her, she says, O I won't take it unless you give me the frame with it. Well, Marm, I thought you wanted my frame more than my likeness, and I did not give it to her.

* * *

Now I went to Canadagua. Here I went into a painters shop, one who painted likenesses, and I my profiles looked so mean when I saw them I asked him what he would show me one day for, how to distinguish the colors and he said $5, and I consented to it and began to paint. He showed me one day and then I went to Bloomfield and took a picture of Mr. Goodwin's painting for a sample on my way. I put up at a tavern and told a Young Lady if she would wash my shirt, I would draw her likeness. Now then I was to execute my skill in painting. I operated once on her but it looked so like a wretch I throwed it away and tried again. The poor Girl sat nipped up so prim and look so smiling it makes me smile when I think of while I was daubing on paint on a piece of paper, it could not be called painting, for it looked more like a strangle cat than it did like her. However I told her it looked like her and she believed it, but I cut her profile and she had a profile if not a likeness.

Then I traveled on and stopped at every house and inquired if they wanted any profile likeness taken, and if I could not get but a trifle, I would paint for the sake of learning. In about 3 days I was quite a painter for I had one dollar for painting, and when I came to Bloomfield I thought I was quite capable of the task. Here I painted this that and the other. After I had got through and ready for a start, one Miss Marvin sent in to have me come in and see her, for she wanted their little children's likeness taken, and I went in and showed her some painting while she called to her husband to come and see them. He came out and sat down in a chair. Come, Says Miss Marvin, won't you have our children's likenesses taken? The reply was no, get out of my house in a minute, or I will horse whip you, you damn profiteers and peddlers, you ought to have a good whipping by everyone that sees you. Get out of my house you rascal. I replied in a soft tone, why now, uncle, you won't hurt me, will you? I shan't go until I have my pictures that your wife has got. They gave them to me and I says now, sir, I will go with pleasure, but I want to take a little spell with you.

I know you are a man who would have acquaintance very well and you won't hurt me. I am one of the best natured fellows you ever see. Now, uncle, you have one of the finest situations (here I was interrupted). Get out of enclosure, you rascal, or I will horse whip you and you shall leave the town in one hour or I will horse whip you all the way out. Stop, says he, give me your name, I'll warn you out of town. Show me your authority to demand my name and you shall have it, and not without my authority. I'll let you know my authority. With that he caught me by the collar and with great threats declares a horse whipping while I was very calm and made pleasant observations which made him the more angry. He pulled me along by the collar and rising on the second step to enter the house while I was on the first.

Now was a good opportunity for me. I flew my hand round and caught him I know not where and dropped on my back and with my foot pitched him over my head and the first that struck was his face on a sharp board purposed for a goose pen and I guess he carries the mark until this day. Now sir if you will come here I will serve you the same sauce again, only touch me with your little finger and I will make you my footstool. After a few minutes of bustle he recovered and [began] to enter a complaint for hurting him. So a woman that belonged in the first tavern told me if I wanted to get away, she would tell me where to go, so she pointed the way through a barnyard and into a footpath which in the end proved the same.

* * *

Then I made up my mind to go to the southard. I said to myself I will go and either make something or nothing, either gain my health or lose it.

Now I had a Sister whom I loved ah, yes I loved too dearly. She was the only Sister I had, and when young our father left us, and if I could assist her it was my great pleasure. After getting her a crepe gown and a new bonnet and I then must leave and my dear Mother to wander again in the Land of Strangers, and with a heart full of grief not only for my connections, but I had left a friend who seemed nearer than connections. For particular reasons I have strove to drive her from my mind, but time will decide all those difficulties. As it is not my object to put down love affairs, I will pass on. Now I came to Charleston where I was sick for a week, and had a little money stolen from me, and after going to Walpole found it necessary to go back and make him appear guilty. Then I came on to Brattleborough and in a week made $23. Now I had a good horse and fifty Dollars. Then I came to Albany and sold my horse which was worth $80 for $40. Then I had $90.

I found my health was as usual very poor, and wishing to gain some knowledge in painting I would play truant for awhile, for all the practice that I had had in miniature was when I was at Charlestown. I been in the habit of painting on paper and a Gentleman says, can't you paint on Ivory? Oh yes but I am out of Ivory. Very well I have a piece and you may paint my miniature, so for the first time I attempted Ivory painting and went so much beyond my expectations that I thought I soon would be a dabster.

* * *

I found my health impairing very fast and to grieve about spilt milk would only shorten my days and deprive me of that independent spirit and ambition which I had to shine in the world. I was and always was unhappy because I could not obtain a fortune. I thought that I Should be one of the happiest fellows in the world if I could only be rich, and I thought as others had began with nothing and became men of fortune that I might I throw aside all my dull notions and went to painting and paid off all my debts and a little to clear out. I then left Baltimore and came to Norfolk.

Here I said to myself that I will make money. I hired me a room and advertised to teach writing, and painting miniatures. I had in a short time 40 schollars and as much as I could do in painting. I painted for $5.00, each. I spent six months in this place and made $300. Just beginning to get a better start again, I just got started in business and four or five painters arrived, but as I had got the start and they found but little to do except one portrait Painter which did not hurt me much. The inhabitants were formerly wealthy, but owing to the change of times there were many broken merchants people who had been in the habit of high living, and it is hard for people to give up their pride and style even rather live poor, than not stylish. Society was very much broken up and family visiting was their greatest amusement. The habits of young men were very much corrupted. A house in the place was kept where they used to spend their time in gambling, etc. From excessive habit they seem to be more fond of this blackard company than that which was more refined.

While I was here there was a gentleman from Curatuck visiting Norfolk. He was introduced to my room and being so well pleased with me he had his miniature taken and said that he would get me work if I would come to Curatuck. Not knowing him too well, I thought the sure side was the best. I said to him if he would draw up a subscription paper and obtain 20 subscribers I would come. In a few weeks I received a letter from [him] stating that he had got the number. I then consid-

ered myself under a pleasing obligation to go from this I went to Curatuck and from thence to Camdin and to Elizabeth City. This was about thirty miles from Norfolk. I enjoyed myself very well and made about $300 in three months, returned to Norfolk to spend the fourth of July, and from thence to N. Y. I left Baltimore in Sept., and now it was July. I had made six hundred dollars. After I failed in Baltimore I would not write to my friends too proud to own that I had been taken in and lost all my money. I said to myself money I must and will have. I found I lacked very much for instruction, and I made up my mind to go to N. Y. and receive instruction from the first artists and then take a trip to the south, and when I can go home in Style then will I go but in any other way I will not show my face.

* * *

I commenced [in London] my profession as an artist; I then delivered my letters of introduction; and met with great hospitality, was invited to dine; and became very intimate with Mr. Bird. I found him a most hospitable fellow and had a most amiable wife in his family. I spent many an hour very pleasantly. I likewise became acquainted with Mr. Cethcart; and immediately became acquainted with the most eminent Artist in the City; I was introduced into a club of artists where they met once a week for the purpose of painting naked figures; for the purpose of learning the human figure; the first subject we had was a young lady, stripped to the beef and placed on a pedestal, and we twenty Artists sitting round her drawing her beautiful figure, perfectly naked; Se Sie————————— [1]

[1] "The Travel Diary of James Guild," *Vermont Historical Society Proceedings*, New Series, **V** (1937), 250-313.

2

A Search
for the
Grand Style

JOHN GALT: THE LIFE AND STUDIES OF
BENJAMIN WEST, 1816

Although John Galt's biography of Benjamin West (1738-1820) was published during the painter's lifetime, it is not notably reliable. The sections here reproduced on West's early years and on his encounter in Rome with Cardinal Albani and his circle of cognoscenti *bear inclusion if only for the aptness of the author's fancy. In the confrontation of American innocence and European sophistication which this meeting represents, West's alleged comment on the Apollo Belvedere unwittingly united the noble savage of his own experience in America with that element of primitivism found in Winckelmann's description of the ancient Greeks, published only five years earlier in his* Thoughts on the Imitation of Greek Art in Painting and Sculpture *of 1755. West later settled in London where he succeeded Sir Joshua Reynolds as President of the Royal Academy. The kindness which he extended to generations of young American painters has already been indicated in his letters to John Singleton Copley.*

The effect of the enthusiasm inspired by Richardson and Fresnoy may be conceived from the following incident. Soon after the young artist had returned to Springfield, one of his schoolfellows, on a Saturday's half holiday, engaged him to give up a party at trap-ball to ride with him to one of the neighboring plantations. At the time appointed the boy came, with the horse saddled. West inquired how he was to ride; "Behind me," said the boy; but Benjamin, full of the dignity of the profession to which he felt himself destined, answered, that he never would ride behind anybody. "O! very well then," said the good-natured boy, "you may take the saddle, and I will get up behind you." Thus mounted, they proceeded on their excursion; and the boy began to inform his companion that his father intended to send him to be an apprentice. "In what business?" inquired West; "a tailor," answered the boy. "Surely," said West, "you will never follow that trade"; animadverting upon its feminine character. The other, however, was a shrewd, soundheaded lad, and defended the election very stoutly, saying that his father had made choice of it for him, and that the person with whom he was to learn the business was much respected by all his neighbors. "But what do you intend to be, Benjamin?" West answered, that he had not thought at all on the subject, but he should like to be a painter. "A painter!" exclaimed the boy, "what sort of a trade is a painter? I never heard of such a thing." "A painter," said West, "is a companion for kings and emperors." "Surely you are mad," replied

the boy, "for there are no such people in America." "Very true," answered Benjamin, "but there are plenty in other parts of the world." The other, still more amazed at the apparent absurdity of this speech, reiterated in a tone of greater surprise, "you are surely quite mad." To this the enthusiast replied by asking him if he really intended to be a tailor. "Most certainly," answered the other. "Then you may ride by yourself, for I will no longer keep your company," said West, and, alighting, immediately returned home.

* * *

It was not, however, the native inhabitants of Rome who constituted the chief attractions of society there, but the number of accomplished strangers of all countries and religions, who, in constant succession, came in pilgrimage to the shrine of antiquity; and who, by the contemplation of the merits and glories of departed worth, often felt themselves, as it were, miraculously endowed with new qualities. The collision of minds fraught with learning, in that high state of excitement which the genius of the place produced on the coldest imaginations, together with those innumerable brilliant and transitory topics which were never elicited in any other city, made the Roman conversations a continual exercise of the understanding. The details of political intrigue, and the follies of individuals, excited but little interest among the strangers in Rome. It seemed as if by an universal tacit resolution, national and personal peculiarities and prejudices were forgotten, and that all strangers simultaneously turned their attention to the transactions and affairs of former ages, and of statesmen and authors now no more. Their mornings were spent in surveying the monuments raised to public virtue, and in giving local features in their minds to the knowledge which they had acquired by the perusal of those works that have perpetuated the dignity of the Roman character. Their evenings were often allotted to the comparison of their respective conjectures, and to ascertain the authenticity and history of the relics which they had collected of ancient art. Sometimes the day was consumed in the study of those inestimable ornaments of religion, by which the fraudulent disposition of the priesthood had, in the decay of its power, rendered itself venerable to the most enlightened minds; and the night was devoted to the consideration of the causes which contribute to the development of genius, or of the events which tend to stifle and overwhelm its powers. Every recreation of the stranger in Rome was an effort of the memory, of abstraction, and of fancy.—Society, in this elevated state of enjoyment, surrounded by the greatest works of human

creation, and placed amidst the monuments of the most illustrious of mankind, and that of the Quakers of Pennsylvania, employed in the mechanical industry of felling timber, and amid the sobriety of rural and commercial economy, were like the extremes of a long series of events, in which, though the former is the necessary consequence of the latter, no resemblance can be traced in their respective characteristics. In America all was young, vigorous, and growing,—the spring of a nation, frugal, active, and simple. In Rome all was old, infirm, and decaying,—the autumn of a people who had gathered their glory, and were sinking into sleep under the disgraceful excesses of the vintage. On the most inert mind, passing from the one continent to the other, the contrast was sufficient to excite great emotion; on such a character as that of Mr. West, who was naturally disposed to the contemplation of the sublime and beautiful, both as to their moral and visible effect, it made a deep and indelible impression. It confirmed him in the wisdom of those strict religious principles which denied the utility of art when solely employed as the medium of amusement; and impelled him to attempt what could be done to approximate the uses of the pencil to those of the pen, in order to render painting, indeed, the sister of eloquence and poetry.

But the course of study in the Roman schools was not calculated to enable him to carry this grand purpose into effect; for the principles by which Michael Angelo, and Raphael had attained their excellence, were no longer regarded. The study of nature was deserted for that of the antique; and pictures were composed according to rules derived from other paintings, without respect to what the subject required, or what the circumstances of the scene probably appeared to be. It was, therefore, not one of the least happy occurrences in his life that he went to Rome when society was not only in the most favorable state for the improvement of his mind, and for convincing him of the deleterious influence of the arts when employed as the embellishments of voluptuousness and luxury; but also when the state of the arts was so mean, that the full effect of studying the antique only, and of grouping characters by academical rules, should appear so striking as to satisfy him that he could never hope for any eminence, if he did not attend more to the phenomena of nature, than to the productions of the greatest genius. The perusal of the works of other painters, he was sensible, would improve his taste; but he was convinced, that the design which he had formed for establishing his own fame, could not be realized, if, for a single moment, he forgot that their works, however exquisite, were but the imitations and forms of those eternal models to which he had been instinctively directed.

It was on the 10th of July, 1760, that he arrived at Rome. The French courier conducted him to a hotel, and, having mentioned in the house that he was an American, and a Quaker, come to study the fine arts, the circumstance seemed so extraordinary, that it reached the ears of Mr. Robinson, afterwards Lord Grantham, who immediately found himself possessed by an irresistible desire to see him; and who, before he had time to dress or refresh himself, paid him a visit, and insisted that he should dine with him. In the course of dinner, that gentleman inquired what letters of introduction the artist had brought with him; and West having informed him, he observed it was somewhat remarkable that the whole of them should be addressed to his most particular friends, adding, that as he was engaged to meet them at a party in the evening, he expected West would accompany him. This attention and frankness was acknowledged as it deserved to be, and is remembered by the artist among those fortunate incidents which have rendered the recollection of his past life so pleasant, as scarcely to leave a wish for any part of it to have been spent otherwise than it was. At the hour appointed, Mr. Robinson conducted him to the house of Mr. Crispigné, an English gentleman who had long resided at Rome, where the evening party was held.

Among the distinguished persons whom Mr. West found in the company, was the celebrated Cardinal Albani. His eminence, although quite blind, had acquired, by the exquisite delicacy of his touch, and the combining powers of his mind, such a sense of ancient beauty, that he excelled all the virtuosi then in Rome, in the correctness of his knowledge of the verity and peculiarities of the smallest medals and intaglios. Mr. Robinson conducted the artist to the inner apartment, where the Cardinal was sitting, and said, "I have the honor to present a young American, who has a letter of introduction to your eminence, and who has come to Italy for the purpose of studying the fine arts." The Cardinal fancying that the American must be an Indian, exclaimed, "Is he black or white?" and on being told that he was very fair, "What as fair as I am?" cried the Cardinal still more surprised. This latter expression excited a good deal of mirth at the Cardinal's expense, for his complexion was of the darkest Italian olive, and West's was even of more than the usual degree of English fairness. For some time after, if it be not still in use, the expression of "as fair as the Cardinal" acquired poverbial currency in the Roman conversations, applied to persons who had any inordinate conceit of their own beauty.

The Cardinal, after some other short questions, invited West to come near him, and running his hands over his features, still more attracted the attention of the company to the stranger, by the admira-

tion which he expressed at the form of his head. This occasioned inquiries respecting the youth; and the Italians concluding that, as he was an American, he must, of course, have received the education of a savage, became curious to witness the effect which the works of art in the Belvidere and Vatican would produce on him. The whole company, which consisted of the principal Roman nobility, and strangers of distinction then in Rome, were interested in the event; and it was arranged in the course of the evening, that on the following morning they should accompany Mr. Robinson and his protegé to the palaces.

At the hour appointed, the company assembled; and a procession, consisting of upwards of thirty of the most magnificent equipages in the capital of Christendom, and filled with some of the most erudite characters in Europe, conducted the young Quaker to view the masterpieces of art. It was agreed that the Apollo should be first submitted to his view, because it was the most perfect work among all the ornaments of Rome; and, consequently, the best calculated to produce that effect which the company were anxious to witness. The statue then stood in a case, enclosed with doors, which could be so opened as to disclose it at once to full view. West was placed in the situation where it was seen to the most advantage, and the spectators arranged themselves on each side. When the keeper threw open the doors, the artist felt himself surprised with a sudden recollection altogether different from the gratification which he had expected; and without being aware of the force of what he said, exclaimed, "My God, how like it is to a young Mohawk warrior!" The Italians, observing his surprise, and hearing the exclamation, requested Mr. Robinson to translate to them what he said; and they were excessively mortified to find that the god of their idolatry was compared to a savage. Mr. Robinson mentioned to West their chagrin, and asked him to give some more distinct explanation, by informing him what sort of people the Mohawk Indians were. He described to him their education; their dexterity with the bow and arrow; the admirable elasticity of their limbs; and how much their active life expands the chest, while the quick breathing of their speed in the chase, dilates the nostrils with that apparent consciousness of vigor which is so nobly depicted in the Apollo. "I have seen them often," added he, "standing in that very attitude, and pursuing, with an intense eye, the arrow which they had just discharged from the bow." This descriptive explanation did not lose by Mr. Robinson's translation. The Italians were delighted, and allowed that a better criticism had rarely been pronounced on the merits of the statue.[1]

[1] John Galt, *The Life and Studies of Benjamin West* (Philadelphia, 1816), pp. 41-43, 122-133.

JOHN TRUMBULL: LETTER TO
THOMAS JEFFERSON, 1789

John Trumbull (1756-1843) was the first of an articulate, college-educated group of painters who aspired to bring the painting of historical subjects to America. His dedication to his profession is here measured in a letter to Thomas Jefferson, then American Ambassador to France, declining a flattering offer to serve as his private secretary. Although Trumbull hoped to profit materially from his projected series of pictures on the American Revolution, his belief in the grandeur of his calling and in the role painting might play in service of the state is clearly heartfelt. Although Trumbull executed the paintings on the Revolution, his plans to sell engravings after them failed, and although he was later named to provide a historical painting for the Rotunda of the National Capitol, neither his paintings nor those of his contemporaries became the instruments of a national policy for the arts.

To Thos. Jefferson, Esq., &c. &c., at Paris

LONDON, JUNE 11TH, 1789

DEAR SIR:

I have received yours of the 1st, by the last post, and am happy that you find the account correct; since writing that, you will have received by Mr. Broome, the bill of exchange. You will receive by the diligence to-morrow, Stern's Sermons, Tristram Shandy, and the Sentimental Journey, unbound; being all of his works which have been published by Wenman, in his very small size; they cost eight shillings, sixpence.

If my affairs were in other respects as I could wish them, I should have given at once a positive answer to your proposition. It would have been an answer of thankfulness and acceptance, for nothing could be proposed to me more flattering to my pride, or more consonant, at least for a time, to my favorite pursuit. The greatest motive I had or have for engaging in, or for continuing my pursuit of painting, has been the wish of commemorating the great events of our country's revolution. I am fully sensible that the profession, as it is generally practiced, is frivolous, little useful to society, and unworthy of a man who has talents for more serious pursuits. But, to preserve and diffuse the memory of the noblest series of actions which have ever presented themselves in the history of man; to give to the present and the future sons of oppression and misfortune, such glorious lessons of their rights,

and of the spirit with which they should assert and support them, and even to transmit to their descendants, the personal resemblance of those who have been the great actors in those illustrious scenes, were objects which gave a dignity to the profession, peculiar to my situation. And some superiority also arose from my having borne personally a humble part in the great events which I was to describe. No one lives with me possessing this advantage, and no one can come after me to divide the honor of truth and authenticity, however easily I may hereafter be exceeded in elegance. Vanity was thus on the side of duty, and I flattered myself that by devoting a few years of life to this object, I did not make an absolute waste of time, or squander uselessly, talents from which my country might justly demand more valuable services; and I feel some honest pride in the prospect of accomplishing a work, such as had never been done before, and in which it was not easy that I should have a rival.

With how much assiduity, and with what degree of success, I have pursued the studies necessarily preparatory to this purpose, the world will decide in the judgment it shall pass on the picture (of Gibraltar) which I now exhibit to them; and I need not fear that this judgment will deceive me, for it will be biased here, to a favorable decision, by no partiality for me, or for my country.

But, while I have done whatever depended upon my personal exertions, I have been under the necessity of employing, and relying upon the exertions of another. The two paintings which you saw in Paris three years ago, (Bunker's Hill and Quebec,) I placed in the hands of a print-seller and publisher, to cause to be engraved, and as the prospect of profit to him was considerable, I relied upon his using the utmost energy and dispatch; instead of which, three years have been suffered to elapse, without almost the smallest progress having been made in the work. Instead therefore of having a work already far advanced to submit to the world and to my countrymen, I am but where I was three years since, with the deduction from my ways and means of three years' expenses, with prospects blighted, and the hope of the future damped by the experience of past mismanagement. And the most serious reflection is, that the memory and enthusiasm for actions however great, fade daily from the human mind; that the warm attention which the nations of Europe once paid to us, begins to be diverted to objects more nearly and immediately interesting to themselves; and that France, in particular, from which country I entertained peculiar hopes of patronage, is beginning to be too much occupied by her own approaching revolution, to think so much of us as perhaps she did formerly.

Thus circumstanced, I foresee the utter impossibility of proceed-

ing in my work, without the warm patronage of my countrymen. Three or four years more must pass before I can reap any considerable advantage from what I am doing in this country, and as I am far from being rich, those years must not be employed in prosecuting a plan, which, without the real patronage of my country, will only involve me in new certainties of great and immediate expense, with little probability of even distant recompense. I do not aim at opulence, but I must not knowingly rush into embarrassment and ruin.

I am ashamed to trouble you with such details, but without them, I could not so well have explained my reason for not giving you at once a decided answer. You see, sir, that my future movements depend entirely upon my reception in America, and as that shall be cordial or cold, I am to decide whether to abandon my country or my profession. I think I shall determine without much hesitation; for although I am secure of a kind reception in any quarter of the globe, if I will follow the general example of my profession by flattering the pride or apologizing for the vices of men, yet the ease, perhaps even elegance, which would be the fruit of such conduct, would compensate but poorly for the contempt which I should feel for myself, and for the necessity which it would impose upon me of submitting to a voluntary sentence of perpetual exile. I hope for better things. Monuments have been in repeated instances voted to her heroes; why then should I doubt a readiness in our country to encourage me in producing monuments, not of heroes only, but of those events on which their title to the gratitude of the nation is founded, and which by being multiplied and little expensive, may be diffused over the world, instead of being bounded to one narrow spot?

Immediately therefore upon my arrival in America, I shall offer a subscription for prints to be published from such a series of pictures as I intend, with the condition of returning their money to subscribers, if the sum received shall not prove to be sufficient to justify me in proceeding with the work; and I shall first solicit the public protection of Congress.

I am told that it is a custom in France, for the king to be considered as a subscriber for one hundred copies of all elegant works engraved by his subjects; that these are deposited in the Bibliothèque du Roi, and distributed as presents to foreigners of distinction and taste, as specimens of the state of the fine arts in France. Would this be a mode of diffusing a knowledge of their origin, and at the same time a lesson on the rights of humanity, improper to be adopted by the United States? And if the example of past greatness be a powerful incentive to emulation, would such prints be improper presents to their servants? The expense would be small, and the purpose of monuments

and medals as rewards of merit, and confirmations of history, would receive a valuable support, since perhaps it may be the fate of prints, sometimes to outlast either marble or bronze.

If a subscription of this sort should fill in such a manner as to justify me, I shall proceed with all possible diligence, and must of course pass some years in Europe; and as I have acquired that knowledge in this country which was my only object for residing here, and shall have many reasons for preferring Paris hereafter, I shall in that case be happy and proud to accept your flattering proposal. But if, on the contrary, my countrymen should not give me such encouragement as I wish and hope, I must give up the pursuit, and of course I shall have little desire to return for any stay in Europe. In the mean time, viewing the absolute uncertainty of my situation, I must beg you not to pass by any more favorable subject which may offer, before I have the happiness to meet you in America, which I hope will be ere long.[1]

> I have the honor to be, very gratefully,
> Dear sir, your most faithful servant,
>
> JOHN TRUMBULL

ON JOHN VANDERLYN'S PANORAMA, 1818

John Vanderlyn (1775-1852) was unique among painters of his generation in seeking his education in Paris rather than in London. The considerable success he won abroad with Marius on the Ruins of Carthage *(1807) did not ensure his success at home. His abandonment of the "higher department of history painting" is mentioned in this note on the panorama which, scaled to the intellect and education of the New York public, he hoped (fruitlessly it turned out) would recoup his fortunes.*

Panorama

Preparations for the rotunda about erecting by Mr. Vanderlyn, for panorama views, have commenced. This building will be at the corner of Chamber and Cross streets, on Park square, and will, no doubt, be completed in a manner so as to be an ornament to the city. Although it was not to have been expected that Mr. Vanderlyn would have left the higher department of historical painting, in which he is so eminent,

[1] John Trumbull, *The Autobiography of Colonel John Trumbull*, Theodore Sizer, ed. (New Haven: Yale University Press, 1953), pp. 160-162.

to devote his time to the more humble, though more profitable, pursuit of painting cities and landscapes—yet, in a new country, taste for the arts must be graduated according to the scale of intellect and education, and where only the scientific connoisseur would admire his Marius and Ariadne, hundreds will flock to his panorama to visit Paris, Rome and Naples. This is to "catch the manners living as they rise," and with them catch the means to promote a taste for the fine arts.

We would suggest to Mr. Vanderlyn now, for fear we should forget it, that panorama views of our battles, such as Chippewa, Erie, New Orleans, Lake Champlain, and so forth with the likeness of officers engaged on those occasions, would not only be highly national and popular, but exceedingly profitable.[1]

WILLIAM DUNLAP: AUTOBIOGRAPHY, 1834

William Dunlap (1766-1839) was a pupil of Benjamin West. After a career as a playwright and producer ended in bankruptcy, he returned to painting portraits and history pictures as described below in these passages from his Autobiography. *The work appeared as part of Dunlap's* A History of the Rise and Progress of the Arts of Design in the United States *(1834), the basic source on the history of early American art. It offers ample evidence of Dunlap's perspective on his own time, the breadth of his acquaintance among American painters, and the most vivid glimpse we have of the struggles of a history painter in America to earn, without private or state support, a living from his work.*

On the 22d of June I sent my picture [*Christ Rejected*] by sea, Doherty attending it, to Boston, having engaged a very fine room for its exhibition, and I returned home, little the better as yet in cash by my experiment. I again visited Boston, and in July, 1822, I put up my picture in Doggett's great room, a noble place, soon afterward appropriated to other purposes; and although I had my vanity gratified, I experienced that very warm weather is unpropitious to exhibitions. My old friend Stuart seemed surprised at the effort I had made, and pointed out some faults—heaven knows there were enough of them. Jarvis and his pupil Henry Inman came to Boston to seek employment, but did little. Henry's beautiful little water-colored likenesses were a source of some profit. Jarvis, in a very friendly way, pointed out an error in the neck and head of the Magdalen, and observed, "Henry noticed it." I subsequently endeavored to remedy the defect. In Mr. John Doggett I found a most friendly man. My friends, Francis J. Oliver, Mr. Heard,

[1] *The National Advocate*, April 21, 1818, in W. Kelby, *Notes on American Artists* (New York: New York Historical Society, 1922), p. 54.

Mr. Pollard, and others, were still, as ever, *my friends*. Sereno E. Dwight, the son of Dr. Dwight, was now a preacher established in Boston. I had some portraits to do, and passed an agreeable summer. In New York an alarm prevailed of yellow fever, but no apprehensions were entertained in the quarter where my family resided. Still my experiment in great historical painting yielded little profit. Again I shipped my picture further east, to Portland; and here the tide of fortune turned. This place yielded, over all expenses, between two and three hundred dollars in two weeks.

On hearing of this success, I passed rapidly by land on to Portland, for the purpose of stopping at all the towns, and securing rooms for exhibition. I obtained public buildings, courthouses, and churches, free of charge. After one day at Portland, I returned by land to Boston again, after having given Doherty a plan of operations for the winter. I visited Newport on my way home, and arrived safely, and with money in my pocket, to my family, and again set up my easel for portraits; but I was now represented as being employed in historical compositions, and for that reason I had few calls for portraits. Perhaps stronger reasons existed—younger candidates and better painters were in the market. I this winter, that of 1822-3, painted a sketch for another great picture of the size of the first. The subject chosen was "The Bearing of the Cross," in which I introduced a crowd of figures attending upon the victim; but they are not "figures to let," but the characters of the evangelists, most of whom had appeared in the "Christ Rejected." Barabbas, now at liberty, occupies one corner—the principal figure is sinking under the cross—the centurion is ordering the seizure of Simon the Cyrenian, etc. I was encouraged to proceed with this study by the success of the "Christ Rejected," from which I received flattering accounts and comfortable remittances of cash. At Portsmouth a sermon was preached, recommending attention to the picture, and the selectmen advised its exhibition on a Sunday evening. My visits to the eastern towns had facilitated my agent's operations, and he was successful.

In the spring of 1823 I was invited by James Hackett, then keeping a store at Utica, to come to that place, with assurances of his engaging some work for my pencil; and early in April I proceeded, after a short stop at Albany, from whence I took some letters from Samuel M. Hopkins and Stephen Van Rensselaer to gentlemen in Utica, and arrived by stage in due time at Bagg's hotel. In 1815 I had boarded for weeks at this house, then acting as paymaster, and had seen with astonishment the growing town on a spot where in 1787, Governor George Clinton made his treaty in the wilderness with the Six Nations. Even in 1815 a rich population and flourishing villages surrounded Utica, and extended west to Lake Erie, through the thriving towns of Geneva,

Canandaigua and Batavia to Buffalo (then in ruins as burnt by the English); but now eight years had increased Utica to a city, and its public buildings, courthouse, banks, churches and hotels, filled me with almost as much surprise as I felt on my first visit. Mr. Hackett, since so well known as a comedian, received me cordially, and I found old acquaintances in James and Walter Cochran, and made lasting friends in J. H. Lothrop, Esq., cashier of the bank of Ontario, E. Wetmore (since his son-in-law), Mr. Walker and his son Thomas, and in short during a spring and summer's residence became as much at home in Utica as I had been at Norfolk. I painted a number of portraits. I left Utica for four days to visit Saratoga, and contract with a builder for an edifice sufficient for the exhibition of the "Christ Rejected." I left the stage on the postroad and walked to Balston, where having slept, I walked to Saratoga Springs before early breakfast, accomplished my business and proceeded on foot to Schenectady—next day returned by stage to Utica. In July my wife met me in Albany at Samuel M. Hopkins', and returned with me to Utica, where we took board with Mrs. Skinner, a sister of my late friend Dr. E. H. Smith. Weir was in Albany exhibiting his picture of Paul at Athens without success. Sir Thomas Lawrence's "West" was sent to Philadelphia and exhibited with a loss of more than $100; Sully's "Capuchin Chapel" lost by its exhibition at Saratoga Springs, as did my "Christ Rejected"; the last, $50.

It may be supposed that having some taste for the picturesque and more for rambling, I did not omit the opportunity neighborhood gave me of visiting Trenton Falls, to which place I rode once and once walked, stopping a day in clambering rocks and making sketches. The village of Trenton I had visited as a paymaster in 1815. I now found with one of its inhabitants a good portrait by Copley.

The last of August my wife left me to return home, and about the middle of September Doherty arrived with my picture, which was put up for exhibition in the courthouse. The exhibition in Utica yielded in three weeks $184.75, giving a profit after paying the expenses and transportation to Utica, of $124.75.

My friend Dr. M. Payne had removed from Montreal to Geneva, and requested me to send on the picture to that place. I accordingly directed a building to be erected for it, and in the meantime sent it to Auburn. On the 18th of October, 1823, I left my friends of Utica and arrived at my house in New York on the 21st.

In December I took a painting room at the corner of Nassau and Pine Streets, but sitters were shy. The "Christ Rejected" was still successful, and I employed a part of the winter of 1823-4, in painting a scene from James Fenimore Cooper's "Spy." I had recently become acquainted with him, and acquaintance has ripened into friendship.

On the 23d of February, 1824, I purchased a large unprepared cloth, intended as a floor cloth, and having access to the garret of the house in which I had my *atelier,* I nailed it to the floor, and gave it several coats of white lead, which being dry, I proceeded to outline the "Bearing of the Cross" from the sketch previously made. So *high* and so *low* was the commencement of this my second *big* picture.

This winter I became a member of a club which called itself the Lunch—members admitted by ballot, one black-ball excluding the candidate. Of the members I recollect G. C. Verplanck, J. F. Cooper, Halleck, Anthony Bleeker, Charles King, James Renwick, James Kent, J. Griscom, Brevoort, Bryant and Morse, as of my acquaintance before and since.

About the beginning of May I hired a building with an entrance from Broadway, and prepared it for my picture, which now approached New York, and on the 21st opened it for exhibition. The attention paid to it so far exceeded my expectation, that I was encouraged to proceed with the "Bearing of the Cross." The receipts were in fourteen weeks $650. Mr. Trumbull's fourth picture for the government was exhibiting part of the time, and his friend Stone of the *Commercial Advertiser,* who represented it as a wonder, said it did not pay the room rent. The American Academy had its exhibition during May and June.

In the meantime I had put up my second picture in my garret in Leonard Street, but on removing the "Christ Rejected" from Broadway, I put the "Bearing of the Cross" up in its place, as a far better light to paint on it. I exhibited it in this place, but not with the success of the first. The "Christ Rejected" was exhibited in the gallery of the American Academy of Fine Arts on shares, and yielded me profit.

In November I visited Philadelphia, where Trumbull's "Resignation of Washington" was exhibiting free of rent in the State House, and yielding no profit. My errand at this time was to find a place for putting up the "Bearing of the Cross," which was done by engaging Sully and Earl's gallery on shares.

To paint exhibition pictures and show them was the business of my life at this time; and from Philadelphia the "Bearing of the Cross" was sent with Doherty to Washington; to which place I went, partly to make arrangements for the picture at Baltimore, and partly to settle my paymaster's accounts—the treasury having made me defaulter to the amount of some thousand dollars; but on investigation the debt was brought down to *one* dollar, and that proceeded from an error in addition.

My next exertion as an artist was the composition of a third picture, connected with the crucifixion, which I called "Calvary." This winter and spring I finished the sketch in oil, thirty inches by twenty-five—probably my best composition.

Before transferring it to the large canvas, I painted from nature the principal figures and groups separately. I had none of that facility which attends the adept in drawing, and now felt the penalty—one of the penalties of my idleness and folly when I had the Royal Academy of England at my command, and the advice of the best historical painter of the age always ready for my instruction—and both neglected. I now, and for some years before, studied the casts from the antique and improved, but my drawing remained deficient. I had neglected "the spring of life," and it never returns.

When studying the casts in the gallery of the American Academy of Fine Arts, I was very much struck by the deficiency apparent in those of Canova when compared with the antique. I was mortified to see that the man who was called the greatest genius the modern world had produced as a sculptor, was in my estimation a pigmy, and I felt, until some years after, when I saw the Mercury of Thorwaldsen in the gallery of the National Academy of Design, that it was in vain for a modern to emulate the statuary of antiquity.

In April I made a journey to Baltimore—received my "Bearing of the Cross" from Rubens Peale, and had it transported to Philadelphia, where it was put up in Sully & Earl's gallery—it proved an unprofitable exhibition; but I passed the first week of May very pleasantly with Sully and other friends.

From the 23d to the 28th of May I made a pleasant excursion to New London and Norwich, to direct a young man in the mode of exhibiting my "Christ Rejected" in those places and further east. Returning home, I found some portrait painting awaiting me, and continued my studies for the "Calvary." Warned by the bad effect of my floor-cloth experiment (for I never got a good surface for the "Bearing of the Cross"), I had a cloth prepared at McCauley's manufactory, Philadelphia, which proved satisfactory. I likewise ordered a canvas, twenty feet by ten, having determined to make a picture from the etched outline of West's "Death on the Pale Horse," taking, as my guide, the printed description; and in the summer of 1825 was busily employed in studies for the "Calvary" and in painting the above-named picture.

Having determined to finish my "Death on the Pale Horse" before the "Calvary," I exerted myself for that purpose, and making an arrangement with the directors of the American Academy of Fine Arts for the use of the gallery at twenty-five dollars a week, I opened the picture to

the public in two months and twenty-six days from the commencement of the outline. This exhibition was successful, and my picture was only taken down to make way for David's "Coronation of Bonaparte."

In November I became acquainted with the person and paintings of Mr. T. Cole, since so well known as the celebrated landscape painter. I did the best I could to make the public acquainted with the extraordinary merit of his pictures even then, and it is among the few of my good deeds. He has proved more than I anticipated, and I have been repaid by his friendship and gratified by his success. Mr. Trumbull attracted my attention to Mr. Cole, by the most liberal praises of his painting, and expressions of surprise at the taste and skill he had manifested.

In January 1826, I had the "Bearing of the Cross" on exhibition at Charleston, the "Death on the Pale Horse" at Norfolk, and the "Christ Rejected" at Washington.

* * *

At this time the National Academy of Design was created, composed of and governed by artists only. I became an active member, being elected an academician. In the spring I continued to paint studies from nature, for the "Calvary," and likewise painted several portraits. In the month of May the National Academy of Design opened their first annual exhibition, which has increased in interest yearly.

About this time I sent my picture of "Christ Rejected" to the *far West,* and it produced profit and compliments; but it likewise produced a letter which I will lay before the reader, as a proof of the effect which a picture may produce in exciting ambition, and of the kind of stuff ambition may be made of.

> Urbana, Ohio, Champaign county, Dec. 30th, 1826. Mr. William Dunlap, I write my respects to you through the influence of the gentleman that had your painting through this country. I informed him that I was an artist of that kind also; am in low circumstances; am 20 years old, and have a great genius for historical painting; and he informed me to write to you, informing you on the subject of painting. He told me that I ought to make some specimens of my work, and if it would justify, I could go to the National Academy of Fine Arts. I wish you to write to me on the subject if you please. The citizens of this place thinks, with tuition, I would make a superior to any artist they had ever saw. I went 40 miles to see your painting, and it creates a new feeling in me. Nothing more at present, but remain your humble servant. H. H.

I saw two pictures in the possession of Mr. Samuel Maverick, said to be Hogarth's; one of them has a drummer which would not dishonor the great painter. These pictures were brought to this country by Mr.

Charles Caton, himself a painter of merit, and were painted by him. The latter part of this month I passed at Albany, having taken my "Death on the Pale Horse" thither, and being enabled, by the politeness of Mr. Stevenson the mayor, Doctor Beck, Mr. Gansevoort, and other gentlemen, to have it exhibited in the great hall of the Academy, where the effect was far beyond what I had seen from it elsewhere. Mr. Croswell advised and assisted me in the most friendly manner in the accomplishment of my object.

I resided at this time with my good friend Cruttenden, and the conversations at his table were ofttimes amusing. We had with us a rough judge from one of the western counties, who was particularly annoyed by a young man of New York, of rather much pretensions to multifarious knowledge. Upon the dandy's talking, with a dictatorial air, of Belzoni and the *Orrery* that he had discovered in an Egyptian pyramid, the old man lost all patience and broke out with: "Belzoni is not so ignorant as to talk of an *Orrery* in an Egyptian pyramid. No, sir, you will not find the word in his writings. The word is modern—a name given to a modern invention, in honor to Lord Orrery. You mean, if you mean anything, the Zodiac." The young man walked off, and the judge supposing him to be an Albanian, turned to me:

> You must not expect anything from this stupid place. There are not three men in it that ever thought. I'll tell you an anecdote.—At a time of yellow fever in New York, two miniature painters, Trott and Tisdale, came to this city; they took a room and painted some heads. This was about the year '96. It was a novelty, and the gentlemen of Albany visited the painters and were pleased with them; and on occasion of a ball they were getting up, they sent them tickets of invitation. But before the ball took place they had time to reflect and consult; and the result was, that a note was written to the painters to say that the gentlemen of Albany must recall the invitation, as, according to the rules, no mechanics could be admitted.

I insert this freely, because of the known intelligence of the inhabitants of a city where our legislature convenes, our highest courts sit, and many of our judges and first men reside, who are accustomed to think and act with propriety. "Sir," he continued, "I saw both the notes myself," which were probably from shopkeepers or their clerks, whose knowledge might not rise higher in the scale than such notes indicate.

From Albany, where I received profit from my exhibition, and pleasure from my friends, I proceeded to Troy, and had the picture exhibited with profit; and thence to Utica, where I found a man apparently equal to the charge of my picture; which was exhibited profitably, and sent on westward. In Utica I found great change—enormous growth— some of my friends gone from thence, and some removed by death; but

Lothrop and his charming family, with many others still ready to add to my pleasure and welfare. I painted at this time several portraits.

At Syracuse, a new place, I had my picture put up in an unfinished church, where it did but little, and I sent it on to Auburn and passed on to Geneva. After a few days I went to Canandaigua and to Rochester. I will copy a passage from my journal—

> When I saw Utica in 1815, I was astonished; in 1823 I admired its growth and again in 1826. Syracuse, Auburn, and Geneva, are all causes of admiration from their prosperity, as is Canandaigua, but all sink into insignificance in comparison with Rochester, when the time of its first settlement is considered. In 1815 it was unknown: now the canal, bridges, churches, court house, hotels, all upon a great scale, excite my astonishment anew at the wonders of the west.

I viewed the Falls of the Genesee River, and soon after embarked in the canal boat, and passed many flourishing villages to Lockport, where the excavations for the canal are of a magnitude to excite the surprise of the untravelled. The canal brought me into Tonawanda Creek, where another scene of a milder aspect is presented, and I soon saw the great Niagara. One of my pictures was on exhibition at Buffalo, and I ordered it on to Detroit. In the towns I had passed I made arrangements for the picture of "Death on the Pale Horse," which was to follow.

Buffalo, which I had left in 1815 a desolated village, I now found a large and thriving town, with splendid hotels, large churches, a theatre, a noble court house, showing enterprise and prosperity; while steamboats and other vessels indicate the commerce of the inland sea. Rain induced me to return without visiting again the Falls of Niagara: I have ever regretted the omission. In the canal boat I retraced my way home. I landed at a village called Lyons, slept and proceeded by stage to Geneva, thence to Auburn, and at Syracuse embarked on the canal for Utica, where I arrived on the 21st of October. A manuscript was here lent me, which I read with interest, written on the Bible and New Testament, by John Q. Adams, as instructions to his son, by this indefatigable man. Extract, respecting the latter:—

> If it be objected, that the principle of benevolence towards our enemies, and forgiveness of injuries, may be found, not only in the books of the Old Testament, but even in some of the heathen writers, and particularly in the Discourses of Socrates, I answer, that the same may be said of the immortality of the soul, and of the rewards and punishments of a future state. The doctrine was not more of a discovery than the precept. But the connection with each other, the authority with which they were taught, and the miracles by which they were enforced, belong exclusively to the mission of Christ.

At Utica I again was employed to paint several portraits; receiving, as usual, the kind attentions of my friends, and indulging my

propensity to ramble about the neighborhood.—On the 4th of November I left Utica, and on the 8th was happy with my family.

During this winter of 1826-7 I painted on my picture of Calvary, but had part of my time occupied by an engagement with the managers of the Bowery Theatre to write occasionally for them. As the subject of filling the vacant panels of the rotunda, at Washington, was at this time agitated in Congress, I wrote to G. C. Verplanck on the subject. The following is an answer to my letter.—

> Washington, Jan. 29, 1827. Dear Sir: I do not know, at this moment, how I can be useful in furthering your views. The whole subject of decorating, as well as finishing the capitol, is now in the hands of a committee, to which I do not belong. General Van Rensselaer is the chairman. I understand that they are very anxious to press the completion of the building; and Mr. Bulfinch, the architect, complains much of the precipitancy. If so, probably they will recommend so large an appropriation to the architect as to leave little for other artists. As soon as they make their report I will send you a copy.
>
> Besides the four vacancies in the rotunda, I have been urging the propriety of placing some works of art connected with the history, or at least with the scenery of the country, in the large room of the President's house, which is now filling up. Its size (80 or 90 feet by 50), its height, etc., fit it admirably for the purpose; and it would be honorable to the nation to apply it thus, instead of filling it merely with mirrors, curtains, and chandeliers, like a tavern ball room, or at best, a city drawing room on a large scale. I am, etc.

A member of the Senate wrote to me—"Col. Trumbull is here, and has been all winter seeking to be employed to fill the vacant panels." About this time the letters written by Trumbull to the President (for which see his biography) were published by the directors of the American Academy, and the originals, by unanimous vote, deposited in the archives.

During the winter and spring of 1826-7 I not only painted on my "Calvary," but put up and painted on the "Bearing of the Cross," and finished several portraits; one of which, Thomas Eddy, was for the governors of the New York Hospital; who afterwards ordered a copy, to place in the Asylum for the Insane, an institution owing its being to Mr. Eddy.—Several copies of this portrait were ordered.

I experienced, during the winter of 1827-8, a great diminution of profit from my exhibition pictures, which were travelling east and west. The incidents attending them would fill a volume. At one place a picture would be put up in a church, and a sermon preached in recommendation of it: in another, the people would be told from the pulpit to avoid it, as blasphemous; and in another the agent is seized for violating the law taxing puppet shows, after permission given to exhibit;

and when he is on his way to another town, he is brought back by constables, like a criminal, and obliged to pay the tax, and their charges for making him a prisoner.—Here the agent of a picture would be encouraged by the first people of the place, and treated by the clergy as if he were a saint; and there received as a mountebank, and insulted by a mob. Such is the variety of our manners, and the various degrees of refinement in our population. On the whole, the reception of my pictures was honorable to me and to my countrymen.[1]

REMBRANDT PEALE: LETTER ON HIS COURT OF DEATH, *1845*

Competing with Dunlap's travelling picture in capturing public attention was Rembrandt Peale's (1778-1860) Court of Death *of 1820. The Genesis of the "Great Moral Painting," intended as the artist states elsewhere to "render useful the rational contemplation of death," and some of the public reaction to the work are described in this letter of 1845 written by the painter to provide background for its continued exhibition. Of significance are the elaborate attempts Peale describes to make his "Discourse on Life and Death" a morally illuminating sermon in paint to the "unlearned and learned."*

PHILADELPHIA, DECEMBER 1, 1845

DEAR SIR,

In answer to your enquiry concerning the Origin of my Picture of the COURT OF DEATH, I shall briefly and simply narrate the process of its invention. Accidentally taking up Bishop Porteus' Poem on Death, poetical as may be deemed his description of the Cavern of Death, and familiar as his personifications may have been to the minds of literary men, it struck me that a Picture thus representing Death as a Monarch with his Ebon sceptre, seated on a Throne, and having on either side, as Prime Ministers, War and Old Age, and sending forth Intemperance and Disease as Agents to execute his will,—would unquestionably present an appalling Scene, better in the description than on the Canvas. I had seen, in Westminster Abbey, ROUBILLIAC's beautiful Monumental Sculpture, representing a Noble Lady lying on her Couch at the close of life, and a Skeleton, wonderfully wrought out of the solid marble, issuing from the Tomb, in an attitude of vigor, but without Muscle, directing his lance towards the heart of the Lady as his Victim, and, with others

[1] William Dunlap, *A History of the Rise and Progress of the Arts of Design in the United States*, 2 Vols. (New York, 1834), Vol. I, pp. 344-357.

felt the absurdity of it. An Angel to receive the parting Soul would be better. I had seen WEST's Death on the Pale Horse, a most impressive Picture, now in the Academy in this City; but my veneration of the Artist could not reconcile me to his personifications; for, though he has given the figure Muscles, they are dried up—to say nothing of the fire from his mouth and the lightning from his hands; yet I had an idea that the case might be more fairly stated on the Canvas. I imagined how I should attempt to paint a Subject founded on Porteus' Poem, and immediately began to sketch with my pencil on a piece of shingle which chanced to be in my hand, a figure enveloped in Drapery, which indicated form and power, with a shadowy but fixed Countenance, and with extended Arms, as a Judge issuing a decree. At his feet I drew a prostrate Corpse, and on one side the figure of an Old Man, submissively approaching. I had a faint Conception of War going forth, impelled by his own passions, and of Intemperance, Luxury and Disease; but having no intention to paint such a Scene, I threw my board away, and thought no more of it. A Month afterwards one of my little daughters produced the board with my sketch upon it. I was flattered by imagining there was some merit in it, and I added a few more figures, thus fixing the subject in my mind, which I immediately transferred to a small piece of canvas, and consulted my father, without sending him my design, whether I should paint the Picture in large? His prudent advice was "No." But some months after, being on a visit to me in Balitmore, I showed him my design, when he enthusiastically said, "Begin it immediately!" My Painting Room was too small, and I had to build a larger one expressly for it, during which I prepared the large canvas, and executed many studies from the life, of figures, heads, hands, and so forth. My good and venerable Father stood as the representative of Old Age, modified by the Antique Bust of Homer; One of my Daughters stood in the place of Virtue, Religion, Hope; and another knelt to the Attitude of Pleasure, I borrowing a Countenance from my imagination. My friend and Critic John Neal, of Portland, impersonated the Warrior, beneath whom a friend consented to sink to the earth in distress, and thus appeared as the Mother of a Naked Child, which I painted from my then youngest daughter. The Corpse was the joint result of a study from a subject in the Medical College and the assistance of my brother Franklin, lying prostrate, with inverted head, which was made a likeness of Mr. Smith founder of the Baltimore Hospital; my brother also, though of irreproachable temperance, stood for the inebriated Youth; my wife and others served to fill up the background. It may be worth while to mention, that for the figure of Famine, following in the train of War, I could find no model, though I sought her in many a haunt of Misery, and therefore drew her from my brain; but, strange

to say, two weeks after the picture was finished, a woman passed my window, who might have been sworn to as the Original.

Thus was my Picture produced, and was intended as a "Discourse on Life and Death"—and I had the satisfaction to find that it could be understood, by the unlearned and the learned—as a proof of this, my old black cook, Aunt Hannah, on seeing the Picture, exclaimed—"Lack-a-day! how I feel for that old man, and his good daughter! There's his Son lying drowned before him, but he says the Lord's prayer, *'thy will be done!'* " In this manner she went through the entire picture, translating it into her own language, entirely to my satisfaction; for I had not employed the Mythology of the Ancients nor the symbols of other Artists. It was not an Allegorical Picture, composed after the examples of LEBRUN, or of any School. I had read some remarks by Pliny on a style of painting which he recommended as capable of embodying thought, principle and character, without the aid of Conventional Allegory, and described one on these principles painted by Apelles, and approved by the Multitude. This picture of the Court of Death is an approach to that style—at any rate, it was the first large Picture, whatever may be its merits or its faults, that has been attempted in modern times, upon the same broad and universal principles. I would lay claim to some little credit for the stand I took in reprobation of Intemperance, before that subject was introduced to popular notice; and the Society of Friends, at least, will give me credit for my views of the Glory and Magnanimity of War; whilst the philosophic Christian must agree with the picture that Death has no terror in the eyes of Virtuous Old Age, and of Innocence, Faith and Hope.

When this Picture was exhibited in Albany a Senator fell dead as he entered the door to see it. It was not the painting that terrified him, as was generally supposed, for he had not seen it—the circumstance was a mere coincidence. There is nothing terrible in it, but the scene of War.—On the contrary, when it had been a month finished, an old friend, a man of strong mind, could not be prevailed upon to visit the Picture, though he possessed a warm desire to see it, until one day I fairly *pushed* him into the room and left him to meditate. An hour after I met him coming out, when he grasped my hand, and thanked me for the good I had done him, acknowledging a dread of death, which he had always disavowed, but which this picture had entirely removed.

Many curious circumstances have attended this Painting, of which I shall mention a few. It was exhibited in Alexandria only one evening in the Theatre, which was closed against Theatrical performances, and the eccentric LORENZO DOW, with his antiquated beard, as if he formed a part of the Picture, took it for his text, and made in front of it an interesting discourse explanatory of it. In New York it was recom-

mended from several Pulpits, as a Great Moral Painting; and the City Corporation, although uninvited, went in a body to see it. One of the most interesting scenes which I witnessed, was when Mr. Stansbury brought his Deaf and Dumb pupils to view it, giving them, by signs, his explanation of it, and eliciting their own remarks. The dead body sensibly affected them, as one of their number had recently been drowned. After the explanations relative to the Aspect of Virtue and that of fascinating vice, a pretty little Girl was asked by the Teacher *which* she preferred? With an arch expression she answered "I love the one that supports her father, but I would rather be like the other beautiful creature!" It is to be hoped she was afterwards better instructed.

After finishing this Painting I commenced another of equal dimensions, upon the same principles, representing Christ's Sermon on the Mount, in which I designed to illustrate the great maxims of Christianity; but the difficulties attending the Exhibition of Paintings so large, induced me to abandon the undertaking; and I restricted my pencil to smaller compositions; the Roman Daughter; the Death of Virginia; Lysippa on the Rock; the Dream of Love, and so forth. It is now 25 years since the Court of Death was painted, but the subject is as new to the rising generation as it was to those who preceded them.[1]

<div style="text-align: center;">

I remain, respectfully, Yours,

REMBRANDT PEALE

</div>

SAMUEL F. B. MORSE: LETTER TO JAMES FENIMORE COOPER, 1849

Samuel F. B. Morse (1791-1872), like Trumbull, saw his hopes of becoming a successful history painter frustrated, but his interest in the arts remained lively long after his experiments with the electric telegraph had become his major occupation. As he states in this letter of 1849 to his friend James Fenimore Cooper, his "ideal of that profession was, perhaps, too exalted" to be fulfilled on these shores. His Congress Hall *of 1821 and* Exhibition Gallery of the Louvre *of 1832 symbolize his failure. Taken together the two pictures reduce a potential theme of American history and the grand style in which it might have been painted to subjects of genre.*

Alas! My dear sir, the very name of *pictures* produces a sadness of heart I cannot describe. Painting has been a smiling mistress to many,

[1] Rembrandt Peale, Letter on his *Court of Death*, published in a pamphlet, 1845.

but she has been a cruel jilt to me. I did not abandon her, she abandoned me. I have taken scarcely any interest in painting for many years. Will you believe it? When last in Paris, in 1845, I did not go into the Louvre, nor did I visit a single picture gallery.

I sometimes indulge a vague dream that I may paint again. It is rather the memory of past pleasures, when hope was enticing me onward only to deceive me at last. Except some family portraits, valuable to me from their likenesses only, I could wish that every picture I ever painted was destroyed. I have no wish to be remembered as a painter, for I never was a painter. My ideal of that profession was, perhaps, too exalted—I may say is too exalted. I leave it to others more worthy to fill the niches of art.[1]

MARGARET FULLER OSSOLI: A RECORD OF IMPRESSIONS OF MR. ALLSTON'S PICTURES, 1839

Margaret Fuller (1810-1850) was both an author and essayist associated with the New England Transcendentalists and an editor of the Dial, *the organ of that movement, from 1840 until 1842. It is difficult to argue with her appraisal of Washington Allston (1779-1843) and his work which she saw at an exhibition in Boston in 1839. Accurately touching upon Allston's failure to realize his ambition in what she calls "the grand historical manner," she blames the artist's temperament, as well as the "Puritanic modes of thought" and the "lack of poetical groundwork" necessary for the appreciation of his work in America. Also still pertinent are her evocation of Allston's gift for lyrical rather than heroic subjects, her evocation of his paintings' quiet, contemplative qualities and her expressions of delight in his landscapes.*

JULY, 1839

On the closing of the Allston exhibition, where I have spent so many hours, I find myself less a gainer than I had expected, and feel that it is time to look into the matter a little, with such a torch or penny rush candle as I can command.

I have seen most of these pictures often before; the Beatrice and Valentine when only sixteen. The effect they produced upon me was so great, that I suppose it was not possible for me to avoid expecting too large a benefit from the artist.

[1] S. F. B. Morse, from a letter to James Fenimore Cooper, November 20, 1849, in *Letters and Journals of S. F. B. Morse,* Edward Lind Morse, ed. (Boston, 1860).

The calm and meditative cast of these pictures, the ideal beauty that shone *through* rather than *in* them, and the harmony of coloring were as unlike anything else I saw, as the Vicar of Wakefield to Cooper's novels. I seemed to recognize in painting that self-possessed elegance, that transparent depth, which I most admire in literature; I thought with delight that such a man as this had been able to grow up in our bustling, reasonable community, that he had kept his foot upon the ground, yet never lost sight of the rose-clouds of beauty floating above him. I saw, too, that he had not been troubled, but possessed his own soul with the blandest patience; and I hoped, I scarce knew what; probably the *mot d'enigme* for which we are all looking. How the poetical mind can live and work in peace and good faith! how it may unfold to its due perfection in an unpoetical society!

From time to time I have seen other of these pictures, and they have always been to me sweet silvery music, rising by its clear tone to be heard above the din of life; long forest glades glimmering with golden light, longingly eyed from the window of some crowded drawing room.

But now, seeing so many of them together, I can no longer be content merely to feel, but must judge these works. I must try to find the center, to measure the circumference; and I fare somewhat as I have done, when I have seen in periodicals detached thoughts by some writer, which seemed so full of meaning and suggestion, that I would treasure them up in my memory, and think about them, till I had made a picture of the author's mind, which his works when I found them collected would not justify. Yet the great writer would go beyond my hope and abash my fancy; should not the great painter do the same?

Yet, probably, I am too little aware of the difficulties the artist encounters, before he can produce anything excellent, fully to appreciate the greatness he has shown. Here, as elsewhere, I suppose the first question should be, What ought we to expect under the circumstances?

There is no poetical ground-work ready for the artist in our country and time. Good deeds appeal to the understanding. Our religion is that of the understanding. We have no old established faith, no hereditary romance, no such stuff as Catholicism, Chivalry afforded. What is most dignified in the Puritanic modes of thought is not favorable to beauty. The habits of an industrial community are not propitious to delicacy of sentiment.

He, who would paint human nature, must content himself with selecting fine situations here and there; and he must address himself, not to a public which is not educated to prize him, but to the small circle within the circle of men of taste.

If, like Wilkie or Newton, he paints direct from nature, only selecting and condensing, or choosing lights and draperies, I suppose he is as well situated now as he could ever have been; but if, like Mr

Allston, he aims at the Ideal, it is by no means the same. He is in danger of being sentimental and picturesque, rather than spiritual and noble. Mr. Allston has not fallen into these faults; and if we can complain, it is never of blemish or falsity, but of inadequacy. Always he has a high purpose in what he does, never swerves from his aim, but sometimes fails to reach it.

The Bible, familiar to the artist's youth, has naturally furnished subjects for his most earnest efforts. I will speak of four pictures on biblical subjects, which were in this exhibition.

Restoring the dead man by the touch of the Prophet's Bones. I should say there was a want of artist's judgment in the very choice of the subject.

In all the miracles where Christ and the Apostles act a part, and which have been favorite subjects with the great painters, poetical beauty is at once given to the scene by the moral dignity, the sublime exertion of faith on divine power in the person of the main actor. He is the natural center of the picture, and the emotions of all present grade from and cluster round him. So in a martyrdom, however revolting or oppressive the circumstances, there is room in the person of the sufferer for a similar expression, a central light which shall illuminate and dignify all round it.

But a miracle effected by means of a relique, or dry bones, has the disagreeable effect of mummery. In this picture the foreground is occupied by the body of the patient in that state of deadly rigidity and pallor so offensive to the sensual eye. The mind must reason the eye out of an instinctive aversion, and force it to its work,—always an undesirable circumstance.

In such a picture as that of the *Massacre of the Innocents,* painful as the subject is, the beauty of forms in childhood, and the sentiment of maternal love, so beautiful even in anguish, charm so much as to counterpoise the painful emotions. But here, not only is the main figure offensive to the sensual eye, thus violating one principal condition of art; it is incapable of any expression at such a time beyond that of physical anguish during the struggle of life suddenly found to re-demand its dominion. Neither can the assistants exhibit any emotions higher than those of surprise, terror, or, as in the case of the wife, an overwhelming anxiety of suspense.

* * *

In fine, the more I have looked at these pictures, the more I have been satisfied that the grand historical style did not afford the scope most proper to Mr. Allston's genius. The Prophets and Sibyls are for the Michael Angelos. The Beautiful is Mr. Allston's dominion. There he rules as a Genius, but in attempts such as I have been con-

sidering, can only show his appreciation of the stern and sublime thoughts he wants force to reproduce.

But on his own ground we can meet the painter with almost our first delight.

A certain bland delicacy enfolds all these creations as an atmosphere. Here is no effort, they have floated across the painter's heaven on the golden clouds of phantasy.

These pictures (I speak here only of figures, of the landscapes a few words anon) are almost all in repose. The most beautiful are Beatrice, The Lady reading a Valentine, The Evening Hymn, Rosalie, The Italian Shepherd Boy, Edwin, Lorenzo and Jessica. The excellence of these pictures is subjective and even feminine. They tell us the painter's ideal of character. A graceful repose, with a fitness for moderate action. A capacity of emotion, with a habit of reverie. Not one of these beings is in a state of *epanchement,* not one is, or perhaps could be, thrown off its equipoise. They are, even the softest, characterized by entire though unconscious self-possession.

* * *

The Landscapes. At these I look with such unalloyed delight, that I have been at moments tempted to wish that the artist had concentrated his powers on this department of art, in so high a degree does he exhibit the attributes of the master; a power of sympathy, which gives each landscape a perfectly individual character. Here the painter is merged in his theme, and these pictures affect us as parts of nature, so absorbed are we in contemplating them, so difficult is it to remember them as pictures. How the clouds float! how the trees live and breathe out their mysterious souls in the peculiar attitude of every leaf. Dear companions of my life, whom yearly I know better, yet into whose heart I can no more penetrate than see your roots, while you live and grow, I feel what you have said to this painter; I can in some degree appreciate the power he has shown in repeating here the gentle oracle.

The soul of the painter is in these landscapes, but not his character. Is not that the highest art? Nature and the soul combined; the former freed from slight crudities or blemishes, the latter from its merely human aspect.

These landscapes are too truly works of art, their language is too direct, too lyrically perfect, to be translated into this of words, without doing them an injury.[1]

[1] Margaret Fuller Ossoli, "A Record of the Impressions Produced by the Exhibition of Mr. Allston's Pictures in the Summer of 1839," *Works of Margaret Fuller Ossoli,* Arthur B. Fuller, ed., 6 Vols. (Boston, 1860), Vol. VI, pp. 285-292.

3

Aesthetics
of the Ideal

WASHINGTON ALLSTON: LECTURES ON ART AND POETRY

Washington Allston's Lectures on Art *reveal the philosophical and speculative turn of mind evident in his paintings. The entire text is too long for inclusion here, but the main lines of his argument, though long and closely reasoned, hopefully become apparent from the excerpts reprinted. His ideas would seem to stem from a variety of sources in eighteenth century philosophy and aesthetics. Burke's writings come to mind as do those of Coleridge whom Allston knew in England, but behind them is ancient tradition of neo-Platonic thought. For Allston, objects perceived by the senses are transformed and transcended by the moral imagination or the Soul in tune with the Infinite Harmony of Creation. Thus objects become merely the point of departure toward what Allston calls Infinite Harmony, Infinite Idea, or simply the Creator. At one point the chain of qualities from the Beautiful to the Appalling he describes as but a symbol of Conscious Reality. For him, Margaret Fuller's comment that "the soul of the painter is in these landscapes but not the character" would have been the highest praise. Most remarkable is the way in which his theories led him to an abstractive view of painting set forth in the section on composition. Painting, he affirms, is capable, like music, of awakening in us by its "harmony of form, color, light, and shadow" and without reference to story, a perception of the higher, universal harmony of creation. The treatise and its implications go far beyond what Allston was able to achieve in his painting and would seem more applicable to the paintings of the French Symbolists or even to those of twentieth-century abstractionists.*

Introductory Discourse

Next to the development of our moral nature, to have subordinated the senses to the mind is the highest triumph of the civilized state. Were it possible to embody the present complicated scheme of society, so as to bring it before us as a visible object, there is perhaps nothing in the world of sense that would so fill us with wonder; for what is there in nature that may not fall within its limits? and yet how small a portion of this stupendous fabric will be found to have any direct, much less exclusive, relation to the actual wants of the body! It might seem, indeed, to an unreflecting observer, that our physical necessities, which, truly estimated, are few and simple, have rather been increased than diminished by the civilized man. But this is not true; for, if a wider duty is imposed on the senses, it is only to minister to

the increased demands of the imagination, which is now so mingled with our every-day concerns, even with our dress, houses, and furniture, that, except with the brutalized, the purely sensuous wants might almost be said to have become extinct: with the cultivated and refined, they are at least so modified as to be no longer prominent.

But this refining on the physical, like everything else, has had its opponents: it is declaimed against as artificial. If by artificial is meant unnatural, we cannot so consider it; but hold, on the contrary, that the whole multiform scheme of the civilized state is not only in accordance with our nature, but an essential condition to the proper development of the human being. It is presupposed by the very wants of his mind; nor could it otherwise have been, any more than could have been the cabin of the beaver, or the curious hive of the bee, without their preëxisting instincts; it is therefore in the highest sense natural, as growing out of the inherent desires of the mind.

But we would not be misunderstood. When we speak of the refined state as not out of nature, we mean such results as proceed from the legitimate growth of our mental constitution, which we suppose to be grounded in permanent, universal principles; and, whatever modifications, however subtile, and apparently visionary, may follow their operation in the world of sense, so long as that operation diverge not from its original ground, its effect must be, in the strictest sense, natural. Thus the wildest visions of poetry, the unsubstantial forms of painting, and the mysterious harmonies of music, that seem to disembody the spirit, and make us creatures of the air,—even these, unreal as they are, may all have their foundation in immutable truth; and we may moreover know of this truth by its own evidence.

* * *

If it be true, then, that even the commonplaces of life must all in some degree partake of the mental, there can be but one rule by which to determine the proper rank of any object of pursuit, and that is by its nearer or more remote relation to our inward nature. Every system, therefore, which tends to degrade a mental pleasure to the subordinate or superfluous, is both narrow and false, as virtually reversing its natural order.

It pleased our Creator, when he endowed us with appetites and functions by which to sustain the economy of life, at the same time to annex to their exercise a sense of pleasure; hence our daily food, and the daily alternation of repose and action, are no less grateful than imperative. That life may be sustained, and most of its functions performed, without any coincident enjoyment, is certainly possible. Our

food may be distasteful, action painful, and rest unrefreshing; and yet we may eat, and exercise, and sleep, nay, live thus for years. But this is not our natural condition, and we call it disease. Were man a mere animal, the very act of living, in his natural or healthy state, would be to him a continuous enjoyment. But he is also a moral and an intellectual being; and, in like manner, is the healthful condition of these, the nobler parts of his nature, attended with something more than a consciousness of the mere process of existence. To the exercise of his intellectual faculties and moral attributes the same benevolent law has superadded a sense of pleasure,—of a kind, too, in the same degree transcending the highest bodily sensation, as must that which is immortal transcend the perishable. It is not for us to ask why it is so; much less, because it squares not with the poor notion of material usefulness, to call in question a fact that announces a nature to which the senses are but passing ministers. Let us rather receive this ennobling law, at least without misgiving, lest in our sensuous wisdom we exchange an enduring gift for a transient gratification.

* * *

As the greater part of those Pleasures which we propose to discuss are intimately connected with the material world, it may be well, perhaps, to assign some reason for the epithet *mental*. To many, we know, this will seem superfluous; but, when it is remembered how often we hear of this and that object delighting the eye, or of certain sounds charming the ear, it may not be amiss to show that such expressions have really no meaning except as metaphors. When the senses, as the medium of communication, have conveyed to the mind either the sounds or images, their function ceases. So also with respect to the objects: their end is attained, at least as to us, when the sounds or images are thus transmitted, which, so far as they are concerned, must forever remain the same within as without the mind. For, where the ultimate end is not in mere bodily sensation, neither the senses nor the objects possess, of themselves, any productive power; of the product that follows, the *tertium aliquid*, whether the pleasure we feel be in a beautiful animal or in according sounds, neither the one nor the other is really the cause, but simply the *occasion*. It is clear, then, that the effect realized supposes of necessity another agent, which must therefore exist only in the mind.

* * *

In the preceding discussion, we have considered the outward world only in its immediate relation to Man, and the Human Being as the

predetermined center to which it was designed to converge. As the subject, however, of what are called the sublime emotions, he holds a different position; for the center here is not himself, nor, indeed, can he approach it within conceivable distance: yet still he is drawn to it, though baffled forever. Now the question is, Where, and in what bias, is this mysterious attraction? It must needs be in something having a clear affinity with us, or we could not feel it. But the attraction is also both pure and pleasurable; and it has just been shown, that we have in ourselves but one principle by which to recognize any corresponding emotion,—namely, the principle of Harmony. May we not then infer a similar Principle without us, an Infinite Harmony, to which our own is attracted? and may we not further,—if we may so speak without irreverence,—suppose our own to have emanated thence when "man became a living soul"? And though this relation may not be consciously acknowledged in every instance, or even in one, by the mass of men, does it therefore follow that it does not exist? How many things act upon us of which we have no knowledge? If we find, as in the case of the Beautiful, the same, or a similar, effect to follow from a great variety of objects which have no resemblance or agreement with one another, is it not a necessary inference, that for their common effect they must all refer to something without and distinct from themselves? Now in the case of the Sublime, the something referred to is not in man: for the emotion excited has an outward tendency; the mind cannot contain it; and the effort to follow it towards its mysterious object, if long continued, becomes, in the excess of interest, positively painful.

Could any finite object account for this? But, supposing the Infinite, we have an adequate cause. If these emotions, then, from whatever object or circumstance, be to prompt the mind beyond its prescribed limits, whether carrying it back to the primitive past, the incomprehensible *beginning,* or sending it into the future, to the unknown *end,* the ever-present Idea of the mighty Author of all these mysteries must still be implied, though we think not of it. It is this Idea, or rather its influence, whether we be conscious of it or not, which we hold to be the source of every sublime emotion. To make our meaning plainer, we should say, that that which has the power of possessing the mind, to the exclusion, for the time, of all other thought, and which presents no *comprehensible* sense of a whole, though still impressing us with a full apprehension of such as a reality,—in other words, which cannot be circumscribed by the forms of the understanding while it strains them to the utmost,—that we should term a sublime object. But whether this effect be occasioned directly by the object itself, or be indirectly suggested by its relations to some other object, its unknown cause, it matters

not; since the apparent power of calling forth the emotion, by what-ever means, is, *quoad* ourselves, its sublime condition.

* * *

But though the position here advanced must necessarily exclude many objects which have hitherto, though, as we think, improperly, been classed with the sublime, it will still leave enough, and more than enough, for the utmost exercise of our limited powers; inasmuch as, in addition to the multitude of objects in the material world, not only the actions, passions, and thoughts of men, but whatever concerns the human being, that in any way—by a hint merely—leads the mind, though indirectly, to the Infinite attributes,—all come of right within the ground assumed.

It will be borne in mind, that the conscious presence of the In-finite Idea is not only *not* insisted on, but expressly admitted to be, in most cases, unthought of; it is also admitted, that a sublime effect is often powerfully felt in many instances where this Idea could not truly be predicated of the apparent object. In such cases, however, some kind of resemblance, or, at least, a seeming analogy to an infinite attribute, is nevertheless essential. It must *appear* to us, for the time, either limitless, indefinite, or in some other way beyond the grasp of the mind: and, whatever an object may *seem* to be, it must needs *in effect* be to *us* even that which it seems. Nor does this transfer the emotion to a different source; for the Infinite Idea, or something analogous, being thus imputed, is in reality its true cause.

It is still the unattainable, the *ever-stimulating,* yet *ever-eluding,* in the character of the sublime object, that gives to it both its term and its effect. And whence the conception of this mysterious character, but from its mysterious prototype, the Idea of the Infinite? Neither does it matter, as we have said, whether actual or supposed; for what the imagination cannot master will master the imagination.

* * *

It is not to be supposed that we have enumerated all the forms of gradation between the Beautiful and the Sublime; such was not our purpose; it is sufficient to have noted the most prominent, leaving the intermediate modifications to be supplied (as they can readily be) by the reader. If we descend from the Beautiful, we shall pass in like manner through an equal variety of forms gradually modified by the grosser material influences, as the Handsome, the Pretty, the Comely, the Plain, and so on, till we fall to the Ugly.

There ends the chain of pleasurable excitement; but not the chain of Forms; which, taking now as if a literal curve, again bends upward, till, meeting the descending extreme of the moral, it seems to complete the mighty circle. And in this dark segment will be found the startling union of deepening discords,—still deepening, as it rises from the Ugly to the Loathsome, the Horrible, the Frightful,* the Appalling.

As we follow the chain through this last region of disease, misery, and sin, of embodied Discord, and feel, as we must, in the mutilated affinities of its revolting forms, their fearful relation to this fair, harmonious creation,—how does the awful fact, in these its breathing fragments, speak to us of a fallen world!

As the living center of this stupendous circle stands the Soul of Man; the *conscious Reality,* to which the vast inclosure is but the symbol. How vast, then, his being! If space could measure it, the remotest star would fall within its limits. Well, then, may he tremble to essay it even in thought; for where must it carry him,—that winged messenger, fleeter than light? Where but to the confines of the Infinite; even to the presence of the unutterable *Life,* on which nothing finite can look and live?

Finally, we shall conclude our Discourse with a few words on the master Principle, which we have supposed to be, by the will of the Creator, the realizing life to all things fair and true and good: and more especially would we revert to its spiritual purity, emphatically manifested through all its manifold operations,—so impossible of alliance with anything sordid, or false, or wicked,—so unapprehensible, even, except for its own most sinless sake. Indeed, we cannot look upon it as other than the universal and eternal witness of God's goodness and love, to draw man to himself, and to testify to the meanest, most obliquitous mind,—at least once in life, be it though in childhood,—that there *is* such a thing as *good without self.*

* * *

On Composition

In the celebrated Marriage at Cana, by Paul Veronese, we see it carried, perhaps, to its utmost limits; and to such an extent, that an hour's travel will hardly conduct us through all its parts; yet we feel no weariness throughout this journey, nay, we are quite unconscious of the time it has taken. It is no disparagement of this remarkable picture, if we consider the subject, not according to the title it bears, but as what the Artist has actually made it,—that is, as a Venetian entertain-

* The Frightful is not the Terrible, though often confounded with it.

ment; and also the effect intended, which was to delight by the exhibition of a gorgeous *pageant*. And in this he has succeeded to a degree unexampled: for literally the eye may be said to *dance* through the picture, scarcely lighting on one part before it is drawn to another, and another, and another, as by a kind of witchery; while the subtile interlocking of each successive novelty leaves it no choice, but, seducing it onward, still keeps it in motion, till the giddy sense seems to call on the Imagination to join in the revel; and every poetic temperament answers to the call, bringing visions of its own, that mingle with the painted crowd, exchanging forms, and giving them voice, like the creatures of a dream.

To those who have never seen this picture, our account of its effect may perhaps appear incredible when they are told, that it not only has no story, but not a single expression to which you can attach a sentiment. It is nevertheless for this very reason that we here cite it, as a triumphant verification of those immutable laws of the mind to which the principles of Composition are supposed to appeal; where the simple technic exhibition, or illustration of *Principles,* without story, or thought, or a single definite expression, has still the power to possess and to fill us with a thousand delightful emotions.

And here we cannot refrain from a passing remark on certain criticisms, which have obtained, as we think, an undeserved currency. To assert that such a work is solely addressed to the senses (meaning thereby that its only end is in mere pleasurable sensation) is to give the lie to our convictions; inasmuch as we find it appealing to one of the mightiest ministers of the Imagination,—the great Law of Harmony,— which cannot be *touched* without awakening by its vibrations, so to speak, the untold myriads of sleeping forms that lie within its circle, that start up in tribes, and each in accordance with the congenial instrument that summons them to action. He who can thus, as it were, embody an abstraction is no mere pander to the senses. And who that has a modicum of the imaginative would assert of one of Haydn's Sonatas, that its effect on him was no other than sensuous? Or who would ask for the *story* in one of our gorgeous autumnal sunsets?

* * *

It is by this summing up, as it were, of the memory, through recurrence, not that we perceive,—which is instantaneous,—but that we enjoy anything as a whole. If we have not observed it in others, some of us, perhaps, may remember it in ourselves, when we have stood before some fine picture, though with a sense of pleasure, yet for many minutes in a manner abstracted,—silently passing through all its har-

monious transitions without the movement of a muscle, and hardly conscious of action, till we have suddenly found ourselves returning on our steps. Then it was,—as if we had no eyes till then,—that the magic Whole poured in upon us, and vouched for its truth in an outbreak of rapture.

The fourth and last division of our subject is the Harmony of Parts; or the essential agreement of one part with another, and of each with the whole. In addition to our first general definition, we may further observe that by a Whole in Painting is signified the complete expression, by means of form, color, light, and shadow of one thought, or series of thoughts, having for their end some particular truth, or sentiment, or action, or mood of mind. We say *thought,* because no images, however put together, can ever be separated by the mind from other and extraneous images, so as to comprise a positive whole, unless they be limited by some intellectual boundary. A picture wanting this may have fine parts, but is not a Composition, which implies parts united to each other, and also suited to some specific purpose, otherwise they cannot be known as united. Since Harmony, therefore, cannot be conceived of without reference to a whole, so neither can a whole be imagined without fitness of parts. To give this fitness, then, is the ultimate task and test of genius: it is, in fact, calling form and life out of what before was but a chaos of materials, and making them the subject and exponents of the will. As the master-principle, also, it is the disposer, regulator, and modifier of shape, line, and quantity, adding, diminishing, changing, shaping, till it becomes clear and intelligible, and it finally manifests itself in pleasurable identity with the harmony within us.[1]

RALPH WALDO EMERSON: THOUGHTS ON ART, 1841

The approach of Ralph Waldo Emerson (1803-1882) to the arts differs from that of Allston more in matters of emphasis than in its fundamental point of view. Where Allston stresses the transforming power of the artist, Emerson would have him more subservient to nature, where God's architecture is already manifest. This is particularly true in the "useful arts" where Emerson's thought parallels that of Greenough in presaging later organic theories of art and architecture. He is closest to Allston in his assertion that the fine artist must closely follow what he calls Ideal Nature, that "everything individual" is "ab-

[1] Washington Allston, *Lectures on Art and Poetry,* Richard H. Dana, Jr., ed. (New York, 1850), pp. 9-14, 52-56, 68-69, 145-146.

stracted," and that in the pursuit of this Ideal the various forms of art tend to be seen as interchangeable.

Every department of life at the present day,—Trade, Politics, Letters, Science, Religion,—seem to feel, and to labor to express the identity of their law. They are rays of one sun; they translate each into a new language the sense of the other. They are sublime when seen as emanations of a Necessity contradistinguished from the vulgar Fate, by being instant and alive, and dissolving man as well as his works, in its flowing beneficence. This influence is conspicuously visible in the principles and history of Art.

On one side, in primary communication with absolute truth, through thought and instinct, the human mind tends by an equal necessity, on the other side, to the publication and embodiment of its thought,—modified and dwarfed by the impurity and untruth which, in all our experience, injures the wonderful medium through which it passes. The child not only suffers, but cries; not only hungers, but eats. The man not only thinks, but speaks and acts. Every thought that arises in the mind, in its rising, aims to pass out of the mind into act; just as every plant, in the moment of germination, struggles up to light. Thought is the seed of action; but action is as much its second form as thought is its first. It rises in thought to the end, that it may be uttered and acted. The more profound the thought, the more burdensome. Always in proportion to the depth of its sense does it knock importunately at the gates of the soul, to be spoken, to be done. What is in, will out. It struggles to the birth. Speech is a great pleasure, and action is a great pleasure; they cannot be forborne.

The utterance of thought and emotion in speech and action may be conscious or unconscious. The sucking child is an unconscious actor. A man in an ecstasy of fear or anger is an unconscious actor. A large part of our habitual actions are unconsciously done, and most of our necessary words are unconsciously said.

The conscious utterance of thought, by speech or action, to any end, is Art. From the first imitative babble of a child to the despotism of eloquence; from his first pile of toys or chip bridge, to the masonry of Eddystone lighthouse or the Erie canal; from the tattooing of the Owhyhees to the Vatican Gallery; from the simplest expedient of private prudence to the American Constitution; from its first to its last works, Art is the spirit's voluntary use and combination of things to serve its end. The Will distinguishes it as spiritual action. Relatively to themselves, the bee, the bird, the beaver have no art, for what they do, they do instinctively; but relatively to the Supreme Being, they have. And the same is true of all unconscious action; relatively to the doer,

it is instinct; relatively to the First Cause, it is Art. In this sense, recognizing the Spirit which informs Nature, Plato rightly said, "Those things which are said to be done by Nature, are indeed done by Divine Art." Art, universally, is the spirit creative. It was defined by Aristotle, "The reason of the thing, without the matter," as he defined the art of shipbuilding to be, "All of the ship but the wood."

If we follow the popular distinction of works according to their aim, we should say, the Spirit, in its creation, aims at use or at beauty, and hence Art divides itself into the Useful and the Fine Arts.

The useful arts comprehend not only those that lie next to instinct, as agriculture, building, weaving, and so forth, but also navigation, practical chemistry, and the construction of all the grand and delicate tools and instruments by which man serves himself; as language; the watch; the ship; the decimal cipher; and also the sciences, so far as they are made serviceable to political economy.

The moment we began to reflect on the pleasure we receive from a ship, a railroad, a dry dock; or from a picture, a dramatic representation, a statue, a poem, we find that they have not a quite simple, but a blended origin. We find that the question,—What is Art? leads us directly to another,—Who is the artist? and the solution of this is the key to the history of Art.

I hasten to state the principle which prescribes, through different means, its firm law to the useful and the beautiful arts. The law is this. The universal soul is the alone creator of the useful and the beautiful; therefore to make anything useful or beautiful, the individual must be submitted to the universal mind.

In the first place, let us consider this in reference to the useful arts. Here the omnipotent agent is Nature; all human acts are satellites to her orb. Nature is the representative of the universal mind, and the law becomes this,—that Art must be a complement to nature, strictly subsidiary. It was said, in allusion to the great structures of the ancient Romans, the aqueducts and bridges,—that their "Art was a Nature working to municipal ends." That is a true account of all just works of useful art. Smeaton built Eddystone lighthouse on the model of an oak tree, as being the form in nature best designed to resist a constant assailing force. Dollond formed his achromatic telescope on the model of the human eye. Duhamel built a bridge, by letting in a piece of stronger timber for the middle of the under surface, getting his hint from the structure of the shin-bone.

The first and last lesson of the useful arts is, that nature tyrannizes over our works. They must be conformed to her law, or they will be ground to powder by her omnipresent activity. Nothing droll, nothing whimsical will endure. Nature is ever interfering with Art. You cannot

build your house or pagoda as you will, but as you must. There is a quick bound set to our caprice. The leaning tower can only lean so far. The verandah or pagoda roof can curve upward only to a certain point. The slope of your roof is determined by the weight of snow. It is only within narrow limits that the discretion of the architect may range. Gravity, wind, sun, rain, the size of men and animals, and such like, have more to say than he. It is the law of fluids that prescribes the shape of the boat,—keel, rudder, and bows,—and, in the finer fluid above, the form and tackle of the sails. Man seems to have no option about his tools, but merely the necessity to learn from Nature what will fit best, as if he were fitting a screw or a door. Beneath a necessity thus almighty, what is artificial in man's life seems insignificant. He seems to take his task so minutely from intimations of Nature, that his works become as it were hers, and he is no longer free.

But if we work within this limit, she yields us all her strength. All powerful action is performed, by bringing the forces of nature to bear upon our objects. We do not grind corn or lift the loom by our own strength, but we build a mill in such a position as to set the north wind to play upon our instrument, or the elastic force of steam, or the ebb and flow of the sea. So in our handiwork, we do few things by muscular force, but we place ourselves in such attitudes as to bring the force of gravity, that is, the weight of the planet, to bear upon the spade or the axe we wield. What is it that gives force to the blow of the axe or crowbar? Is it the muscles of the laborer's arm, or is it the attraction of the whole globe below it, on the axe or bar? In short, in all our operations we seek not to use our own, but to bring a quite infinite force to bear.

Let us now consider this law as it affects the works that have beauty for their end, that is, the productions of the Fine Arts.

Here again the prominent fact is subordination of man. His art is the least part of his work of art. A great deduction is to be made before we can know his proper contribution to it.

Music, eloquence, poetry, painting, sculpture, architecture. This is a rough enumeration of the Fine Arts. I omit rhetoric, which only respects the form of eloquence and poetry. Architecture and eloquence are mixed arts, whose end is sometimes beauty and sometimes use.

It will be seen that in each of these arts there is much which is not spiritual. Each has a material basis, and in each the creating intellect is crippled in some degree by the stuff on which it works. The basis of poetry is language, which is material only on one side. It is a demigod. But being applied primarily to the common necessities of man, it is not new created by the poet for his own ends.

The basis of music is the qualities of the air and the vibrations

of sonorous bodies. The pulsation of a stretched string or wire, gives the ear the pleasure of sweet sound, before yet the musician has enhanced this pleasure by concords and combinations.

Eloquence, as far as it is a fine art, is modified how much by the material organization of the orator, the tone of the voice, the physical strength, the play of the eye and countenance! All this is so much deduction from the purely spiritual pleasure. All this is so much deduction from the merit of Art, and is the attribute of Nature.

In painting, bright colors stimulate the eye, before yet they are harmonized into a landscape. In sculpture and in architecture, the material, as marble or granite; and in architecture, the mass,—are sources of great pleasure, quite independent of the artificial arrangement. The art resides in the model, in the plan, for it is on that the genius of the artist is expended, not on the statue, or the temple. Just as much better as is the polished statue of dazzling marble than the clay model; or as much more impressive as is the granite cathedral or pyramid than the ground-plan or profile of them on paper, so much more beauty owe they to Nature than to Art.

There is a still larger deduction to be made from the genius of the artist in favor of Nature than I have yet specified.

A jumble of musical sounds on a viol or a flute, in which the rhythm of the tune is played without one of the notes being right, gives pleasure to the unskillful ear. A very coarse imitation of the human form on canvas, or in waxwork,—a very coarse sketch in colors of a landscape, in which imitation is all that is attempted,—these things give to unpracticed eyes, to the uncultured, who do not ask a fine spiritual delight, almost as much pleasure as a statue of Canova or a picture of Titian.

And in the statue of Canova, or the picture of Titian, these give the great part of the pleasure; they are the basis on which the fine spirit rears a higher delight, but to which these are indispensable.

Another deduction from the genius of the artist is what is conventional in his art, of which there is much in every work of art. Thus how much is there that is not original in every particular building, in every statue, in every tune, in every painting, in every poem, in every harangue. Whatever is national or usual; as the usage of building all Roman churches in the form of a cross, the prescribed distribution of parts of a theatre, the custom of draping a statue in classical costume. Yet who will deny that the merely conventional part of the performance contributes much to its effect?

One consideration more exhausts, I believe, all the deductions from the genius of the artist in any given work.

This is the adventitious. Thus the pleasure that a noble temple

gives us, is only in part owing to the temple. It is exalted by the beauty of sunlight, by the play of the clouds, by the landscape around it, by its grouping with the houses, and trees, and towers, in its vicinity. The pleasure of eloquence is in greatest part owing often to the stimulus of the occasion which produces it; to the magic of sympathy, which exalts the feeling of each, by radiating on him the feeling of all.

The effect of music belongs how much to the place, as the church, or the moonlight walk, or to the company, or, if on the stage, to what went before in the play, or to the expectation of what shall come after.

In poetry, "It is tradition more than invention helps the poet to a good fable." The adventitious beauty of poetry may be felt in the greater delight which a verse gives in happy quotation than in the poem.

It is a curious proof of our conviction that the artist does not feel himself to be the parent of his work and is as much surprised at the effect as we, that we are so unwilling to impute our best sense of any work of art to the author. The very highest praise we can attribute to any writer, painter, sculptor, builder, is, that he actually possessed the thought or feeling with which he has inspired us. We hesitate at doing Spenser so great an honor as to think that he intended by his allegory the sense we affix to it. We grudge to Homer the wise human circumspection his commentators ascribed to him. Even Shakespeare, of whom we can believe everything, we think indebted to Goethe and to Coleridge for the wisdom they detect in his Hamlet and Anthony. Especially have we this infirmity of faith in contemporary genius. We fear that Allston and Greenough did not foresee and design all the effect they produce on us.

Our arts are happy hits. We are like the musician on the lake, whose melody is sweeter than he knows, or like a traveller, surprised by a mountain echo, whose trivial word returns to him in romantic thunders.

In view of these facts, I say that the power of Nature predominates over the human will in all works of even the fine arts, in all that respects their material and external circumstances. Nature paints the best part of the picture; carves the best part of the statue; builds the best part of the house; and speaks the best part of the oration. For all the advantages to which I have adverted are such as the artist did not consciously produce. He relied on their aid, he put himself in the way to receive aid from some of them, but he saw that his planting and his watering waited for the sunlight of Nature, or was vain.

Let us proceed to the consideration of the great law stated in the beginning of this essay, as it affects the purely spiritual part of a work of art.

As in useful art, so far as it is useful, the work must be strictly

subordinated to the laws of Nature, so as to become a sort of continuation, and in no wise a contradiction of Nature; so in art that aims at beauty as an end, must the parts be subordinated to Ideal Nature, and everything individual abstracted, so that it shall be the production of the universal soul.

The artist, who is to produce a work which is to be admired not by his friends or his townspeople, or his contemporaries, but by all men; and which is to be more beautiful to the eye in proportion to its culture, must disindividualize himself, and be a man of no party, and no manner, and no age, but one through whom the soul of all men circulates, as the common air through his lungs. He must work in the spirit in which we conceive a prophet to speak, or an angel of the Lord to act, that is, he is not to speak his own words, or do his own works, or think his own thoughts, but he is to be an organ through which the universal mind acts.

In speaking of the useful arts, I pointed to the fact, that we do not dig, or grind, or hew, by our muscular strength, but by bringing the weight of the planet to bear on the spade, axe, or bar. Precisely analogous to this, in the fine arts, is the manner of our intellectual work. We aim to hinder our individuality from acting. So much as we can shove aside our egotism, our prejudice, and will, and bring the omniscience of reason upon the subject before us, so perfect is the work. The wonders of Shakespeare are things which we saw whilst he stood aside, and then returned to record them. The poet aims at getting observations without aim; to subject to thought things seen without (voluntary) thought.

In eloquence, the great triumphs of the art are, when the orator is lifted above himself; when consciously he makes himself the mere tongue of the occasion and the hour, and says what cannot but be said. Hence the French phrase *l'abandon,* to describe the self-surrender of the orator. Not his will, but the principle on which he is horsed, the great connection and crisis of events thunder in the ear of the crowd.

In poetry, where every word is free, every word is necessary. Good poetry could not have been otherwise written than it is. The first time you hear it, it sounds rather as if copied out of some invisible tablet in the Eternal mind, than as if arbitrarily composed by the poet. The feeling of all great poets has accorded with this. They found the verse, not made it. The muse brought it to them.

In sculpture, did ever anybody call the Apollo a fancy piece? Or say of the Laocoön how it might be made different? A masterpiece of art has in the mind a fixed place in the chain of being, as much as a plant or a crystal.

The whole language of men, especially of artists, in reference to this subject, points at the belief, that every work of art, in proportion

to its excellence, partakes of the precision of fate; no room was there for choice; no play for fancy; for the moment, or in the successive moments, when that form was seen, the iron lids of Reason were unclosed, which ordinarily are heavy with slumber: that the individual mind became for the moment the vent of the mind of humanity.

There is but one Reason. The mind that made the world is not one mind, but *the* mind. Every man is an inlet to the same, and to all of the same. And every work of art is a more or less pure manifestation of the same. Therefore we arrive at this conclusion, which I offer as a confirmation of the whole view: That the delight, which a work of art affords, seems to arise from our recognizing in it the mind that formed Nature again in active operation.

It differs from the works of Nature in this, that they are organically reproductive. This is not: but spiritually it is prolific by its powerful action on the intellects of men.

In confirmation of this view, let me refer to the fact, that a study of admirable works of art always sharpens the perceptions of the beauty of Nature; that a certain analogy reigns throughout the wonders of both; that the contemplations of a work of great art draws us into a state of mind which may be called religious. It conspires with all exalted sentiments.

Proceeding from absolute mind, whose nature is goodness as much as truth, they are always attuned to moral nature. If the earth and sea conspire with virtue more than vice,—so do the masterpieces of art. The galleries of ancient sculpture in Naples and Rome strike no deeper conviction into the mind than the contrast of the purity, the severity, expressed in these fine old heads, with the frivolity and grossness of the mob that exhibits, and the mob that gazes at them. These are the countenances of the first-born, the face of man in the morning of the world. No mark is on these lofty features of sloth, or luxury, or meanness, and they surprise you with a moral admonition, as they speak of nothing around you, but remind you of the fragrant thoughts and the purest resolutions of your youth.

Herein is the explanation of the analogies which exist in all the arts. They are the reappearance of one mind, working in many materials to many temporary ends. Raphael paints wisdom; Handel sings it, Phidias carves it, Shakespeare writes it, Wren builds it, Columbus sails it, Luther preaches it, Washington arms it, Watt mechanizes it. Painting was called "silent poetry"; and poetry "speaking painting." The laws of each art are convertible into the laws of every other.

Herein we have an explanation of the necessity that reigns in all the kingdom of art.

Arising out of eternal reason, one and perfect, whatever is beauti-

ful rests on the foundation of the necessary. Nothing is arbitrary, nothing is insulated in beauty. It depends forever on the necessary and the useful. The plumage of the bird, the mimic plumage of the insect, has a reason for its rich colors in the constitution of the animal. Fitness is so inseparable an accompaniment of beauty, that it has been taken for it. The most perfect form to answer an end, is so far beautiful. In the mind of the artist, could we enter there, we should see the sufficient reason for the last flourish and tendril of his work, just as every tint and spine in the sea-shell preëxists in the secreting organs of the fish. We feel, in seeing a noble building, which rhymes well, as we do in hearing a perfect song, that it is spiritually organic, that is, had a necessity in nature, for being, was one of the possible forms in the Divine mind, and is now only discovered and executed by the artist, not arbitrarily composed by him.

And so every genuine work of art has as much reason for being as the earth and the sun. The gayest charm of beauty has a root in the constitution of things. The Iliad of Homer, the songs of David, the odes of Pindar, the tragedies of Æschylus, the Doric temples, the Gothic cathedrals, the plays of Shakespeare, were all made not for sport, but in grave earnest, in tears, and smiles of suffering and loving men.

Viewed from this point, the history of Art becomes intelligible, and, moreover, one of the most agreeable studies in the world. We see how each work of art sprang irresistibly from necessity, and, moreover, took its form from the broad hint of Nature. Beautiful in this wise is the obvious origin of all the known orders of architecture, namely, that they were the idealizing of the primitive abodes of each people. Thus the Doric temple still presents the semblance of the wooden cabin, in which the Dorians dwelt. The Chinese pagoda is plainly a Tartar tent. The Indian and Egyptian temples still betray the mounds and subterranean houses of their forefathers. The Gothic church plainly originated in a rude adaptation of forest trees, with their boughs on, to a festal or solemn edifice, as the bands around the cleft pillars still indicate the green withes that tied them. No one can walk in a pine barren, in one of the paths which the woodcutters make for their teams, without being struck with the architectural appearance of the grove, especially in winter, when the bareness of all other trees shows the low arch of the Saxons. In the woods, in a winter afternoon, one will see as readily the origin of the stained glass window with which the Gothic cathedrals are adorned, in the colors of the western sky, seen through the bare and crossing branches of the forest. Nor, I think, can any lover of nature enter the old piles of Oxford and the English cathedrals, without feeling that the forest overpowered the mind of the builder, with its ferns, its spikes of flowers, its locust, its oak, its pine, its fir, its spruce. The

cathedral is a blossoming in stone, subdued by the insatiable demand of harmony in man. The mountain of granite blooms into an eternal flower, with the lightness and delicate finish, as well as aerial proportions and perspective of vegetable beauty.

There was no wilfulness in the savages in this perpetuating of their first rude abodes. The first form in which they built a house would be the first form of their public and religious edifice also. This form becomes immediately sacred in the eyes of their children, and the more so, as more traditions cluster round it, and is, therefore, imitated with more splendor in each succeeding generation.

In like manner, it has been remarked by Goethe, that the granite breaks into parallelopipeds, which, broken in two, one part would be an obelisk; that in Upper Egypt the inhabitants would naturally mark a memorable spot by setting up so conspicuous a stone. Again, he suggested we may see in any stone wall, on a fragment of rock, the projecting veins of harder stone, which have resisted the action of frost and water, which has decomposed the rest. This appearance certainly gave the hint of the hieroglyphics inscribed on their obelisk. The amphitheatre of the old Romans,—anyone may see its origin, who looks at the crowd running together to see any fight, sickness, or odd appearance in the street. The first comers gather round in a circle; those behind stand on tiptoe; and further back they climb on fences or window sills, and so make a cup of which the object of attention occupies the hollow area. The architect put benches in this order, and enclosed the cup with a wall, and behold a coliseum.

It would be easy to show of very many fine things in the world, in the customs of nations, the etiquette of courts, the constitution of governments, the origin in very simple local necessities. Heraldry, for example, and the ceremonies of a coronation, are a splendid burlesque of the occurrences that might befall a dragoon and his footboy. The College of Cardinals were originally the parish priests of Rome. The leaning towers originated from the civil discords which induced every lord to build a tower. Then it became a point of family pride,—and for pride a leaning tower was built.

This strict dependence of art upon material and ideal nature, this adamantine necessity, which it underlies, has made all its past, and may foreshow its future history. It never was in the power of any man, or any community, to call the arts into being. They come to serve' his actual wants, never to please his fancy. These arts have their origin always in some enthusiasm, as love, patriotism, or religion. Who carved marble? The believing man, who wished to symbolize their gods to the waiting Greeks.

The Gothic cathedrals were built, when the builder and the priest

and the people were overpowered by their faith. Love and fear laid every stone. The Madonnas of Raphael and Titian were made to be worshipped. Tragedy was instituted for the like purpose, and the miracles of music;—all sprang out of some genuine enthusiasm, and never out of dilettantism and holidays. But now they languish, because their purpose is merely exhibition. Who cares, who knows what works of art our government have ordered to be made for the capitol? They are a mere flourish to please the eye of persons who have associations with books and galleries. But in Greece, the Demos of Athens divided into political factions upon the merits of Phidias.

In this country, at this time, other interests than religion and patriotism are predominant, and the arts, the daughters of enthusiasm, do not flourish. The genuine offspring of our ruling passions we behold. Popular institutions, the school, the reading room, the post office, the exchange, the insurance company, and an immense harvest of economical inventions, are the fruit of the equality and the boundless liberty of lucrative callings. These are superficial wants; and their fruits are these superficial institutions. But as far as they accelerate the end of political freedom and national education, they are preparing the soil of man for fairer flowers and fruits in another age. For beauty, truth, and goodness are not obsolete; they spring eternal in the breast of man; they are as indigenous in Massachusetts as in Tuscany, or the Isles of Greece. And that Eternal Spirit, whose triple face they are, moulds from them forever, for his mortal child, images to remind him of the Infinite and Fair.[1]

ALEXANDER EVERETT: GREENOUGH'S STATUE OF WASHINGTON, 1844

The story of Horatio Greenough's (1805-1852) George Washington is not a happy one. Surrounded by controversy from the time of its arrival in 1841 from Italy, the statue was removed from the Rotunda of the National Capitol in 1847, allowed to weather on the Capitol grounds for over fifty years, and finally moved to relative obscurity in the Smithsonian Institution where it now stands. The major points at issue in the controversy are reviewed in this defense of Greenough's work by Alexander Everett (1790-1847), brother of Edward Everett, a diplomat, friend, and supporter of Greenough. The conflict turned on points brought up later in the Hawthorne-Powers conversations. The

[1] Ralph Waldo Emerson, "Thoughts on Art," *The Dial*, Vol. I, no. 3 (January, 1841), pp. 367-378.

arguments in the statue's favor set forth here closely parallel those of the sculptor.

This magnificent product of genius does not seem to be appreciated at its full value in this metropolis of "the freest and most enlightened people on the globe." I have met with few persons here who have spoken of it in terms of strong or even moderate satisfaction. Everyone has some fault to point out, that appears to withdraw his attention entirely from the grandeur and beauty of the whole, which, when they are pressed upon him, he is compelled to acknowledge. One is dissatisfied that the figure is colossal; another that the face is not an exact copy of Stuart's portrait; a third, that the posture is sitting and not standing; a fourth, that there is a want of repose in the general expression; a fifth, that one of the ankles is incorrectly modelled; and so of the rest. Most of these objections proceed, as I have heard them stated, from persons who would think themselves wronged if their sensibility to the grand and beautiful in nature and art were called in question. But how feeble must this quality be in one who can see nothing in so splendid a monument but some trifling real or imaginary fault! I should not blame anyone for indicating and insisting on what he might consider as blemishes, if he were also to exhibit a proper feeling for the acknowledged merits of the work: but I almost lose patience when I hear a person, not without some pretensions to good taste, after a visit of an hour to the statue, making no other remark than that one of the ankles is incorrectly modelled; an error which, after a careful examination for the express purpose, I have been wholly unable to discover. This remark is nearly a repetition of the one made by the Athenian cobbler, upon the first exhibition of one of the celebrated Venuses of antiquity—that there was a wrong stitch in one of her sandals. It affords a curious, though not very agreeable proof, how exactly human nature repeats itself under similar circumstances, even to the slightest and apparently most accidental particulars.

The most satisfactory expression of feeling that I have met with here, in regard to the statue, was prompted by the finer and truer sensibility inherent in the heart of woman. It proceeded from a company of ladies whom I happened to encounter on my first visit to the building that contains this great national monument. They were strangers to me, and had not the air of persons belonging to the fashionable coteries of our large cities; but they evidently possessed—what is much more important—cultivated minds, and a keen susceptibility to the influence of natural and moral beauty. They appeared to have been travelling extensively, and one of them had under her arm a large sketch-book. They expressed in various forms the highest admiration of the statue, and

one of them finally remarked, as a sort of summary of the whole, that it produced upon her mind a stronger impression of sublimity and grandeur than she had received from the cataract of Niagara.

The objections above mentioned to the size, attitude, and costume of the statute, and to the character of the features, proceed upon the supposition, that it was the interest of the artist to make the nearest possible approach to the person and countenance of Washington, as represented in the most authentic portraits and statues; and in costume, to the dress that he actually wore. This supposition is obviously an erroneous one. These are matters which have their importance as points of historical information—especially in connection with a character of so much interest. But the object of the artist, in a work of this kind, is much older than that of satisfying curiosity upon these particulars. It was, as it should have been, his purpose to call forth, in the highest possible degree, the sentiment of the moral sublime, which the contemplation of the character of Washington is fitted to excite. This purpose required such a representation of his person, for instance, as, consistently with truth to nature, would tend most strongly to produce this result. A servile adherence to the existing portraits is not essential to the accomplishment of such a purpose, and might even be directly opposed to it; as, for example, if these had been executed in the early youth or extreme old age of the subject. Still less would it be necessary to preserve the costume of the period, which is already out of fashion, and for every subject, except the satisfaction of antiquarian curiosity, entirely unsuitable for effect in sculpture. The colossal size—the antique costume—the more youthful air of the face—are circumstances which, without materially impairing the truth to nature, increase very much the moral impression, and, instead of furnishing grounds for objection, are positive merits of high importance.

The question between a sitting and a standing posture is substantially the same as whether the subject was to be presented under a civil or a military aspect. In the latter case, a standing posture would undoubtedly have been preferable. But if the ascendency, given by Washington through his whole career to the virtues of the patriot citizen over the talents of the military chieftain, was the noblest trait in his character, and if it was the duty of the artist to exhibit him, on this occasion, under the circumstances in which he appeared, in real life, to the greatest advantage, then the civil aspect of the subject, and with it the sitting posture, like the other particulars that have been mentioned, instead of being a ground of objection, is a high positive merit.

It has been mentioned in private, as an objection made by a person whose judgment in some respects would be considered as entitled to respect, that there is a want of repose in the attitude. The arms are

extended in a way in which they could not be placed for any length of time without producing fatigue; and we feel, it is said, the same sort of uneasiness on witnessing this attitude in a statue that we should if it were maintained permanently by a living person in our presence.

It is rather difficult to comprehend the precise meaning of this objection as applied to the statue of Washington. When it is the intention of the artist to express repose, the indications of activity, of any kind, are, of course, out of place. Where it is intended to express activity, the indications of repose would, for the same reason, be incongruous with the subject. It is no more an objection to the statue of Washington that the arms are placed in an attitude which, after a short time, would become fatiguing to a living person, than it is an objection to the antique group of Laocoön that the muscles of a living man could not remain more than a few minutes in the state of extreme tension, indicated in that celebrated work, without convulsions, or to the Apollo Belvidere, that he stands, with foot drawn back and arm extended, in the position of an archer who has just discharged an arrow from his bow. In the famous equestrian statue of Peter the Great, at St. Petersburg, the horse is rearing on his hinder legs, while the fore legs remain suspended in the air at some distance from the ground. This is an attitude which could not be maintained by a living horse for more than two or three seconds; but, far from being made a ground of objection to the work, it has been regarded as its greatest merit, and as the precise quality which has given it the character of being the finest equestrian statue in Europe.

It was not the design of the artist to represent his subject in a state of repose. On the contrary, the obvious intention is to exhibit the noblest trait in his intellectual and moral character. I mean his habitual control over all the irregular propensities of his nature, at the point of time when it reached its fullest active development. In his practical career, this point was indicated by the resignation of his commission, as commander-in-chief, into the hands of the President of Congress. But that was a scene which comes within the province of painting rather than sculpture. A group so vast is beyond the reach of the chisel. It was the difficult duty of the artist to embody the sentiment which governed the conduct of Washington on that occasion, in a single figure. His success in conquering this difficulty, and producing, by a single figure, a moral emotion, superior, probably, to any that could be called forth by the finest painting of the scene before Congress, is one of the noblest triumphs of his noble art. To say that the work indicates activity and not repose, is only saying, in other words, that it was executed in conformity to the leading point in a plan, which was suggested, or rather imperiously dictated, by the nature of the subject.

It is rather unpleasant to be compelled, in commenting on this splendid effort of genius, to meet such objections as these, instead of joining in the general expression of mingled admiration and delight which it ought to elicit from the whole public. I make no pretensions to connoisseurship in the art of sculpture, and judge of the merit of the work merely by the impression which it makes upon my own mind; but I can say for myself, that after seeing the most celebrated specimens of ancient and modern sculpture to be found in Europe, including the Laocoön and the Apollo Belvidere, with the finest productions of Canova, Thorwaldsen, Sergell, and Chantrey, I consider the Washington of Greenough as superior to any of them, and as the master-piece of the art. The hint seems to have been taken from the Olympian Jupiter of Phidias, who said himself that he had caught the inspiration under which he conceived the plan of that great glory of ancient sculpture, from a passage in the Iliad. In this way the noble work of Greenough connects itself, by the legitimate filiation of kindred genius, transmitting its magnetic impulses through the long lines of intervening centuries, with the poetry of Homer. The vast dimensions of the Jupiter of Phidias may have made it to the eye a more imposing and majestic monument; but if the voluntary submission of transcendent power to the moral law of duty be, as it certainly is, a more sublime spectacle than any positive exercise of the same power over inferior natures, then the subject of the American sculptor is more truly divine than that of his illustrious prototype in Greece. When Jupiter shakes Olympus with his nod, the imagination is affected by a grand display of energy, but the heart remains untouched. When Washington, with an empire in his grasp, resigns his sword to the President of Congress, admiration of his great intellectual power is mingled with the deepest emotions of delightful sympathy, and we involuntarily exclaim with one of the characters in a scene of much less importance, as depicted by an elegant female writer: "There spoke the true thing; now my own heart is satisfied."

The present location of the statue is, of course, merely provisional. It is much to be regretted that the light in the Rotunda was found to be unfavorable, as there is no other hall in any of the buildings belonging to the Union sufficiently lofty and extensive to become a suitable, permanent place of deposit for this monument. How, when, and where, such a one shall be provided is a problem of rather difficult solution. If, as has sometimes been suggested, the patrimonial estate of Washington, at Mount Vernon, should ever be purchased by the country, and a public building erected there to serve as a sort of National Mausoleum, or Western Westminster Abbey, the statue would become, of course, its principal ornament. But the execution of this plan, should it ever be realized, is probably reserved for the good taste and liberality

of some future generation. In the meanwhile, the noblest achievement of the art of sculpture, dedicated to the memory of the greatest man that ever lived in the tide of time, will be permitted by a country which received from his hands gifts no less precious than Independence and Liberty, to take up its abode in a paltry barrack.[1]

NATHANIEL HAWTHORNE: A VISIT TO THE STUDIO OF HIRAM POWERS, 1858

Puritan scruples over the nudity required by idealized, classical sculpture in marble continued to bother Hiram Powers (1805-1873) as it did other sculptors of his generation who, like Powers, had been attracted to Italy by the cheap cost of living, of material, and of skilled Italian stone workers. Nathaniel Hawthorne (1804-1864), whose fascination with sculpture is evident in his Marble Faun, *touches upon the essentials of the problem in this account of his meeting with the sculptor in Florence in 1858. Hawthorne also airs here his opinion of the artistically inadequate solution of the problem by which a marble whiteness like the New England snow removed "the object represented into a sort of spiritual region, and so gives chaste permission to those nudities which would otherwise suggest immodesty."*

Mr. Powers called in the evening,—a plain personage, characterized by strong simplicity and warm kindliness, with an impending brow, and large eyes, which kindle as he speaks. He is gray, and slightly bald, but does not seem elderly, nor past his prime. I accept him at once as an honest and trustworthy man, and shall not vary from this judgment. Through his good offices, the next day, we engaged the Casa del Bello, at a rent of fifty dollars a month, and I shall take another opportunity (my fingers and head being tired now) to write about the house, and Mr. Powers, and what appertains to him, and about the beautiful city of Florence. At present, I shall only say further, that this journey from Rome has been one of the brightest and most uncareful interludes of my life; we have all enjoyed it exceedingly, and I am happy that our children have it to look back upon.

At our visit to Powers's studio on Tuesday, we saw a marble copy of the fisher-boy holding a shell to his ear, and the bust of Proserpine, and two or three other ideal busts; various casts of most of the ideal statues and portrait busts which he has executed. He talks very freely

[1] Alexander H. Everett, "Greenough's Statue of Washington," *United States Magazine and Democratic Review*, **XIV** (June, 1844), 618-621.

about his works, and is no exception to the rule that an artist is not apt to speak in a very laudatory style of a brother artist. He showed us a bust of Mr. Sparks by Persico,—a lifeless and thoughtless thing enough, to be sure,—and compared it with a very good one of the same gentleman by himself; but his chiefest scorn was bestowed on a wretched and ridiculous image of Mr. King, of Alabama, by Clarke Mills, of which he said he had been employed to make several copies for Southern gentlemen. The consciousness of power is plainly to be seen, and the assertion of it by no means withheld, in his simple and natural character; nor does it give me an idea of vanity on his part to see and hear it. He appears to consider himself neglected by his country,—by the government of it, at least,—and talks with indignation of the byways and political intrigue which, he thinks, win the rewards that ought to be bestowed exclusively on merit. An appropriation of twenty-five thousand dollars was made, some years ago, for a work of sculpture by him, to be placed in the Capitol; but the intermediate measures necessary to render it effective have been delayed; while the above-mentioned Clarke Mills—certainly the greatest bungler that ever botched a block of marble —has received an order for an equestrian statue of Washington. Not that Mr. Powers is made bitter or sour by these wrongs, as he considers them; he talks of them with the frankness of his disposition when the topic comes in his way, and is pleasant, kindly, and sunny when he has done with it.

His long absence from our country has made him think worse of us than we deserve; and it is an effect of what I myself am sensible, in my shorter exile: the most piercing shriek, the wildest yell, and all the ugly sounds of popular turmoil, inseparable from the life of a republic, being a million times more audible than the peaceful hum of prosperity and content which is going on all the while.

He talks of going home, but says that he has been talking of it every year since he first came to Italy; and between his pleasant life of congenial labor, and his idea of moral deterioration in America, I think it doubtful whether he ever crosses the sea again. Like most exiles of twenty years, he has lost his native country without finding another; but then it is as well to recognize the truth,—that an individual country is by no means essential to one's comfort.

Powers took us into the farthest room, I believe, of his very extensive studio, and showed us a statue of Washington that has much dignity and stateliness. He expressed, however, great contempt for the coat and breeches, and masonic emblems, in which he had been required to drape the figure. What would he do with Washington, the most decorous and respectable personage that ever went ceremoniously through the realities of life? Did anybody ever see Washington nude? It is inconceivable.

He had no nakedness, but I imagine he was born with his clothes on, and his hair powdered, and made a stately bow on his first appearance in the world. His costume, at all events, was a part of his character, and must be dealt with by whatever sculptor undertakes to represent him. I wonder that so very sensible a man as Powers should not see the necessity of accepting drapery, and the very drapery of the day, if he will keep his art alive. It is his business to idealize the tailor's actual work. But he seems to be especially fond of nudity, none of his ideal statues, so far as I know them, having so much as a rag of clothes. His statue of California, lately finished, and as naked as Venus, seemed to me a very good work; not an actual woman, capable of exciting passion, but evidently a little out of the category of human nature. In one hand she holds a divining rod. "She says to the emigrants," observed Powers, 'Here is the gold, if you choose to take it.' " But in her face, and in her eyes, very finely expressed, there is a look of latent mischief, rather grave than playful, yet somewhat impish or sprite-like; and, in the other hand, behind her back, she holds a bunch of thorns. Powers calls her eyes Indian. The statue is true to the present fact and history of California, and includes the age-long truth as respects the "auri sacra fames." . . .

When we had looked sufficiently at the sculpture, Powers proposed that we should now go across the street and see the Casa del Bello. We did so in a body, Powers in his dressing-gown and slippers, and his wife and daughters without assuming any street costume.

* * *

Meanwhile, I like Powers all the better, because he does not put his life wholly into marble. We had much talk, nevertheless, on matters of sculpture, for he drank a cup of tea with us, and stayed a good while.

He passed a condemnatory sentence on classic busts in general, saying that they were conventional, and not to be depended upon as true representations of the persons. He particularly excepted none but the bust of Caracalla; and, indeed, everybody that has seen this bust must feel the justice of the exception, and so be the more inclined to accept his opinion about the rest. There are not more than half a dozen —that of Cato the Censor among the others—in regard to which I should like to ask his judgment individually. He seems to think the faculty of making a bust an extremely rare one. Canova put his own likeness into all the busts he made. Greenough could not make a good one; nor Crawford, nor Gibson. Mr. Harte, he observed,—an American sculptor, now a resident in Florence,—is the best man of the day for making busts. Of course, it is to be presumed that he excepts himself; but I would

not do Powers the great injustice to imply that there is the slightest professional jealousy in his estimate of what others have done, or are now doing, in his own art. If he saw a better man than himself, he would recognize him at once, and tell the world of him; but he knows well enough that, in this line, there is no better, and probably none so good. It would not accord with the simplicity of his character to blink a fact that stands so broadly before him.

We asked him what he thought of Mr. Gibson's practice of coloring his statues, and he quietly and slyly said that he himself had made wax figures in his earlier days, but had left off making them now. In short, he objected to the practice wholly, and said that a letter of his on the subject had been published in the London "Athenæum," and had given great offense to some of Mr. Gibson's friends. It appeared to me, however, that his arguments did not apply quite fairly to the case, for he seems to think Gibson aims at producing an illusion of life in the statue, whereas I think his object is merely to give warmth and softness to the snowy marble, and so bring it a little nearer to our hearts and sympathies. Even so far, nevertheless, I doubt whether the practice is defensible, and I was glad to see that Powers scorned, at all events, the argument drawn from the use of color by the antique sculptors, on which Gibson relies so much. It might almost be implied, from the contemptuous way in which Powers spoke of color, that he considers it an impertinence on the face of visible nature, and would rather the world had been made without it; for he said that everything in intellect or feeling can be expressed as perfectly, or more so, by the sculptor in colorless marble, as by the painter with all the resources of his palette. I asked him whether he could model the face of Beatrice Cenci from Guido's picture so as to retain the subtle expression, and he said he could, for that the expression depended entirely on the drawing, "the picture being a badly colored thing." I inquired whether he could model a blush, and he said "Yes"; and that he had once proposed to an artist to express a blush in marble, if he would express it in picture. On consideration, I believe one to be as impossible as the other; the life and reality of the blush being in its tremulousness, coming and going. It is lost in a settled red just as much as in a settled paleness, and neither the sculptor nor painter can do more than represent the circumstances of attitude and expression that accompany the blush. There was a great deal of truth in what Powers said about this matter of color, and in one of our interminable New England winters it ought to comfort us to think how little necessity there is for any hue but that of the snow.

Mr. Powers, nevertheless, had brought us a bunch of beautiful roses, and seemed as capable of appreciating their delicate blush as we were. The best thing he said against the use of color in marble was to

the effect that the whiteness removed the object represented into a sort of spiritual region, and so gave chaste permission to those nudities which would otherwise suggest immodesty. I have myself felt the truth of this in a certain sense of shame as I looked at Gibson's tinted Venus.

He took his leave at about eight o'clock, being to make a call on the Bryants, who are at the Hôtel de New York, and also on Mrs. Browning, at Casa Guidi.[1]

[1] Nathaniel Hawthorne, *Passages from the French and Italian Notebooks* (Boston, 1873), pp. 291-294, 304-307.

4

The
Landscape

GEORGE CATLIN: LETTER FROM THE MOUTH
OF THE YELLOWSTONE RIVER, 1832

Upon seeing a group of Indians in 1829 during his student days in Philadelphia, George Catlin (1796-1872), struck by their "silent and stoic dignity," decided to devote his life to recording the appearance and customs of the American Indian. His travels and residence with various tribes produced six hundred pictures by 1838. In this letter of 1832, written near the beginning of his campaigns, Catlin expresses the reasons for his dedication and the romantic attraction he so deeply felt to the wilderness and the noble savage.

Mouth of Yellow Stone, Upper Missouri, 1832

I arrived at this place yesterday in the steamer "Yellow Stone," after a voyage of nearly three months from St. Louis, a distance of two thousand miles, the greater part of which has never before been navigated by steam; and the almost insurmountable difficulties which continually oppose the *voyageur* on this turbid stream, have been by degrees overcome by the indefatigable zeal of Mr. Chouteau, a gentleman of great perseverance, and part proprietor of the boat. To the politeness of this gentleman I am indebted for my passage from St. Louis to this place, and I had also the pleasure of his *company,* with that of Major Sanford, the government agent for the Missouri Indians.

* * *

You will, no doubt, be somewhat surprised on the receipt of a Letter from me, so far strayed into the Western World; and still more startled, when I tell you that I am here in the full enthusiasm and practice of my art. That enthusiasm alone has brought me into this remote region, 3,500 miles from my native soil; the last 2,000 of which have furnished me with almost unlimited models, both in landscape and the human figure, exactly suited to my feelings. I am now in the full possession and enjoyments of those conditions, on which alone I was induced to pursue the art as a profession; and in anticipation of which alone, my admiration for the art could ever have been kindled into a pure flame. I mean the free use of nature's undisguised models, with the privilege of selecting for myself. If I am here losing the benefit of the fleeting fashions of the day, and neglecting that elegant polish, which the world says an artist should draw from a continual intercourse with the polite world; yet have I this consolation, that in this country, I am entirely divested of those dangerous steps and allurements which

beset an artist in fashionable life; and have little to steal my thoughts away from the contemplation of the beautiful models that are about me. If, also, I have not here the benefit of that feeling of emulation, which is the life and spur to the arts, where artists are associates together; yet am I surrounded by living models of such elegance and beauty, that I feel an unceasing excitement of a much higher order— the certainty that I am drawing knowledge from the true source. My enthusiastic admiration of man in the honest and elegant simplicity of nature, has always fed the warmest feelings of my bosom, and shut half the avenues to my heart against the specious refinements of the accomplished world. This feeling, together with the desire to study my art, independently of the embarrassments which the ridiculous fashions of civilized society have thrown in its way, has led me to the wilderness for a while, as the true school of the arts.

I have for a long time been of the opinion, that the wilderness of our country afforded models equal to those from which the Grecian sculptors transferred to the marble such inimitable grace and beauty; and I am now more confirmed in this opinion, since I have immersed myself in the midst of thousands and tens of thousands of these knights of the forest; whose whole lives are lives of chivalry, and whose daily feats, with their naked limbs, might vie with those of the Grecian youths in the beautiful rivalry of the Olympian games.

No man's imagination, with all the aids of description that can be given to it, can ever picture the beauty and wildness of scenes that may be daily witnessed in this romantic country; of hundreds of these graceful youths, without a care to wrinkle, or a fear to disturb the full expression of pleasure and enjoyment that beams upon their faces—their long black hair mingling with their horses' tails, floating in the wind, while they are flying over the carpeted prairie, and dealing death with their spears and arrows, to a band of infuriated buffaloes; or their splendid procession in a war-parade, arrayed in all their gorgeous colors and trappings, moving with most exquisite grace and manly beauty, added to that bold defiance which man carries on his front, who acknowledges no superior on earth, and who is amenable to no laws except the laws of God and honor.

In addition to the knowledge of human nature and my art, which I hope to acquire by this toilsome and expensive undertaking, I have another in view, which, if it should not be of equal service to me, will be of no less interest and value to posterity. I have, for many years past, contemplated the noble races of red men who are now spread over these trackless forests and boundless prairies, melting away at the approach of civilization. Their rights invaded, their morals corrupted, their lands wrested from them, their customs changed, and therefore lost to the

world; and they at last sunk into the earth, and the ploughshare turning the sod over their graves, and I have flown to their rescue—not of their lives or of their race (for they are *"doomed"* and must perish), but to the rescue of their looks and their modes, at which the acquisitive world may hurl their poison and every besom of destruction, and trample them down and crush them to death; yet, phœnix-like, they may rise from the "stain on a painter's palette," and live again upon canvas, and stand forth for centuries yet to come, the living monuments of a noble race. For this purpose, I have designed to visit every tribe of Indians on the Continent, if my life should be spared; for the purpose of procuring portraits of distinguished Indians, of both sexes in each tribe, painted in their native costume; accompanied with pictures of their villages, domestic habits, games, mysteries, religious ceremonies, and so forth with anecdotes, traditions, and history of their respective nations.

If I should live to accomplish my design, the result of my labors will doubtless be interesting to future ages; who will have little else left from which to judge of the original inhabitants of this simple race of beings, who require but a few years more of the march of civilization and death, to deprive them of all their native customs and character. I have been kindly supplied by the Commander-in-Chief of the Army and the Secretary of War, with letters to the commander of every military post, and every Indian agent on the Western Frontier, with instructions to render me all the facilities in their power, which will be of great service to me in so arduous an undertaking. The opportunity afforded me by familiarity with so many tribes of human beings in the simplicity of nature, devoid of the deformities of art; of drawing fair conclusions in the interesting sciences of physiognomy and phrenology; of manners and customs, rites, ceremonies, and the like; and the opportunity of examining the geology and mineralogy of this western, and yet unexplored country, will enable me occasionally to entertain you with much new and interesting information, which I shall take equal pleasure in communicating by an occasional Letter in my clumsy way.[1]

WILLIAM CULLEN BRYANT: TO COLE, THE PAINTER, DEPARTING FOR EUROPE

The close relationship between Thomas Cole (1801-1848) and William Cullen Bryant (1794-1878) has been celebrated in Asher B. Durand's Kindred Spirits *which portrays poet and painter in contemplation of*

[1] George Catlin, *Illustration of the Manners, Customs, and Conditions of the North American Indians* (New York, 1841), pp. 14-16.

nature's wonders. The verses below are Bryant's warning to the painter that the unspoiled American wilderness reveals most clearly the unfolding of Divine purpose and alone allows landscape painting to become the "acts of religion"—acts which Bryant describes in his Funeral Oration *on Cole's death in 1848, of which excerpts also follow.*

> Thine eyes shall see the light of distant skies:
> Yet, Cole! thy heart shall bear to Europe's strand
> A living image of our own bright land,
> Such as upon thy glorious canvas lies.
> Lone lakes—savannahs where the bison roves—
> Rocks rich with summer garlands—solemn streams—
> Skies where the desert eagle wheels and screams—
> Spring bloom and autumn blaze of boundless groves.
>
> Fair scenes shall greet thee where thou goest—fair
> But different—everywhere the trace of men.
> Paths, homes, graves, ruins, from the lowest glen
> To where life shrinks from the fierce Alpine air.
> Gaze on them, till the tears shall dim thy sight,
> But keep that earlier, wilder image bright.[1]

WILLIAM CULLEN BRYANT: FUNERAL ORATION ON THE DEATH OF THOMAS COLE, 1848

For Cole was not only a great artist but a great teacher; the contemplation of his works made men better. It is said of one of the old Italian painters that he never began a painting without first offering a prayer. The paintings of Cole are of that nature that it hardly transcends the proper use of language to call them acts of religion. Yet do they never strike us as strained or forced in character; they teach but what rose spontaneously in the mind of the artist; they were the sincere communications of his own moral and intellectual being. One of the most eminent among the modern German painters, Overbeck, is remarkable for the happiness with which he has caught the devotional manner of the old ecclesiastical painters, blending it with his own more exquisite knowledge of art, and shedding it over forms of fairer symmetry. Yet has he not escaped a certain mannerism; the air of submissive awe, the manifest consciousness of a superior presence, which he so invariably bestows on all his personages, becomes at last a matter of repetition and circumscribes his walk to a narrow circle. With Cole it was otherwise; his mode of treating his subjects was not bounded by the narrow limits of any system; the moral interest he gave them took no

[1] William Cullen Bryant, "To Cole, the Painter, Departing for Europe," 1829.

set form or predetermined pattern; its manifestations wore the diversity of that creation from which they were drawn.

* * *

Reverencing his profession as the instrument of good to mankind, Cole pursued it with an assiduity which knew no remission. I have heard him say that he never willingly allowed a day to pass without some touch of the pencil. He delighted in hearing old ballads sung or books read while he was occupied in painting, seeming to derive, from the ballad or the book, a healthful excitement in the task which employed his hand. So accustomed had he grown to this double occupation that he would sometimes desire his female friends to read to him while he was writing letters. In the contemplation of nature, however, for the purposes of his art, I remember to have heard him say that the presence of those who were not his familiar friends, disturbed him. To that task he surrendered all his faculties, and no man, I suppose, ever took into his mind a more vivid image of what he beheld. His sketches were sometimes but the slightest notes of his subject, often unintelligible to others, but to him luminous remembrancers from which he would afterwards reconstruct the landscape with surprising fidelity. He carried to his painting room the impressions received by the eye and there gave them to the canvas; he even complained of the distinctness with which they haunted him. "Have you not found," said he, writing to a distinguished friend—"I have—that you never succeed in painting scenes, however beautiful, immediately on returning from them? I must wait for time to draw a veil over the common details, the unessential parts, which shall leave the great features, whether the beautiful or the sublime, dominant in the mind."

He could not endure a town life; he must live in the continual presence of rural scenes and objects. A country life he believed essential to the cheerfulness of the artist and to a healthful judgment of his own works; in the throng of men he thought that the artist was apt to lean too much on the judgment of others, and to find their immediate approbation necessary to his labors. In the retirement of the country he held that the simple desire of excellence was likely to act with more strength and less disturbance, and that its products would be worthier and nobler. He could not bear that his art should be degraded by inferior motives. "I do not mean," said he, not long before his death, "to paint any more pictures with a direct view to profit." [1]

[1] William Cullen Bryant, *Funeral Oration on the Death of Thomas Cole before the National Academy of Design, May 4, 1848* (published as a pamphlet).

THOMAS COLE: ESSAY ON AMERICAN SCENERY, 1835

Bryant's verbal art, expressed in poems such as "Thanatopsis" (1816), spells out more specifically a religious orientation toward nature than do Cole's paintings. In the tangle of new growth and decay in the American wilderness, which represented for Bryant the process of inchoation or the cycle of human life, Cole in this lecture of 1835 finds only an element of the picturesque. For parallels to the extensive metaphors of Bryant's poetry one would have to look at the complex programs of Cole's Course of Empire *or* Voyage of Life. *But Cole's assertion that "the wilderness is yet a fitting place to speak of God" and Bryant's description of his character reveals that even in his least pretentious landscapes Cole was indeed a kindred spirit. The thoughts in this and other writing on the American landscape run parallel to those expressed in Emerson's* Thoughts on Art *of 1841.*

The Essay, which is here offered, is a mere sketch of an almost illimitable subject—American Scenery; and in selecting the theme the writer placed more confidence in its overflowing richness, than in his own capacity for treating it in a manner worthy of its vastness and importance.

It is a subject that to every American ought to be of surpassing interest; for, whether he beholds the Hudson mingling waters with the Atlantic—explores the central wilds of this vast continent, or stands on the margin of the distant Oregon, he is still in the midst of American scenery—it is his own land; its beauty, its magnificence, its sublimity —all are his; and how undeserving of such a birthright, if he can turn towards it an unobserving eye, an unaffected heart!

Before entering into the proposed subject, in which I shall treat more particularly of the scenery of the Northern and Eastern States, I shall be excused for saying a few words on the advantages of cultivating a taste for scenery, and for exclaiming against the apathy with which the beauties of external nature are regarded by the great mass, even of our refined community.

It is generally admitted that the liberal arts tend to soften our manners; but they do more—they carry with them the power to mend our hearts.

Poetry and Painting sublime and purify thought, by grasping the past, the present, and the future—they give the mind a foretaste of its immortality, and thus prepare it for performing an exalted part amid

the realities of life. And *rural nature* is full of the same quickening spirit—it is, in fact, the exhaustless mine from which the poet and the painter have brought such wondrous treasures—an unfailing fountain of intellectual enjoyment, where all may drink, and be awakened to a deeper feeling of the works of genius, and a keener perception of the beauty of our existence. For those whose days are all consumed in the low pursuits of avarice, or the gaudy frivolities of fashion, unobservant of nature's loveliness, are unconscious of the harmony of creation—

> Heaven's roof to them
> Is but a painted ceiling hung with lamps;
> No more—that lights them to their purposes—
> They wander 'loose about;' they nothing see,
> Themselves except, and creatures like themselves,
> Short lived, short sighted.

What to them is the page of the poet where he describes or personifies the skies, the mountains, or the streams, if those objects themselves have never awakened observation or excited pleasure? What to them is the wild Salvator Rosa, or the aerial Claude Lorrain?

There is in the human mind an almost inseparable connection between the beautiful and the good, so that if we contemplate the one the other seems present; and an excellent author has said, "it is difficult to look at any objects with pleasure—unless where it arises from brutal and tumultuous emotions—without feeling that disposition of mind which tends towards kindness and benevolence; and surely, whatever creates such a disposition, by increasing our pleasures and enjoyments, cannot be too much cultivated."

It would seem unnecessary to those who can see and feel, for me to expatiate on the loveliness of verdant fields, the sublimity of lofty mountains, or the varied magnificence of the sky; but that the number of those who *seek* enjoyment in such sources is comparatively small. From the indifference with which the multitude regard the beauties of nature, it might be inferred that she had been unnecessarily lavish in adorning this world for beings who take no pleasure in its adornment. Who in grovelling pursuits forget their glorious heritage. Why was the earth made so beautiful, or the sun so clad in glory at his rising and setting, when *all* might be unrobed of beauty without affecting the insensate multitude, so they can be "lighted to their purposes?"

It *has not* been in vain—the good, the enlightened of all ages and nations, have found pleasure and consolation in the beauty of the rural earth. Prophets of old retired into the solitudes of nature to wait the inspiration of heaven. It was on Mount Horeb that Elijah witnessed the mighty wind, the earthquake, and the fire; and heard the "still

small voice"—that voice is YET heard among the mountains! St. John preached in the desert;—the wilderness is YET a fitting place to speak of God. The solitary Anchorites of Syria and Egypt, though ignorant that the busy world is man's noblest sphere of usefulness, well knew how congenial to religious musings are the pathless solitudes.

He who looks on nature with a "loving eye," cannot move from his dwelling without the salutation of beauty; even in the city the deep blue sky and the drifting clouds appeal to him. And if to escape its turmoil—if only to obtain a free horizon, land and water in the play of light and shadow yields delight—let him be transported to those favored regions, where the features of the earth are more varied, or yet add the sunset, that wreath of glory daily bound around the world, and he, indeed, drinks from pleasure's purest cup. The delight such a man experiences is not merely sensual, or selfish, that passes with the occasion leaving no trace behind; but in gazing on the pure creations of the Almighty, he feels a calm religious tone steal through his mind, and when he has turned to mingle with his fellow men, the chords which have been struck in that sweet communion cease not to vibrate.

In what has been said I have alluded to wild and uncultivated scenery; but the cultivated must not be forgotten, for it is still more important to man in his social capacity—necessarily bringing him in contact with the cultured; it encompasses our homes, and, though devoid of the stern sublimity of the wild, its quieter spirit steals tenderly into our bosoms mingled with a thousand domestic affections and heart-touching associations—human hands have wrought, and human deeds hallowed all around.

And it is here that taste, which is the perception of the beautiful, and the knowledge of the principles on which nature works, can be applied, and our dwelling-places made fitting for refined and intellectual beings.

If, then, it is indeed true that the contemplation of scenery can be so abundant a source of delight and improvement, a taste for it is certainly worthy of particular cultivation; for the capacity for enjoyment increases with the knowledge of the true means of obtaining it.

In this age, when a meager utilitarianism seems ready to absorb every feeling and sentiment, and what is sometimes called improvement in its march makes us fear that the bright and tender flowers of the imagination shall all be crushed beneath its iron tramp, it would be well to cultivate the oasis that yet remains to us, and thus preserve the germs of a future and a purer system. And now, when the sway of fashion is extending widely over society—poisoning the healthful streams of true refinement, and turning men from the love of simplicity and beauty, to a senseless idolatry of their own follies—to lead

them gently into the pleasant paths of Taste would be an object worthy of the highest efforts of genius and benevolence. The spirit of our society is to contrive but not to enjoy—toiling to produce more toil—accumulating in order to aggrandize. The pleasures of the imagination, among which the love of scenery holds a conspicuous place, will alone temper the harshness of such a state; and, like the atmosphere that softens the most rugged forms of the landscape, cast a veil of tender beauty over the asperities of life.

Did our limits permit I would endeavor more fully to show how necessary to the complete appreciation of the Fine Arts is the study of scenery, and how conducive to our happiness and well-being is that study and those arts; but I must now proceed to the proposed subject of this essay—American Scenery!

There are those who through ignorance or prejudice strive to maintain that American scenery possesses little that is interesting or truly beautiful—that it is rude without picturesqueness, and monotonous without sublimity—that being destitute of those vestiges of antiquity, whose associations so strongly affect the mind, it may not be compared with European scenery. But from whom do these opinions come? From those who have read of European scenery, of Grecian mountains, and Italian skies, and never troubled themselves to look at their own; and from those travelled ones whose eyes were never opened to the beauties of nature until they beheld foreign lands, and when those lands faded from the sight were again closed and forever; disdaining to destroy their trans-atlantic impressions by the observation of the less fashionable and unfamed American scenery. Let such persons shut themselves up in their narrow shell of prejudice—I hope they are few,—and the community increasing in intelligence, will know better how to appreciate the treasures of their own country.

I am by no means desirous of lessening in your estimation the glorious scenes of the old world—that ground which has been the great theater of human events—those mountains, woods, and streams, made sacred in our minds by heroic deeds and immortal song—over which time and genius have suspended an imperishable halo. No! But I would have it remembered that nature has shed over *this* land beauty and magnificence, and although the character of its scenery may differ from the old world's, yet inferiority must not therefore be inferred; for though American scenery is destitute of many of those circumstances that give value to the European, still it has features, and glorious ones, unknown to Europe.

A very few generations have passed away since this vast tract of the American continent, now the United States, rested in the shadow of primæval forests, whose gloom was peopled by savage beasts, and

scarcely less savage men; or lay in those wide grassy plains called prairies—

The Gardens of the Desert, these
The unshorn fields, boundless and beautiful.

And, although an enlightened and increasing people have broken in upon the solitude, and with activity and power wrought changes that seem magical, yet the most distinctive, and perhaps the most impressive, characteristic of American scenery is its wildness.

It is the most distinctive, because in civilized Europe the primitive features of scenery have long since been destroyed or modified—the extensive forests that once overshadowed a great part of it have been felled—rugged mountains have been smoothed, and impetuous rivers turned from their courses to accommodate the tastes and necessities of a dense population—the once tangled wood is now a grassy lawn; the turbulent brook a navigable stream—crags that could not be removed have been crowned with towers, and the rudest valleys tamed by the plough.

And to this cultivated state our western world is fast approaching; but nature is still predominant, and there are those who regret that with the improvements of cultivation the sublimity of the wilderness should pass away: for those scenes of solitude from which the hand of nature has never been lifted, affect the mind with a more deep toned emotion than aught which the hand of man has touched. Amid them the consequent associations are of God the creator—they are his undefiled works, and the mind is cast into the contemplation of eternal things.

As mountains are the most conspicuous objects in landscape, they will take the precedence in what I may say on the elements of American scenery.

It is true that in the eastern part of this continent there are no mountains that vie in altitude with the snow-crowned Alps—that the Alleghanies and the Catskills are in no point higher than five thousand feet; but this is no inconsiderable height; Snowdon in Wales, and Ben-Nevis in Scotland, are not more lofty; and in New Hampshire, which has been called the Switzerland of the United States, the White Mountains almost pierce the region of perpetual snow. The Alleghanies are in general heavy in form; but the Catskills, although not broken into abrupt angles like the most picturesque mountains of Italy, have varied, undulating, and exceedingly beautiful outlines—they heave from the valley of the Hudson like the subsiding billows of the ocean after a storm.

American mountains are generally clothed to the summit by dense

forests, while those of Europe are mostly bare, or merely tinted by grass or heath. It may be that the mountains of Europe are on this account more picturesque in form, and there is a grandeur in their nakedness; but in the gorgeous garb of the American mountains there is more than an equivalent; and when the woods "have put their glory on," as an American poet has beautifully said, the purple heath and yellow furze of Europe's mountains are in comparison but as the faint secondary rainbow to the primal one.

But in the mountains of New Hampshire there is a union of the picturesque, the sublime, and the magnificent; there the bare peaks of granite, broken and desolate, cradle the clouds; while the vallies and broad bases of the mountains rest under the shadow of noble and varied forests; and the traveller who passes the Sandwich range on his way to the White Mountains, of which it is a spur, cannot but acknowledge, that although in some regions of the globe nature has wrought on a more stupendous scale, yet she has nowhere so completely married together grandeur and loveliness—there he sees the sublime melting into the beautiful, the savage tempered by the magnificent.

I will now speak of another component of scenery, without which every landscape is defective—it is water. Like the eye in the human countenance, it is a most expressive feature: in the unrippled lake, which mirrors all surrounding objects, we have the expression of tranquillity and peace—in the rapid stream, the headlong cataract, that of turbulence and impetuosity.

In this great element of scenery, what land is so rich? I would not speak of the Great Lakes, which are in fact inland seas—possessing some of the attributes of the ocean, though destitute of its sublimity; but of those smaller lakes, such as Lake George, Champlain, Winnipisiogee, Otsego, Seneca, and a hundred others, that stud like gems the bosom of this country. There is one delightful quality in nearly all these lakes—the purity and transparency of the water. In speaking of scenery it might seem unnecessary to mention this; but independent of the pleasure that we all have in beholding pure water, it is a circumstance which contributes greatly to the beauty of landscape; for the reflections of surrounding objects, trees, mountains, sky, are most perfect in the clearest water; and the most perfect is the most beautiful.

I would rather persuade you to visit the "Holy Lake," the beautiful "Horican," than attempt to describe its scenery—to behold you rambling on its storied shores, where its southern expanse is spread, begemmed with isles of emerald, and curtained by green receding hills —or to see you gliding over its bosom, where the steep and rugged mountains approach from either side, shadowing with black precipices the innumerable islets—some of which bearing a solitary tree, others

a group of two or three, or a "goodly company," seem to have been sprinkled over the smiling deep in Nature's frolic hour. These scenes are classic—History and Genius have hallowed them. War's shrill clarion once waked the echoes from these now silent hills—the pen of a living master has portrayed them in the pages of romance—and they are worthy of the admiration of the enlightened and the graphic hand of Genius.

Though differing from Lake George, Winnipisiogee resembles it in multitudinous and uncounted islands. Its mountains do not stoop to the water's edge, but through varied screens of forest may be seen ascending the sky softened by the blue haze of distance—on the one hand rise the Gunstock Mountains; on the other the dark Ossipees, while above and far beyond, rear the "cloud capt" peaks of the Sandwich and White Mountains.

I will not fatigue with a vain attempt to describe the lakes that I have named; but would turn your attention to those exquisitely beautiful lakes that are so numerous in the Northern States, and particularly in New Hampshire. In character they are truly and peculiarly American. I know nothing in Europe which they resemble; the famous lakes of Albano and Nemi, and the small and exceedingly picturesque lakes of Great Britain may be compared in size, but are dissimilar in almost every other respect. Embosomed in the primitive forest, and sometimes overshadowed by huge mountains, they are the chosen places of tranquillity; and when the deer issues from the surrounding woods to drink the cool waters, he beholds his own image as in a polished mirror,—the flight of the eagle can be seen in the lower sky; and if a leaf falls, the circling undulations chase each other to the shores unvexed by contending tides.

There are two lakes of this description, situated in a wild mountain gorge called the Franconia Notch, in New Hampshire. They lie within a few hundred feet of each other, but are remarkable as having no communication—one being the source of the wild Amonoosuck, the other of the Pemigiwasset. Shut in by stupendous mountains which rest on crags that tower more than a thousand feet above the water, whose rugged brows and shadowy breaks are clothed by dark and tangled woods, they have such an aspect of deep seclusion, of utter and unbroken solitude, that, when standing on their brink a lonely traveller, I was overwhelmed with an emotion of the sublime, such as I have rarely felt. It was not that the jagged precipices were lofty, that the encircling woods were of the dimmest shade, or that the waters were profoundly deep; but that over all, rocks, wood, and water, brooded the spirit of repose, and the silent energy of nature stirred the soul to its inmost depths.

I would not be understood that these lakes are always tranquil; but

that tranquillity is their great characteristic. There are times when they take a far different expression; but in scenes like these the richest chords are those struck by the gentler hand of nature.

And now I must turn to another of the beautifiers of the earth—the Waterfall; which in the same object at once presents to the mind the beautiful, but apparently incongruous idea, of fixedness and motion—a single existence in which we perceive unceasing change and everlasting duration. The waterfall may be called the voice of the landscape, for, unlike the rocks and woods which utter sounds as the passive instruments played on by the elements, the waterfall strikes its own chords, and rocks and mountains re-echo in rich unison. And this is a land abounding in cataracts; in these Northern States where shall we turn and not find them? Have we not Kaaterskill, Trenton, the Flume, the Genesee, stupendous Niagara, and a hundred others named and nameless ones, whose exceeding beauty must be acknowledged when the hand of taste shall point them out?

In the Kaaterskill we have a stream, diminutive indeed, but throwing itself headlong over a fearful precipice into a deep gorge of the densely wooded mountains—and possessing a singular feature in the vast arched cave that extends beneath and behind the cataract. At Trenton there is a chain of waterfalls of remarkable beauty, where the foaming waters, shadowed by steep cliffs, break over rocks of architectural formation, and tangled and picturesque trees mantle abrupt precipices, which it would be easy to imagine crumbling and "time disparting towers."

And Niagara! that wonder of the world!—where the sublime and beautiful are bound together in an indissoluble chain. In gazing on it we feel as though a great void had been filled in our minds—our conceptions expand—we become a part of what we behold! At our feet the floods of a thousand rivers are poured out—the contents of vast inland seas. In its volume we conceive immensity; in its course, everlasting duration; in its impetuosity, uncontrollable power. These are the elements of its sublimity. Its beauty is garlanded around in the varied hues of the water, in the spray that ascends the sky, and in that unrivalled bow which forms a complete cincture round the unresting floods.

The river scenery of the United States is a rich and boundless theme. The Hudson for natural magnificence is unsurpassed. What can be more beautiful than the lake-like expanses of Tapaan and Haverstraw, as seen from the rich orchards of the surrounding hills? hills that have a legend, which has been so sweetly and admirably told that it shall not perish but with the language of the land. What can be more imposing than the precipitous Highlands; whose dark founda-

tions have been rent to make a passage for the deep-flowing river? And, ascending still, where can be found scenes more enchanting? The lofty Catskills stand afar off—the green hills gently rising from the flood, recede like steps by which we may ascend to a great temple, whose pillars are those everlasting hills, and whose dome is the blue boundless vault of heaven.

The Rhine has its castled crags, its vine-clad hills, and ancient villages; the Hudson has its wooded mountains, its rugged precipices, its green undulating shores—a natural majesty, and an unbounded capacity for improvement by art. Its shores are not besprinkled with venerated ruins, or the palaces of princes; but there are flourishing towns, and neat villas, and the hand of taste has already been at work. Without any great stretch of the imagination we may anticipate the time when the ample waters shall reflect temple, and tower, and dome, in every variety of picturesqueness and magnificence.

In the Connecticut we behold a river that differs widely from the Hudson. Its sources are amid the wild mountains of New Hampshire; but it soon breaks into a luxuriant valley, and flows for more than a hundred miles, sometimes beneath the shadow of wooded hills, and sometimes glancing through the green expanse of elm-besprinkled meadows. Whether we see it at Haverhill, Northampton, or Hartford, it still possesses that gentle aspect; and the imagination can scarcely conceive Arcadian vales more lovely or more peaceful than the valley of the Connecticut—its villages are rural places where trees overspread every dwelling, and the fields upon its margin have the richest verdure.

Nor ought the Ohio, the Susquehannah, the Potomac, with their tributaries, and a thousand others, be omitted in the rich list of the American rivers—they are a glorious brotherhood; but volumes would be insufficient for their description.

In the Forest scenery of the United States we have that which occupies the greatest space, and is not the least remarkable; being primitive, it differs widely from the European. In the American forest we find trees in every stage of vegetable life and decay—the slender sapling rises in the shadow of the lofty tree, and the giant in his prime stands by the hoary patriarch of the wood—on the ground lie prostrate decaying ranks that once waved their verdant heads in the sun and wind. These are circumstances productive of great variety and picturesqueness—green umbrageous masses—lofty and scathed trunks— contorted branches thrust athwart the sky—the mouldering dead below, shrouded in moss of every hue and texture, from richer combinations than can be found in the trimmed and planted grove. It is true that the thinned and cultivated wood offers less obstruction to the feet, and the trees throw out their branches more horizontally, and are conse-

quently more umbrageous when taken singly; but the true lover of the picturesque is seldom fatigued—and trees that grow widely apart are often heavy in form, and resemble each other too much for picturesqueness. Trees are like men, differing widely in character; in sheltered spots, or under the influence of culture, they show few contrasting points; peculiarities are pruned and trained away, until there is a general resemblance. But in exposed situations, wild and uncultivated, battling with the elements and with one another for the possession of a morsel of soil, or a favoring rock to which they may cling—they exhibit striking peculiarities, and sometimes grand originality.

For variety, the American forest is unrivalled: in some districts are found oaks, elms, birches, beeches, planes, pines, hemlocks, and many other kinds of trees, commingled—clothing the hills with every tint of green, and every variety of light and shade.

There is a peculiarity observable in some mountainous regions, where trees of a genus band together—there often may be seen a mountain whose foot is clothed with deciduous trees, while on its brow is a sable crown of pines; and sometimes belts of dark green encircle a mountain horizontally, or are stretched in well-defined lines from the summit to the base. The nature of the soil, or the courses of rivulets, are the causes of this variety;—and it is a beautiful instance of the exhaustlessness of nature; often where we should expect unvarying monotony, we behold a charming diversity. Time will not permit me to speak of the American forest trees individually; but I must notice the elm, that paragon of beauty and shade; the maple, with its rainbow hues; and the hemlock, the sublime of trees, which rises from the gloom of the forest like a dark and ivy-mantled tower.

There is one season when the American forest surpasses all the world in gorgeousness—that is the autumnal;—then every hill and dale is riant in the luxury of color—every hue is there, from the liveliest green to deepest purple—from the most golden yellow to the intensest crimson. The artist looks despairingly upon the glowing landscape, and in the old world his truest imitations of the American forest, at this season, are called falsely bright, and scenes in Fairy Land.

The sky will next demand our attention. The soul of all scenery, in it are the fountains of light, and shade, and color. Whatever expression the sky takes, the features of the landscape are affected in unison, whether it be the serenity of the summer's blue, or the dark tumult of the storm. It is the sky that makes the earth so lovely at sunrise, and so splendid at sunset. In the one it breathes over the earth the crystal-like ether, in the other the liquid gold. The climate of a great part of the United States is subject to great vicissitudes, and we complain; but nature offers a compensation. These very vicissitudes are

the abundant sources of beauty—as we have the temperature of every clime, so have we the skies—we have the blue unsearchable depths of the northern sky—we have the upheaped thunder-clouds of the Torrid Zone, fraught with gorgeousness and sublimity—we have the silver haze of England, and the golden atmosphere of Italy. And if he who has travelled and observed the skies of other climes will spend a few months on the banks of the Hudson, he must be constrained to acknowledge that for variety and magnificence American skies are unsurpassed. Italian skies have been lauded by every tongue, and sung by every poet, and who will deny their wonderful beauty? At sunset the serene arch is filled with alchemy that transmutes mountains, and streams, and temples, into living gold.

But the American summer never passes without many sunsets that might vie with the Italian, and many still more gorgeous—that seem peculiar to this clime.

Look at the heavens when the thunder shower has passed, and the sun stoops behind the western mountains—there the low purple clouds hang in festoons around the steeps—in the higher heaven are crimson bands interwoven with feathers of gold, fit for the wings of angels— and still above is spread that interminable field of ether, whose color is too beautiful to have a name.

It is not in the summer only that American skies are beautiful; for the winter evening often comes robed in purple and gold, and in the westering sun the iced groves glitter as beneath a shower of diamonds —and through the twilight heaven innumerable stars shine with a purer light than summer ever knows.

I will now venture a few remarks on what has been considered a grand defect in American scenery—the want of associations, such as arise amid the scenes of the old world.

We have many a spot as umbrageous as Vallombrosa, and as picturesque as the solitudes of Vaucluse; but Milton and Petrarch have not hallowed them by their footsteps and immortal verse. He who stands on Mont Albano and looks down on ancient Rome, has his mind peopled with the gigantic associations of the storied past; but he who stands on the mounds of the West, the most venerable remains of American antiquity, *may* experience the emotion of the sublime, but it is the sublimity of a shoreless ocean un-islanded by the recorded deeds of man.

Yet American scenes are not destitute of historical and legendary associations—the great struggle for freedom has sanctified many a spot, and many a mountain, stream, and rock has its legend, worthy of poet's pen or the painter's pencil. But American associations are not so much of the past as of the present and the future. Seated on a pleasant knoll,

look down into the bosom of that secluded valley, begirt with wooded hills—through those enamelled meadows and wide waving fields of grain, a silver stream winds lingeringly along—here, seeking the green shade of trees—there, glancing in the sunshine: on its banks are rural dwellings shaded by elms and garlanded by flowers—from yonder dark mass of foliage the village spire beams like a star. You see no ruined tower to tell of outrage—no gorgeous temple to speak of ostentation; but freedom's offspring—peace, security, and happiness, dwell there, the spirits of the scene. On the margin of that gentle river the village girls may ramble unmolested—and the glad school-boy, with hook and line, pass his bright holiday—those neat dwellings, unpretending to magnificence, are the abodes of plenty, virtue, and refinement. And in looking over the yet uncultivated scene, the mind's eye may see far into futurity. Where the wolf roams, the plough shall glisten; on the gray crag shall rise temple and tower—mighty deeds shall be done in the now pathless wilderness; and poets yet unborn shall sanctify the soil.

It was my intention to attempt a description of several districts remarkable for their picturesqueness and truly American character; but I fear to trespass longer on your time and patience. Yet I cannot but express my sorrow that the beauty of such landscapes are quickly passing away—the ravages of the axe are daily increasing—the most noble scenes are made desolate, and oftentimes with a wantonness and barbarism scarcely credible in a civilized nation. The way-side is becoming shadeless, and another generation will behold spots, now rife with beauty, desecrated by what is called improvement; which, as yet, generally destroys Nature's beauty without substituting that of Art. This is a regret rather than a complaint; such is the road society has to travel; it may lead to refinement in the end, but the traveller who sees the place of rest close at hand, dislikes the road that has so many unnecessary windings.

I will now conclude, in the hope that, though feebly urged, the importance of cultivating a taste for scenery will not be forgotten. Nature has spread for us a rich and delightful banquet. Shall we turn from it? We are still in Eden; the wall that shuts us out of the garden is our own ignorance and folly. We should not allow the poet's words to be applicable to us—

> Deep in rich pasture do thy flocks complain?
> Not so; but to their master is denied
> To share the sweet serene.

May we at times turn from the ordinary pursuits of life to the pure enjoyment of rural nature; which is in the soul like a fountain of cool waters to the way-worn traveller; and let us

 Learn
 The laws by which the Eternal doth sublime
 And sanctify his works, that we may see
 The hidden glory veiled from vulgar eyes.[1]

ASHER B. DURAND: LETTERS ON LANDSCAPE
PAINTING, 1855

*These epistolary articles by the landscape painter Asher B. Durand
(1796-1886) appeared in the* Crayon, *an influential vehicle published
in America for American and English writing on art. Durand's moralism
is not unlike that of Emerson, Bryant, or Cole, but he stresses here the
technical proficiency required to record the particularities of nature.
Although such an attitude was not limited to Americans, it was encour-
aged by the fact that in America nature remained so convincingly
unspoiled that painters could find abundant opportunity for that fusion
of realism and religious idealism which Durand describes.*

Letter II

DEAR SIR:

IN recommending you, in the beginning of your studies, directly
to Nature, I would not deceive you with the expectation, that you will
thus most speedily acquire the art of picture-making—that is much
sooner acquired in the studio or the picture gallery.

I refer you to Nature early, that you may receive your first im-
pressions of beauty and sublimity, unmingled with the superstitions of
Art—for Art has its superstitions as well as religion—*that* you may learn
to paint with intelligence and sincerity—that your works shall address
themselves to intelligent and sympathetic minds, and spare you the
mortification of ever seeing them allotted to swell the lumber of the
garret and the auction room.

Form is the first subject to engage your attention. Take pencil and
paper, not the palette and brushes, and draw with scrupulous fidelity
the outline or contour of such objects as you shall select, and, so far
as your judgment goes, choose the most beautiful or characteristic of
its kind. If your subject be a tree, observe particularly wherein it differs
from those of other species: in the first place, the termination of its
foliage, best seen when relieved on the sky, whether pointed or rounded,
drooping or springing upward, and so forth; next mark the character
of its trunk and branches, the manner in which the latter shoot off from

[1] Thomas Cole, "Essay on American Scenery," *The American Monthly
Magazine,* New Series, I (January, 1836), 1-12.

the parent stem, their direction, curves, and angles. Every kind of tree has its traits of individuality—some kinds assimilate, others differ widely —with careful attention, these peculiarities are easily learned, and so, in a greater or less degree, with all other objects. By this course you will also obtain the knowledge of that natural variety of form, so essential to protect you against frequent repetition and monotony. A moment's reflection will convince you of the vital importance of drawing, and the continual demand for its exercise in the practice of outline, before you begin to paint.

I know you will regard this at first thought as an unnecessary restriction, and become impatient to use the brush, under the persuasion that you can with it make out your forms, and at the same time produce color, and light, and shade. In this you deceive yourself—as many others have done, till the consequent evil has become irremediable, for slovenly and imperfect drawing finds but a miserable compensation in the palpable efforts to disguise or atone for it, by the blandishments of color and effect.

Practice drawing with the pencil till you are sure of your hand, and not only that,—till you shall have learned by heart the characteristic forms of all objects, animals, and the human figure included, so far as you may require their use in pictures; no matter how long it takes, it will be time gained. You will say that I impose on you a difficult and painful task: difficult it is, but not painful nor ungrateful, and let me assure you that its faithful performance is accompanied by many enjoyments that experience only can enable you to appreciate. Every step of conscious progress that you make, every successful transcript of the chosen subject, will send a thrill of pleasure to your heart, that you will acknowledge to give you the full measure of compensation.

As a motive to meet with courage and perseverance every difficulty in the progress of your studies, and patiently to endure the frequent discouragements attending your failures and imperfect efforts, so long as your love for Nature is strong and earnest, keeping steadily in view the high mission of the Art you have chosen, I can promise you that the time will come when you will recall the period of these faithful struggles with a more vivid enjoyment than that which accompanies the old man's recollections of happy childhood. The humblest scenes of your successful labors will become hallowed ground to which, in memory at least, you will make many a joyous pilgrimage, and, like Rousseau, in the fullness of your emotions, kiss the very earth that bore the print of your oft-repeated footsteps.

There is yet another motive for referring you to the study of Nature early—its influence on the mind and heart. The external appearance of this our dwelling-place, apart from its wondrous structure and

functions that minister to our well-being, is fraught with lessons of
high and holy meaning, only surpassed by the light of Revelation.
It is impossible to contemplate with right-minded, reverent feeling, its
inexpressible beauty and grandeur, forever assuming new forms of im-
pressiveness under the varying phases of cloud and sunshine, time and
season, without arriving at the conviction

> That all which we behold
> Is full of blessings

that the Great Designer of these glorious pictures has placed them before
us as types of the Divine attributes, and we insensibly, as it were, in
our daily contemplations,

> To the beautiful order of his works
> Learn to conform the order of our lives.

Thus regarding the objects of your study, the intellect and feel-
ings become elevated and purified, and in proportion as you acquire
executive skill, your productions will, unawares, be imbued with that
undefinable quality recognized as sentiment or expression which dis-
tinguishes the true landscape from the mere sensual and *striking* picture.

Thus far I have deemed it well to abstain from much practical
detail in the pursuit of our subject, preferring first to impress you with
a sense of the elevated character of the Art, which a just estimate of its
capacity and purposes discloses, and this course may still be extended
in reference to the wide field for its exercise, which lies open before
you. If it be true—and it appears to be demonstrated, so far as English
scenery is concerned—that Constable was correct when he affirmed
that there was yet room for a natural landscape painter, it is more
especially true in reference to our own scenery; for although much has
been done, and well done, by the gifted Cole and others, much more
remains to do. Go not abroad then in search of material for the exercise
of your pencil, while the virgin charms of our native land have claims
on your deepest affections. Many are the flowers in our untrodden wilds
that have blushed too long unseen, and their original freshness will
reward your research with a higher and purer satisfaction, than apper-
tains to the display of the most brilliant exotic. The "lone and tranquil"
lakes embosomed in ancient forests, that abound in our wild districts,
the unshorn mountains surrounding them with their richly-textured
covering, the ocean prairies of the West, and many other forms of Na-
ture yet spared from the pollutions of civilization, afford a guarantee
for a reputation of originality that you may elsewhere long seek and
find not.

I desire not to limit the universality of the Art, or require that

the artist shall sacrifice aught to patriotism; but, untrammelled as he is, and free from academic or other restraints by virtue of his position, why should not the American landscape painter, in accordance with the principle of self-government, boldly originate a high and independent style, based on his native resources? ever cherishing an abiding faith that the time is not far remote when his beloved Art will stand out amid the scenery of his "own green forest land," wearing as fair a coronal as ever graced a brow "in that Old World beyond the deep."

Truly yours,

A. B. DURAND

Letter IV

"You had better learn to make shoes," said the venerable Colonel Trumbull, one day, to a stripling who was consulting him in reference to his choice of painting as a profession, "better learn to make shoes or dig potatoes than to become a painter in this country." I felt that this was a harsh repulse to the young man, and most unexpected from such an authority. I was not then a painter, but secretly hoping to become one. I felt a strong sympathy for the vicitm, and thought he was unkindly treated, but I can now imagine that there might have appeared to the mind of the veteran artist sufficient ground for such advice, and that it may have been an act of kindness rather than severity. It is better to make shoes, or dig potatoes, or follow any other honest calling to secure a livelihood, than seek the pursuit of Art for the sake of gain. For whoever presumes to embrace her with the predominant motive of pecuniary reward, or any mere worldly distinction, will assuredly find but a bundle of reeds in his arms. The great law that provides for the sustenance of the soul through the ministry of spiritual things, has fixed an immovable barrier between its own pursuits and those which supply our physical wants. For this reason, we cannot serve God and mammon, however specious our garb of hypocrisy; and I would sooner look for figs on thistles than for the higher attributes of Art from one whose ruling motive in its pursuit is money. This is one of the principal causes operating to the degradation of Art, perverting it to the servility of a mere trade; and next to this, is its prostitution by means of excess in color, strong effects and skillful manipulation, solely for the sensuous gratification of the eye. Through such motives the Art becomes debased, and a picture so painted, be its subject landscape or figure, may well be considered but an empty decoration. But, fortunately for Art, such is not its true purpose, and it is only through the religious integrity of motive by which all real Artists have ever been actuated, that it still preserves its original purity,

impressing the mind through the visible forms of material beauty, with a deep sense of the invisible and immaterial, for which end all this world's beauty and significance, beyond the few requirements of our animal nature, seems to be expressly given. And such is the verdict which the best judgment of the world, in all ages, has rendered, by awarding the highest rank to the artist who has kept in due subordination the more sensuous qualities with which material beauty is invested, thereby constituting his representation the clear exponent of that *intention* by which every earnest spirit enjoys the assurance of our spiritual nature, and scorns the subtlety and logic of positive philosophy.

Every experienced artist knows that it is difficult to see nature truly: that for this end long practice is necessary. We see, yet perceive not, and it becomes necessary to cultivate our perception so as to comprehend the essence of the object seen. The poet sees in nature more than mere matter of fact, yet he does not see more than is there, nor what another may not see when *he* points it out. His is only a more perfect exercise of perception just as the drapery of a fine statue is seen by the common eye, and pronounced beautiful, and the enlightened observer also pronounces it beautiful; but the one ascribes it to the graceful folding, the other to its expression of the figure beneath, but neither sees more nor less in quantity than the other, but with unequal degrees of completeness, in perception. Now, the highest beauty of this drapery consists in the perfection of its disposition, so as to best indicate the beautiful form it clothes, not possessing of itself too much attractiveness, nor lose its value by too strongly defining the figure. And so should we look on external Nature.

Why have the creations of Raphael conferred on him the title of *divine?* Because he saw through the sensuous veil, and embodied the spiritual beauty with which nature is animate, and in whose presence the baser "passions shrink and tremble, and are still." It is a mistake to suppose that Raphael and other earnest minds have added anything of their own to the perfection of their common model. They have only depicted it as they saw it, in its fullness and purity, looking on it with childlike affection and religious reverence, ever watchful that no careless or presumptuous touch should mar its fair proportions. And it is the same with regard to inanimate or animate creation. Childlike affection and religious reverence for the beauty that nature presents before us, form a basis of reliance which the conflicts of opinion can never disturb. Learn first to perceive with truthfulness, and then aim to embody your perceptions; take no thought on the question of genius or of future fame; with these you have nothing to do. Seek not to rival or surpass a brother artist, and above all, let not the love of money overleap the love of Art.

To appreciate Art, cultivation is necessary, but its power may be felt without that, and the feeling will educate itself into the desired appreciation, and derive from it a corresponding degree of pleasure, according to the purity or depravity, the high or low character, of the Art that awakens it. And, as the true and the beautiful are inseparably connected and the highest beauty with the highest truth, it follows that the most truthful picture must be the most beautiful, according to the nature of its subject. Where is the portrait-painter, having a just sense of his responsibilities, who has not often thrown down his brush in despair, after many fruitless attempts to express the soul that beams at times through the eye of beauty, and so with the yet more mysterious power of lofty intellect? And there is to be seen a corresponding soul and depth of expression in the beauty of landscape nature, which dignifies the Art that embodies it, and improves and elevates the mind that loves to contemplate its pictorial image.

But, suppose we look on a fine landscape simply as a thing of beauty—a source of innocent enjoyment in our leisure moments—a sensuous gratification with the least expenditure of thought or effort of the intellect, how much better is it than many a more expensive toy for which human skill and industry are tasked, and wealth continually lavished! How many of our men of fortune, whom nature and circumstance have well fitted for such enjoyment, surrender, as it were, their birthright, for a mess of pottage, by resorting to costly and needless luxuries, which consume, without satisfying—while Art invites to her feast of beauty, where indulgence never cloys, and entails no penalty of self-reproach! [1]

WORTHINGTON WHITTREDGE: AUTOBIOGRAPHY

Among the many American painters attracted in the mid-nineteenth century to the German city of Düsseldorf was the landscapist Worthington Whittredge (1820-1910). There he learned the precise, literal technique for which the painters of that city were famous, a technique suitable to the patient realism of our own landscape school. These passages from Whittredge's biography, though written half a century after the events described, offer a glimpse of the life led by Americans abroad, of the repatriated German Emanuel Leutze (1816-1868) at work on his Washington Crossing the Delaware, *and of Whittredge's*

[1] Asher B. Durand, "Letters on Landscape Painting," *The Crayon,* I (1855), 34-35, 97-98.

teacher Andreas Achenbach (1815-1910). Here too are some recollections on the rise and decline of the Hudson River School by a man who was closely involved with it and a significant description of the wildness of the American forest seen afresh by one of its painters after a long absence.

Leutze was in his prime when I came to Düsseldorf. I suppose there is no artist now living who is as familiar as I am with the assembling of his great picture of "Washington Crossing the Delaware." I had not been in Düsseldorf an hour before he showed me a pencil sketch of this subject, about six by ten inches in size. This little sketch was substantially the same in its arrangement as the completed picture. A large canvas for it had been ordered that day. When it came he set to work immediately drawing in the boat and figures with charcoal, and without a model. All the figures were carefully corrected from models when he came to paint them. But he found great difficulty in finding American types for the heads and figures, all the German models being either too small or too closely set in their limbs for his purpose. He caught every American that came along and pressed him into service. Mr. John Groesbeck of Cincinnati, a man over six feet, called to see me at Leutze's studio and was taken for one of the figures almost before he had time to ask me how I was getting along. My own arrival and that of my friend were a godsend to him. This friend, a thin sickly-looking man—in fact all his life a half-invalid—was seized, a bandage put around his head, a poor wounded fellow put in the boat with the rest, while I was seized and made to do service twice, once for the steersman with the oar in my hand and again for Washington himself. I stood two hours without moving, in order that the cloak of the Washington could be painted at a single sitting, thus enabling Leutze to catch the folds of the cloak as they were first arranged. Clad in Washington's full uniform, heavy chapeau and all, spy-glass in one hand and the other on my knee, I was nearly dead when the operation was over. They poured champagne down my throat and I lived through it. This was all because no German model could be found anywhere who could fill Washington's clothes, a perfect copy which Leutze, through the influence of Mr. Steward, had procured from the Patent Office in Washington. The head of Washington in this picture was painted from Houdon's bust, a profile being represented. It is a very dignified figure, looking intently but calmly through the cold mist to the opposite shore vaguely visible over fields of broken ice. One figure only in the boat was painted from any but an American and he was a tall Norwegian, acquainted with ice and accustomed to a boat and could be admitted. A large por-

tion of the great canvas is occupied by the sky. Leutze mixed the colors for it over night and invited Andreas Achenbach and myself to help him cover the canvas the next day, it being necessary to blend the colors easily, to cover it all over in one day. It was done; Achenbach thought of the star, and painted it, a lone almost invisible star, the last to fade in the morning light. This picture is now, after having had two other owners, the Goupils and Marshall O. Roberts, in the possession of our Metropolitan Museum, a good place for it. It was bought at the sale of the effects of the late Mr. Roberts by our public-spirited citizen, Mr. John S. Kennedy, at $20,000, and presented to the Museum by him. Another noble picture by Leutze is, "Westward the Course of Empire takes its Way." It is a fresco painted on the wall, in imitation of the old Italian frescoes. It is the last of the works of importance which this eminent artist painted. His "Henry the Eighth and Anne Boleyn," a small picture painted in Düsseldorf, won him immediate fame when exhibited there. It is one of the most complete of all his works and one which shows perhaps better than any other a keen sense of beauty, which cannot be said of all his pictures. In fact in a great deal of his work is carelessness beyond excuse. Painting was easy to him. He never worried over his pictures. He was of a sunny disposition, a charming companion, and his natural endowments were many. He had a remarkable memory, as well for what he saw in nature and wished afterwards to introduce into his pictures, as for what he read.

The "Düsseldorf School" was known at this time in America chiefly through an exhibition in New York of a large number of paintings painted by different German artists residing there. This exhibition belonged to a Mr. Boker who was the German Consul residing then in New York. It was the first exhibition in America if not in the entire world, which was opened to show paintings at night. A prominent business man, Mr. William H. Osborne, going down Broadway one morning where the exhibition was held, stopped for a moment to see it, and then told Mr. Boker that he was in a great hurry and couldn't stop to look at his fine pictures and asked him why he couldn't exhibit them at night. Mr. Boker took the hint, prepared gas jets and opened his exhibition at night as well as during the day and had great success. I have never heard that the exhibition of paintings by night was ever before attempted. It was an American expedient born of necessity in a country where everybody was in a hurry. The merchant wanted to see his pictures after the day's work was done and he had had his dinner and could sit quietly and examine them. Many years later in Rome, when I went to a great Charity Ball at the Palazzo Doria where there were plenty of Claude Lorraines that I wanted very much to see, I could

not see them for they were all in utter darkness. And so throughout Italy and every country I visited I never at that time saw a single gallery opened at night.

But with all Mr. Boker's light on his pictures in Broadway, and the thousands of people who went to see them, and all the quarter-dollars he took in by his exhibition, it was but a little while before the works of the "Düsseldorf School" as it was called fell into considerable disrepute. Critics began to criticize many of the works most admired by the public, and with much good reason. Many of these works were in the hardest German style, colorless and with nothing to recommend them except their design. This was to be sure often a compensation for lack of color and the charm of handling but it was not enough and never will be enough to satisfy us in the realm of art.

I found the professors of the Academy in Düsseldorf among the most liberal-minded artists I ever met, extolling English, French, Belgian, Norwegian, and Russian art. The Düsseldorf School, when I reached there, was made up from students of all countries; there were few French students and only a few Englishmen, but Norway, Sweden, Russia, Belgium, and Holland were strong in their representation. The School therefore was not alone the teachings of a few professors in the Academy but of the whole mass collected at that once famous rendezvous, and America had Leutze there, the most talked-about artist of them all in 1850.

I am mentioned sometimes in the catalogues of exhibitions as the pupil of Andreas Achenbach. This would be true if I could say that he ever gave me a regular lesson or in fact any lessons at all. He hated, with a hatred amounting to disgust, to see artists imitating his pictures, and he had no sympathy whatever for the usual French atelier where numbers of students were doing nothing more than imitating the techniques of their masters. He used to say these ateliers were not making artists at all, that not one teacher in a hundred could place himself in the shoes of his pupil and help him on his own way.

I cannot say that I was made unhappy by these remarks for I firmly believed that I could persuade him to give me lessons. I felt the necessity of some kind of criticism of my work and I thought I could get it of Achenbach if in some way I could find a room near by, where he could come now and then and visit me. It was then that I determined to use my wits. I knew Mrs. Achenbach, and discovered that in their house (which was a large and elegant establishment where Achenbach had his studio) there was in the attic a little room perhaps eight by ten feet, a storage room. How to get in was a problem only to be settled by getting on the right side of the lady of the house. I studied German hard, so as to make myself agreeable in conversation, and finally

approached her to know if I could not occupy the garret room. She was not half so stiff as I expected she would be. I had sent to New York for a present for her and told her so. I told her it was a piece of furniture "not made in Germany," but further I would not explain. I got into the attic room, set up my easel and there was still left space to turn around. A part of the conditions were that in passing her husband's studio which was immediately underneath, I was not to go in without being invited even if the door was open. I walked on tip-toe past his studio for an entire year without once going in, except on business, and that was seldom.

I purchased some pictures in Düsseldorf for friends in Cincinnati and purchased some from Achenbach, and this gave me free entry, sometimes, "on business." I had occupied the little room one week and had my large picture of "Sieben Gebirge" well under way, having commenced it elsewhere, when one morning my jolly master stepped in, cigar in mouth, and with a hearty "Wie gehts?" (How are you?). He glanced at the picture and said, "Sehr gut" (Very good), and immediately began to tell a story, and he kept on telling stories and making jokes until he was called to dinner—and that was all the instruction I got at that time and is a fair example of all his visits during the year that I was in his house. His talk sometimes took a serious turn, but this was generally at the "Mahlkasten" (Paint Box), a club in which all the artists of the town congregated every evening. I could have learned just as much about painting if I had never met him anywhere else but at this club during the whole year that I was with him.

* * *

I soon found myself in working traces but it was the most crucial period of my life. It was impossible for me to shut out from my eyes the works of the great landscape painters which I had so recently seen in Europe, while I knew well enough that if I was to succeed I must produce something new and which might claim to be inspired by my home surroundings. I was in despair. Sure, however, that if I turned to nature I should find a friend, I seized my sketch box and went to the first available outdoor place I could find. I hid myself for months in the recesses of the Catskills. But how different was the scene before me from anything I had been looking at for many years! The forest was a mass of decaying logs and tangled brush wood, no peasants to pick up every vestige of fallen sticks to burn in their miserable huts, no well-ordered forests, nothing but the primitive woods with their solemn silence reigning everywhere. I think I can say that I was not the first or by any means the only painter of our country who has returned after

a long visit abroad and not encountered the same difficulties in tackling home subjects. Very few independent minds have ever come back home and not been embarrassed with this same problem. And it is to be hoped that none will ever return without being bothered in the same way.

* * *

The Hudson River School—1860 to 1880

A landscape painter is only at home when he is out of doors. It matters not whether he is an "impressionist" or one of the older school who dwelt with more rigor on form and outline. We all have different eyes and different souls, and each is affected or should be, through these mediums; that all sorts of impressions are received and all sorts of work is produced is only saying that all sorts of artists are at work. There is no denying the fact that the early landscape painters of America were too strongly affected by the prevailing idea that we had the greatest country in the world for *scenery*. Everybody talked of our wonderful mountains, rivers, lakes, and forests, and the artists thought the only way to get along was to paint *scenery*. This led to much wandering of our artists. Simplicity of subject was not in demand. It must be some great display on a big canvas to suit the taste of the times. Great railroads were opened through the most magnificent *scenery* the world ever saw, and the brush of the landscape painter was needed immediately. Bierstadt and Church answered the need.

For more homely scenery this need was answered by a group of artists known as the Hudson River School—all of whom I knew, and one of whom I was. Among them was Jervis McEntee, Church, Gifford, Kensett, Hubbard, Inness, Wyant, Casilear, and the two Harts, James and William. Mr. Durand stood with them in everything that related to their method of study. Not all their pictures were painted out of doors, but they were all "got together" either out of doors or from careful studies. Some went far and wide for material, Church to the Andes, Casilear to Switzerland, but nearly all of them worked along our own seacoast, in the Catskills, and along the Hudson River. It is from this group of landscape painters that sprung the "Hudson River School," a name given them by a savage critic who wrote for the "New York Tribune." This critic probably never reflected that the Hudson River School, if it were a school, must have something distinctive about it and instead of the term being, as he intended, a term of ridicule, it might become a term of approbation. At all events, the day of ridicule has gone by. Many of the men I have mentioned have become famous. Innes, Wyant, and others waited long to be recognized, but they are now

acknowledged to be among the best landscape painters of our country. Schools of art are not born like mushrooms in a night. They are the result of the slow accumulation of work done by many men without any organization as teachers, but who, in the aggregate, stamp the work of their period with a national or local character different from all other schools. This would seem to have been easier in the old days than it is now when all the nations are hobnobbing together and shaking hands as if they were all of one breed. If art in America is ever to receive any distinctive character so that we can speak of an American School of Art, it must come from this new condition, the close intermingling of the peoples of the earth in our peculiar form of government. In this I have some hope for the future of American Art. We are a very young nation to stand as well as we do in art compared with the people of the old world. Our young artists, especially the landscape painters, are experimenting.[1]

GEORGE INNESS: LETTER ON IMPRESSIONISM, 1884

The writings of George Inness (1825-1894) are full of intemperate judgments and vague, pantheistic musings on art and the spirit. Here, however, at the height of a long career, he takes issue with Impressionism by asserting the painter's traditional concern with light, atmosphere, and particularly mass and space. By 1884 many of the Impressionists, themselves convinced that the latter elements were being lost in their work, had entered a phase of revision and would perhaps have agreed in part with Inness. The American points out the intense color and the patterned flatness by which Monet sought to structure his pictures. His letter is that of a painter reared in an older landscape school well established in America. He sounds like an academic, but he sees sharply, and today, as Monet's work seems perhaps more arbitrary—if no less dazzling—than it once did, his remarks seem less impertinent.

TARPON SPRINGS, FLORIDA, [1884]

A copy of your letter has been handed to me in which I find your art editor has classified my work among the "Impressionists." The article is certainly all that I could ask in the way of compliment. I am sorry, however, that either of my works should have been so lacking in the necessary detail that from a legitimate landscape-painter I

[1] Worthington Whittredge, "The Autobiography of Worthington Whittredge," John I. Baur, ed., *Brooklyn Museum Journal,* I (1942), 22-25, 42, 55-56.

have come to be classed as a follower of the new fad "Impressionism." As, however, no evil extreme enters the world of mind except as an effort to restore the balance disturbed by some previous extreme, in this instance say Preraphaelism, absurdities frequently prove to be the beginnings of uses ending in a clearer understanding of the legitimate as the rationale of the question involved.

We are all the subjects of impressions, and some of us legitimates seek to convey our impressions to others. In the art of communicating impressions lies the power of generalizing without losing that logical connection of parts to the whole which satisfies the mind.

The elements of this, therefore, are solidity of objects and transparency of shadows in a breathable atmosphere through which we are conscious of spaces and distances. By the rendering of these elements we suggest the invisible side of painting, and the want of that grammar gives to pictures either the flatness of the silhouette or the vulgarity of an over-strained objectivity or the puddling twaddle of Preraphaelism.

Every fad immediately becomes so involved in its application, in the want of understanding of its mental origin, and the great desire of people to label men and things, that one extreme is made to meet with the other in a muddle of unseen life application. And as no one is long what he labels himself, we see realists whose power is in a strong poetic sense as with Corbet [sic]. And Impressionists, who from a desire to give a little objective interest to their pancake of color, seek aid from the weakness of Preraphaelism, as with Monet. Monet made by the power of life through another kind of humbug. For when people tell me that the painter sees nature in the way the Impressionists paint it, I say "Humbug!" from the lie of intent to the lie of ignorance.

Monet induces the humbug of the first form and the stupidity of the second. Through malformed eyes we see imperfectly and are subjects for the optician. Though the normally formed eye sees within degrees of distinctness and without blur, we want for good art sound eyesight. It is well known that we through the eye realize the objective only through the experiences of life. All is flat, and the mind is in no realization of space except its powers are exercised through the sense of feeling. That is, what is objective to us is a response to the universal principle of truth. . . .

The first great principle in art is unity representing directness of intent, the second is order representing cause, and the third is realization representing effect.[1]

[1] George Inness, Jr., *The Life, Art and Letters of George Inness* (New York, 1917), pp. 168-173.

5

Prospects
and Problems

JOHN NEAL: AMERICAN PAINTERS AND PAINTING, 1829

John Neal (1793-1876) was a magazine editor, narrative poet, essayist, novelist, and America's first art critic. He travelled abroad, knew many of the artists of his day, and wrote with a pungency rare in nineteenth century criticism. Trumbull's historical pictures were "valuable only as a collection of tolerably well arranged portraits," and Allston's paintings generated "a sort of artificial heat." Despite his asperity, he believed that a gradual improvement in American art was inevitable, democratically trusted in the public taste, and, like most Americans of his day, had no reverance for the past.

We have certainly, either by nature, which is not very probable, or by accident, something that appears like a decided predisposition for painting in this country. At this moment, there are more distinguished American painters, than are to be found in any one of what are called the modern schools of Europe. Our head-makers are without number and some without price, our historical by the acre, our portrait, our landscape and our still-life painters, if not too numerous to mention, are much too numerous to particularize. They are better than we deserve; and more than we know what to do with. Their progress, too, is altogether astonishing, if we consider the disadvantages under which they have labored, with no models, no casts, no academy figures, and little or no opportunity for them ever to see the old masters gathered together, where they could either be copied or studied with impunity. But astonishing as their progress may have been, it is nothing to what it should be, and *will* be, if they are diligent and faithful for the next half a dozen years. The whole country is on their side now. Pictures of worth are beginning to be relished—by and by they will be understood; after that, they will soon become not merely an article for the rich, a luxury for the few, but things for everybody, familiar household furniture. Already are they quite as *necessary* as the chief part of what goes to the embellishment of a house, and far more beautiful than most of the other furniture. If you cannot believe this, you have but to look at the multitude of portraits, wretched as they generally are, that may be found in every village of our country. You can hardly open the door of a best-room anywhere, without surprising, or being surprised by, the picture of somebody, plastered to the wall and staring at you with both eyes and a bunch of flowers. And the fashion once set, even for bad pictures, there is a certain market for good ones in embryo. Virtuosi abound everywhere; critics in the furtherest off and most unheard of

country villages—people who are not to be satisfied with the skill and taste of their doer of tavern-signs, Jersey-wagons, chairs and cradles. And is nothing to come of this? Will not vanity, the love of distinction, the pride of wealth, travel, to say nothing of taste or knowledge, tend to improve the condition of painters and the quality of painting through-out our whole country in a geometrical ratio hereafter? They certainly will. Of this, our artists may be assured; and for this, if they are prudent, they will prepare themselves, by devout study and zealous labor. The day is near at hand—we speak in the spirit of allowed prophecy—when pictures that are now thought well of, by good judges, will not be tolerated by the multitude; when such portraits as we see covering the walls, not only of our academies and exhibitions, but those of our mother country, would not be allowed to show their face in the dwelling of a tolerably educated man. This may appear extravagant to those who have not considered the matter much; nor observed the wonderful changes that have been wrought in Philadelphia, where the first annual exhibition appeared; in New York, where the next had place; in Baltimore and Boston, where they have now been repeated several years running, since our painters and the public have had an opportunity of meeting together face to face in a body. How many pictures—how many painters that were spoken well of, by those who were allowed to occupy the judgment seat among the people, are now forgotten, or remembered only for the purpose of registering the growth and improvement of public opinion. We can remember when the wretched landscapes of Mr. West, done before he knew his right hand from his left in painting, were treated as prodigies for a boy. Now they would be laughed at, were they shown as the early productions of an apprentice to a painter of fire-buckets, looking-glass tablets, or militia standards. Ten or twelve years ago, Copley was a high standard—perhaps the highest we knew, for Stewart was then alive, in portraiture. Now the very multitude see that his portraits are colored porcelain—polished marble—smoothed over with oil and rottenstone. So with a number more, whom we may refer to hereafter—to say nothing of the Capitol-pictures by Mr. Trumbull, which have undergone the strangest apotheosis ever heard of, within six or eight years.[1]

HORATIO GREENOUGH: REMARKS ON AMERICAN ART, 1843

Horatio Greenough (1805-1852), in addition to being one of America's foremost sculptors, was a writer with a wide knowledge of the arts.

[1] John Neal, "American Painters and Painting," *The Yankee, and Boston Literary Gazette*, New Series, No. 1 (1829), pp. 48-51.

His remarks on form and function are today far better known than his sculpture. In this essay, first published in 1843, he reveals a faith like that of John Neal in the future of the arts in a democracy. He appears unshaken in his belief that the practical materialistic concerns of America are but temporary obstacles to its progress. Another source of his optimism is the freedom of art teaching in America from the stultifying influence of European academies.

The susceptibility, the tastes, and the genius which enable a people to enjoy the Fine Arts, and to excel in them, have been denied to the Anglo-Americans, not only by European talkers, but by European thinkers. The assertion of our obtuseness and inefficiency in this respect, has been ignorantly and presumptuously set forth by some persons, merely to fill up the measure of our condemnation. Others have arrived at the same conclusion, after examining our political and social character, after investigating our exploits and testing our capacities. They admit that we trade with enterprise and skill, that we build ships cunningly and sail them well, that we have a quick and far-sighted apprehension of the value of a territory, that we make wholesome homespun laws for its government, and that we fight hard when molested in any of these homely exercises of our ability; but they assert that there is a stubborn, antipoetical tendency in all that we do, or say, or think; they attribute our very excellence in the ordinary business of life, to causes which must prevent our development as artists.

Enjoying the accumulated result of the thought and labor of centuries, Europe has witnessed our struggles with the hardships of an untamed continent, and the disadvantages of colonial relations, with but a partial appreciation of what we aim at, with but an imperfect knowledge of what we have done. Seeing us intently occupied during several generations in felling forests, in building towns, and constructing roads, she thence formed a theory that we are good for nothing except these pioneer efforts. She taunted us, because there were no statues or frescoes in our log-cabins; she pronounced us unmusical, because we did not sit down in the swamp with an Indian on one side, and a rattlesnake on the other, to play the violin. That she should triumph over the deficiencies of a people who had set the example of revolt and republicanism, was natural; but the reason which she assigned for those deficiencies was not the true reason. She argued with the depth and the sagacity of a philosopher who should conclude, from seeing an infant imbibe with eagerness its first aliment, that its whole life would be occupied in similar absorption.

Sir Walter Scott, rank Tory as he was, showed more good sense, when, in recommending an American book to Miss Edgeworth, he accounted for such a phenomenon, by saying, "that people once possessed

of a three-legged stool, soon contrive to make an easy-chair." Humble
as the phrase is, we here perceive an expectation on his part, that the
energies now exercised in laying the foundations of a mighty empire,
would in due time rear the stately columns of civilization, and crown the
edifice with the entablature of letters and of arts. Remembering that one
leg of the American stool was planted in Maine, a second in Florida,
and the third at the base of the Rocky Mountains, he could scarce ex-
pect that the chair would become an easy one in a half-century.

It is true, that before the Declaration of Independence, Copley
had in Boston formed a style of portrait which filled Sir Joshua Rey-
nolds with astonishment; and that West, breaking through the bar of
Quaker prohibition, and conquering the prejudice against a provincial
aspirant, had taken a high rank in the highest walk of art in London.
Stuart, Trumbull, Allston, Morse, Leslie, Newton followed in quick
succession, while Vanderlyn won golden opinions at Rome, and bore
away high honors at Paris. So far were the citizens of the Republic from
showing a want of capacity for art, that we may safely affirm, that the
bent of their genius was rather peculiarly in that direction, since the
first burins of Europe were employed in the service of the American
pencil, before Irving had written, and while Cooper was yet a child.
That England, with these facts before her, should have accused us of
obtuseness in regard to art, and that we should have pleaded guilty to
the charge, furnishes the strongest proof of her disposition to underrate
our intellectual powers, and of our own ultra docility and want of self-
reliance.

Not many years since, one of the illustrious and good men of
America exclaimed in addressing the nation:

> Excudent alii mollius spirantia æra,
> Credo equidem; vivos ducent de marmore voltus!

Since that period art has received a new impulse among us. Artists have
arisen in numbers; the public gives its attention to their productions;
their labors are liberally rewarded. It seems now admitted that wealth
and cultivation are destined to yield in America the same fruits that
they have given in Italy, in Spain, in France, Germany and England.
It seems now admitted that there is no anomalous defect in our mental
endowments; that the same powers displayed in clearing the forest and
tilling the farm, will trim the garden. It seems clear that we are destined
to have a school of art. It becomes a matter of importance to decide how
the youth who devote themselves to these studies are to acquire the
rudiments of imitation, and what influences are to be made to act upon
them. This question seemed at one time to have been decided. The
friends of art in America looked to Europe for an example, and with

the natural assumption that experience had made the old world wise in what relates to the fine arts, determined upon forming Academies as the more refined nations of the continent have ended by doing. We might as well have proposed a national church establishment. That the youth must be taught is clear—but in framing an institution for that object, if we look to countries grown old in European systems, it must be for warning rather than example. We speak from long experience and much observation of European Academies. We entertain the highest respect for the professional ability and for the personal character of the gentlemen who preside over those institutions. Nay, it is our conviction of their capacity and of their individual willingness to impart knowledge, which forces upon us the opinion of the rottenness of the systems of which they are the instruments.

De Tocqueville remarks upon the British aristocracy, that, notwithstanding their sagacity as a body, and their integrity and high-toned character as individuals, they have gradually absorbed everything and left the people nothing; while he declares the American *employés,* though they are sometimes defaulters and dishonest, yet, after all, get little beyond their dues, and are obliged to sacrifice both reputation and self-respect in order to obtain that little. Those who direct the Academies of Fine Arts in Europe, are prone to take an advantage of their position analogous to that enjoyed by the aforesaid aristocracy. As the latter come to regard the mass as a flock to be fed, and defended, and cherished, for the sake of their wool and mutton, so the former are not slow to make a band of educandi the basis of a hierarchy. Systems and manner soon usurp the place of sound precept. Faith is insisted on rather than works. The pupils are required to be not only docile but submissive. They are not free.

To minds once opened to the light of knowledge, an adept may speak in masses, and the seed will fall on good ground; but to awaken a dormant soul, to impart first principles, to watch the budding of the germ of rare talent, requires a contact and relations such as no professor can have with a class, such as few men can have with any boy. If Europe must furnish a model of artistical tuition, let us go at once to the records of the great age of art in Italy, and we shall there learn that Michael Angelo and Raphael, and their teachers also, were formed without any of the cumbrous machinery and mill-horse discipline of a modern Academy. They were instructed, it is true; they were apprenticed to painters. Instead of passively listening to an experienced proficient merely, they discussed with their fellow students the merits of different works, the advantages of rival methods, the choice between contradictory authorities. They formed one another. Sympathy warmed them, opposition strengthened, and emulation spurred them on. In these latter days,

classes of boys toil through the rudiments under the eye of men who are themselves aspirants for the public favor, and who, deriving no benefit, as masters from their apprentices, from the proficiency of the lads, look upon every clever graduate as a stumbling-block in their own way. Hence their system of stupefying discipline, their tying down the pupil to mere manual execution, their silence in regard to principles, their cold reception of all attempts to invent. To chill in others the effort to acquire is in them the instinctive action of a wish to retain. Well do we remember the expression of face and the tone of voice with which one of these bashaws of an European Academy once received our praise of the labors of a man grown grey in the practice of his art, but who, though his works were known and admired at Naples and Peters-burgh, at London and Vienna, had not yet won from the powers that were his *exequatur*—"Yes, sir, yes! clever boy, sir! *promises well!*"

The president and the professors of an Academy are regarded by the public as, of course, at the head of their respective professions. Their works are models, their opinions give the law. The youth are awed and dazzled by their titles and their fame; the man of genius finds them arrayed in solid phalanx to combat his claim. In those countries where a court bestows all encouragement, it is found easy to keep from those in power all knowledge of a dangerous upstart talent. How far this mischievous influence can be carried may be gathered from the position in which Sir Joshua Reynolds and *his court* managed to keep men like Wilson and Gainsborough. He who sees the productions of these men in company with those of their contemporaries, and who remembers the impression which Sir Joshua's writings had conveyed of their stand-ing as artists, will perceive with surprise that they were not the victims of any overt act of misrepresentation, but that they were quietly and gently praised out of the rank due to them into an inferior one, by a union of real talent, constituted influence, and a sly, cool, consistent management.

Many of the ablest painters and sculptors of Europe have expressed to us directly and frankly the opinion that Academies, furnished though they be with all the means to form the eye, the hand, and the mind of the pupil, are positively hindrances instead of helps to art.

The great element of execution, whether in painting or in sculp-ture, is imitation. This is the language of art. Almost all clever boys can learn this to a degree far beyond what is supposed. That objects be placed before them calculated to attract their attention and teach them the rules of proportion, while they educate the eye to form and color, no one will dispute; but the insisting upon a routine, the depriving them of all choice or volition, the giving a false preference to readiness of hand over power of thought, all these are great evils, and we fully

believe that they fall with a withering force on those minds especially whose nourishment and guidance they were intended to secure—we mean on those minds which are filled with a strong yearning after excellence; warm sympathies, quick, delicate, and nice perceptions, strong will and a proud consciousness of creative power of mind, joined to diffidence of their capacity to bring into action the energies they feel within them. The paltry prizes offered for the best performances seldom rouse men of this order; they may create in such souls an unamiable contempt for their unsuccessful competitors; they may give to successful mediocrity inflated hopes, a false estimate of its own powers. As a substantial help they are worthless even to the tyro who wins them.

Leonardo da Vinci coiled a rope in his studio, and drew from it, with the subtlest outline and the most elaborate study of light and shade. "Behold!" said he, "my academy!" He meant to show that the elements of art can be learned without the pompous array of the antique school or the lectures of the professor. Few will be tempted to follow his example; but even that were far better than a routine of instruction which, after years of drudgery and labor, sends forth the genius and the blockhead so nearly on a level with each other, the one manacled with precepts, the other armed with them at all points.

The above reflections have been drawn from us by the oft-repeated expressions of regret which we have listened to, "that from the constitution of our society, and the nature of our institutions, no influences can be brought to bear upon art with the vivifying power of court patronage." We fully and firmly believe that these institutions are more favorable to a natural, healthful growth of art than any hot-bed culture whatever. We cannot—(as did Napoleon)—make, by a few imperial edicts, an army of battle painters, a hierarchy of drum-and-fife glorifiers. Nor can we, in the life-time of an individual, so stimulate this branch of culture, so unduly and disproportionately endow it, as to make a Walhalla start from a republican soil. The monuments, the pictures, the statues of the republic will represent what the people love and wish for,—not what they can be made to accept, not how much taxation they will bear. We hope by such slow growth to avoid the reaction resulting from a morbid development; a reaction like that which attended the building of St. Peter's; a reaction like that consequent upon the outlay which gave birth to the royal mushroom at Versailles; a reaction like that which we anticipate in Bavaria, unless the people of that country are constituted differently from the rest of mankind.

If there be any youth toiling through the rudiments of art, at the forms of the simple and efficient school at New York, (whose title is the only pompous thing about it), with a chilling belief that elsewhere the difficulties he struggles with are removed or modified, we call upon him

to be of good cheer, and to believe—what from our hearts we are convinced of—that there is at present no country where the development and growth of an artist is more free, healthful, and happy than it is in these United States. It is not until the tyro becomes a proficient—nay, an adept—that his fortitude and his temper are put to tests more severe than elsewhere—tests of which we propose to speak more at large on a future occasion.[1]

JAMES JACKSON JARVES: THE ART IDEA, 1864

James Jackson Jarves (1815-1888), editor, essayist, and the first American collector of Italian primitives shares Greenough's view that the "homely necessities of an incipient civilization" are only transient bars to the flourishing of an American art. Although he is sensitive to the obstacles in American culture, he sees in the freedom of our artistic institutions, the richness of the American continent, the increasing refinement of taste, and the lack of an oppressive past forces which will lead to the fruition of American art, not in narrow isolation, but in free association with the art of all people.

For the present, America, like England, prefers the knowledge which makes her rich and strong, to the art that implies cultivation as well as feeling rightly to enjoy it. In either country, climate, race, and religion are adverse, as compared with Southern lands, to its spontaneous and general growth. Americans calculate, interrogate, accumulate, debate. They yet find their chief success in getting, rather than enjoying; in having, rather than being: hence, material wealth is the great prize of life. Their character tends to thrift, comfort, and means, rather than final aims. It clings earthward, from faith in the substantial advantages of things of sense. We are laying up a capital for great achievements by and by. Our world is still of the flesh, with bounteous loyalty to the devil. Religion, on the side either of heaven or hell, has but little of the fervid, poetical, affectionate sentiment of the Roman creed and ritual. In divorcing it from the supersensuous and superstitious, Protestantism has gone to the other extreme, making it too much a dogma. Franklin most rules the common mind. He was eminently great and wise. But his greatness and wisdom was unspiritual, exhibiting the advantages that spring from intellectual foresight and homely virtue; in short, the practical craft of the scientist, politician, and merchant. His maxims

[1] Horatio Greenough, "Remarks on American Art," *Travels, Observations and Experiences of a Yankee Stonecutter* (New York, 1852), pp. 116-126.

have fallen upon understandings but too well disposed by will and temperament to go beyond his meaning, so that we need the counteracting element which is to be found in the art-sentiment.

What progress has it made in America?

To get at this there are three points of view: the individual, national, and universal. American art must be submitted to each, to get a correct idea of it as a whole. Yet it can scarcely be said to have fairly begun its existence, because, in addition to the disadvantages art is subjected to in America in common with England, it has others more distinctively its own.

The popular faith is more rigidly puritanical in tone. This not only deprives art of the lofty stimulus of religious feeling, but subjects it to suspicion, as of doubtful morality.

Art also is choked by the stern cares and homely necessities of an incipient civilization. Men must work to live, before they can live to enjoy the beautiful.

It has no antecedent art: no abbeys in picturesque ruins; no stately cathedrals, the legacies of another faith and generation; no mediæval architecture, rich in crimson and gold, eloquent with sculpture and color, and venerable with age; no aristocratic mansions. in which art enshrines itself in a selfish and unappreciating era, to come forth to the people in more auspicious times; no state collections to guide a growing taste; no caste of persons of whom fashion demands encouragement to art-growth; no ancestral homes, replete with a storied portraiture of the past; no legendary lore more dignified than forest or savage life; no history more poetical or fabulous than the deeds of men almost of our own generation, too like ourselves in virtues and vices to seem heroic,—men noble, good, and wise, but not yet arrived to be gods; and, the greatest loss of all, no lofty and sublime poetry.

Involuntarily, the European public is trained to love and know art. The most stolid brain cannot wholly evade or be insensible to the subtle influences of so many means constantly about it calculated to attract the senses into sympathy with the Beautiful. The eye of the laborer is trained and his understanding enlightened as he goes to and fro the streets to his daily labor; so, too, the perceptions and sentiments of the idle and fashionable throng in their pursuit of pleasure. A vast school of art equally surrounds the student and non-student. None can remain entirely unconscious of its presence, any more than of the invigorating sensations of fine weather. Hence the individual aptness of Italians, Germans, and Frenchmen to appreciate and pronounce upon art, independent of the press and academic axioms, thus creating for their artists an outside school, which perhaps is of more real benefit

to them than the one within doors in which they acquired their elementary knowledge and skill. Of these incentives to art-progress America is still destitute.

To this loss of what may be termed a floating æsthetic capital must be added the almost equal destitution of institutions for instruction in the science of art, except in a crude and elementary way. Academies and schools of design are few, and but imperfectly established. Public galleries exist only in idea. Private collections are limited in range, destitute of masterpieces, inaccessible to the multitude. Studios would effect much for the development of taste and knowledge, were they freely visited, by bringing our public into more cordial relations with artists, who do not yet exercise their legitimate influence. In a nation of lyceums and lecturers, every topic except art is heard. Indeed, outside of occasional didactic teaching and a few works not much read, we are without other resources of æsthetic education on a public scale than meager exhibitions of pictures on private speculation in some of the chief cities.

* * *

First, it has freedom of development, and a growing national knowledge, refinement, and taste, to stimulate it, and strengthen the common instinct of beauty, which never wholly deserts human nature even in the most untoward conditions. It has also a few earnest hearts to cherish its feeling, and promote its spread, with the enthusiasm of sincerity, and conviction of its importance to moral welfare and complete education.

Secondly, it is not overborne by the weight of a glorious past, disheartening the weak of the present, and rendering many, even of the strong, servile and mind-ridden. True, it has not the compensating virtue of lofty example and noble standard; but the creative faculty is freer, and more ready to shape itself to the spirit of its age. Especially is our country free from those weighty intellectual authorities and conventional conditions which powerfully tend to hedge in the student to prescribed paths, undermine his originality, and warp his native individualism.

Thirdly, art is in no sense a monopoly of government, religion, or social caste. It is not even under permanent bondage to fashion. It rather leads or misleads it than is led by it. For its sustenance it appeals directly to the people. Borne along on the vast ocean of democracy, art being a vital principle of life, it will eventually spread everywhere, and promote the happiness of all.

Fourthly, it possesses a fresh, vigorous, broad continent for its

field: in the natural world, grand, wild, and inspiriting; in man, enterprising, energetic, and ambitious, hesitating at no difficulties, outspoken, hardy of limb, and quick of action; thought that acknowledges no limits; mind that dares to solve all questions affecting humanity to their remotest consequences, daring, doubting, believing, and hoping, giving birth to new ideas, which are ever passing on to new forms.

But the favorable conditions named are more negative than positive in character. Indeed, in this respect the art of America is on the same footing as the remaining branches of her civilization. Their specific advantages of growth over the Old World are simply greater latitude of choice, and few obstacles to overcome in the way of time-worn ideas and effete institutions. In one word, art is free here; as free to surpass all previous art as it is free to remain, if it so inclines, low and common. But if America elects to develop her art wholly out of herself, without reference to the accumulated experience of older civilizations, she will make a mistake, and protract her improvement. There is a set of men among us who talk loftily of the independent, indigenous growth of American art; of its freedom of obligation to the rest of the world; of its inborn capacity to originate, invent, create, and make anew; of the spoiling of those minds whose instincts prompt them to study art where it is best understood and most worthily followed. Perhaps so! Nevertheless it would be a great waste of time to adopt such a system, and possibly it might fail. This sort of art-knownothingism is as impracticable, and as contrary to our national life, as its foolish political brother, which perished still-born. We have not time to invent and study everything anew. The fast-flying nineteenth century would laugh us to scorn should we attempt it. No one dreams of it in science, ethics, or physics. Why then propose it in art? We are a composite people. Our knowledge is eclectic. The progress we make is due rather to our free choice and action than to any innate superiority of mind over other nations. We buy, borrow, adopt, and adapt. With a seven-league boot on each leg, our pace is too rapid for profound study and creative thought. For some time to come, Europe must do for us all that we are in too much of a hurry to do for ourselves. It remains, then, for us to be as eclectic in our art as in the rest of our civilization. To get artistic riches by virtue of assimilated examples, knowledge, and ideas, drawn from all sources, and made national and homogeneous by a solidarity of our own, is our right pathway to consummate art.

No invidious nationalism should enter into art competition or criticism. The true and beautiful cannot be permanently monopolized by race, class, or sect. God has left them as free and universal as the air we breathe. We should therefore copy his liberality, and invite art to our shores, generously providing for it, without other motive than its

merits. From whatever source it may come, Greek, Italian, French, English, or German, nay, Chinese, Hindu, and African, welcome it, and make it our own. Let every public work, as are our institutions, be free to the genius of all men. Let us even compete with other nations, in inviting to our shores the best art of the world. As soon as it reaches our territory, it becomes part of our flesh and blood. Whither the greatest attraction tends, thither will genius go and make its home. Titian was not a Venetian by birth, but his name now stands for the highest excellence of that school, as Raphael does for that of Rome, and Leonardo for the Milanese. In adopting genius, a country profits not the artist so much as itself. Both are thereby honored. Foreign governments set a wise example in throwing open the designs for their public edifices to the artistic competition of the world. Least of all should America be behind in this sound policy, for no country stands in sorer need of artistic aid.[1]

BISHOP WILLIAM LAWRENCE: MEMOIR OF J. P. MORGAN

John Pierpont Morgan (1837-1913) belonged to a generation of American collectors who in the last decades of the nineteenth century brought to this country a vast treasury of the world's artistic heritage. In these years of rapidly acquired fortunes there were many newly rich Americans who, turning from a patronage of American artists, bought mediocre European paintings as outward signs of their new status and, hopefully, of their cosmopolitan sophistication. But to collectors such as Morgan, Henry Clay Frick, John G. Johnson, Henry Walters, and Isabella Stewart Gardiner who bought with discrimination and made their collections available to the public either in museums already formed or in those they built themselves, Americans owe an eternal debt of gratitude. Below is a description of Morgan's residence at Prince's Gate, London, and of the man who formed the most extensive of all these great private collections. In it are described those objects with which Morgan lived and those which were closest to him before he undertook his last great campaign of acquisition and before he transported his whole priceless assembly of paintings, porcelains, miniatures, ivories, books, and manuscripts to America.

I doubt whether there has ever been a private dwelling house so filled with works of the richest art. As one entered the front door, he

[1] James Jackson Jarves, *The Art Idea* (Cambridge, 1864), pp. 173-176, 196-199.

was still in a conventional London house, until passing along three or four yards, his eye turned and looked through the door on the left into the dining-room—in size an ample city dining-room, but in glory of color such as few other domestic dining-rooms ever enjoyed. The visitor was amazed and thrilled at the pictures: Sir Joshua Reynolds' masterpiece, *Madame Delmé and Children,* a great full-length portrait of a lady by Gainsborough, another [*of Mrs. Scott-Jackson*] by Romney. One's eye seemed to pierce the wall into the outer world through the landscapes of Constable [*The White Horse*] and Hobbema. Behind Mr. Morgan's chair at the end of the table hung a lovely Hoppner of three children [*The Goodsall Children*], a beautiful boy standing in the center, full of grace. Why did Mr. Morgan have this picture behind him? If you would sit in his chair, which faced the front of the house with the two windows looking out upon the hedge and trees of Hyde Park, you would discover between these two windows a narrow mirror, which enabled Mr. Morgan to have before him always the reflected portrait of the figure of the boy. As one passed through the hall, each picture was a gem. In the center of the hall, where the dividing wall used to stand, was a graceful bronze figure, turning at will upon its base, once the weather vane of the Sainte Chapelle [*Ange de Lude* now in the Frick collection]; near it a stone figure from the Duomo of Florence; cabinets standing about with reliquaries, statuettes and other figures.

Before going into the two rooms at the back, one passed upstairs to the next floor and entered a large drawing-room at the left. The beautiful *Elizabeth* [*Georgiana*], *Duchess of Devonshire,* by Gainsborough, looked down from the mantel. When I saw it for the first time, my memory slipped back [to Mr. Morgan's story of] how he gained possession of the picture. It was, as everybody knows, stolen in 1876 immediately after it had been purchased by Messrs. Agnew at the Wynn-Ellis sale at a large price. At the end of twenty-five years it was discovered in Chicago, and in April 1901, was given back to Messrs. Agnew. Mr. Morgan said that one day in 1901, after a short absence from New York, as he came home his butler said that a representative of the Messrs. Agnew had called and that he had the *Duchess of Devonshire* with him. "Where is he?" asked Mr. Morgan, "I want to see him." "He was just going to sail for home and is gone." Mr. Morgan said, "I was determined to have that picture and I took the next ship for England. My ship was faster than his. He arrived in London on Saturday, I on Sunday. I sent word to one of the firm that I must see him on Monday morning before he went down town. He came to Prince's Gate, and I said, 'You have the *Duchess of Devonshire.*' " "Yes," he replied. "You remember that my father on the afternoon before that picture was

stolen was about to buy it and was going to make his decision the next morning. He wanted it. What my father wanted, I want, and I must have the *Duchess*." "Very good," said the dealer. "What is the price?" asked Mr. Morgan. "That is for you to say, Mr. Morgan." "No, whatever price your firm thinks is fair, I pay." And the *Duchess of Devonshire* . . . was hung in Prince's Gate.

Turning from her, one's eye glanced about the room and recognized portraits made familiar through prints and engravings of a Rembrandt, a Frans Hals, a child by Velasquez, and the magnificent Van Dyck *Woman in Red and Child*. Two or three tables solid, with shallow drawers, stood in the room. As we opened one drawer after another, the wealth of beauty, color and fineness of execution of hundreds of miniatures were disclosed. As we took up one miniature after another, small and large, we realized not only the beauty of the miniature but the wealth and appropriateness of the frame, for when a miniature had been purchased with an unworthy frame, an artist had designed a frame in harmony with the style of the date of the miniature and set it round with gold and often with rows of pearls and diamonds. Each miniature with its frame seemed to compose one beautiful cluster of jewels.

Glancing at two glorious Turners, one at each side of the large door, we passed into the next room, a perfect example of Louis XVI, walls, rugs, furniture, and ornaments of the richest of that day. Across the hall to the front, we entered the Fragonard Room, whose walls were drawn in by the builder to meet the exact dimensions and designs of the panels. [These are the Fragonards now in the Frick Collection.] In the center stood a table covered with a glass cabinet filled with beautiful jeweled boxes. A glimpse of the portrait of the most attractive boy that one has ever seen, probably by Velasquez, drew one into the Louis XV room, where there were beautiful cabinets and examples of Sèvres. Portraits of Queen Anne of Austria and her brother, Cardinal Ferdinand, by Rubens, looked down upon us.

As one went down the staircase, a shelf at the landing was filled with a number of china pug dogs, such as ladies collected in their parlors some thirty years ago. Mr. Morgan's devotion to his mother's memory retained these here, although from every other point of view they were out of harmony with the surroundings.

As we stepped down the last two or three stairs, Van Dyck's *Duke of Warwick* facing us directly, seemed to be walking toward us. Going from the hall to the two rooms at the back, we entered on the right the parlor where guests were received. Here great and graceful Gainsboroughs and Raeburns gave warmth to the atmosphere, while the furniture given by Louis XV to the King of Denmark seemed always to have belonged here. When, a few months before, Queen Alexandra and

her sister, the Empress of Russia, were being shown about the house, one of them exclaimed, "Why, there are the chairs!" and the other said, "So they are." Mr. Morgan said, "What chairs?" "Why, our brother had those chairs but they disappeared and we never knew what had become of them; they must have been sold."

The vital center of the house was the adjoining room, Mr. Morgan's own. Over the mantel hung the portrait of his father; his portrait hung also over the mantel in his library in New York. On the right of the chimney hung the portrait of Miss Croker in her beautiful youth by Lawrence, and on the mantel beside it stood a large photograph of herself at the age of 93 given by her to Mr. Morgan. How many women would have the hardihood to encourage this contrast? One must say, however, that in the revelation of the growth of character, the contrast is in favor of the old lady. On the other side of the chimney hung Romney's portrait of Lady Hamilton reading the news of Nelson's victory, her eyes filled with glad surprise. Diagonally across from *Miss Croker* hung Sir Thomas Lawrence's full-length portrait of Miss Farren, Lady Derby. The walls were rich with other portraits and pictures, the tables and bookcases strewn with statuettes and works of art dating from 3000 B.C. up to the twentieth century, some of them left there by dealers for Mr. Morgan to inspect, others selected by himself in Rome, Egypt and elsewhere.

At a dinner party one evening, Mrs. Talbot, the wife of the then Bishop of Southwark, said to me, "What a mass of interesting things are in this house!" I answered, "Mrs. Talbot, the most interesting thing in this house is the host." For that reason, one thinks always of Mr. Morgan's chair in the corner near the fireplace, with *Miss Croker* overhead, the sun pouring in from the window and the song of a bullfinch, the most beautiful bird voice I ever heard, making the air rich with melody. Beside Mr. Morgan was always his card table, his pack of cards for solitaire at any moment and a box of great cigars nearby. Here he passed hours at a time, talking, thinking, dozing, and playing solitaire. Many smaller men make their room a keep from which all guests are excluded. Although his secretary passed the mornings in this room and dictation of telegrams might be going on, the doors were almost always open and we went in and out at will, sitting and talking,—indeed, that was the living-room downstairs for all the members of the party.

It was this atmosphere of domesticity in the midst of the richest of treasures that made Prince's Gate unique; everything in the house was a part of the house, and the house was the home of its master. To be sure, beneath were two large rooms of steel, each of them furnished with glass cases which were illuminated by electric lights. In the one was table china, rich and precious; in the other, great pieces of old silver

for the center of the table. These were in the house not to be gazed upon by visitors but to be used every day.

Domestic as the house was, it was at the same time open to hundreds of visitors who had requested the privilege of Mr. Morgan and who presented his card. As one passed through the hall, he met two or three persons at a time, connoisseurs, artists, representatives of nobility from every country in Europe and from America, attended by the faithful Margaret, who, beginning as a young servant girl with his father, was the housekeeper, guide and factotum of Prince's Gate. Henry, also a young servant of his father, was the butler who took up his story with the visitors when Margaret was overburdened.

The remarkable feature about this man of material wealth and splendor was that his personality mastered as well as pervaded it all. Every smallest ornament or richest picture had the hallmark of his individuality. And yet Mr. Morgan never talked of them or of the things that he owned except as he saw that they were of interest to others. His friends and the public unconsciously recognized this personality. Great as was his yacht, people never spoke of the *Corsair* and Mr. Morgan entering the harbor; it was Mr. Morgan on the *Corsair*. When he was away from his library, the library seemed empty. However rich the trappings, they took their proper place, merely as the trappings of the man. It was this that made his manner of life seem princely.

Mr. Morgan enjoyed London. It was the home of his father and the home of quite a fraction of his life. Business cares were there of course, as they were everywhere; nevertheless it was easier for him to break away from them there than in New York. His time was comparatively his own. His position in London too was unique. Recognized by everyone, but more independent of conventional and general social obligations than in New York, he was more at leisure to be the host, and where he had a small company of friends with whom he could talk in an unguarded way, he felt at ease. Two or three characteristics come to mind as I think of him in London. I doubt if any private citizen ever lived in as comfortable splendor as did Mr. Morgan. Some may have had more comfort, others more splendor, but his was splendor with comfort. It is a question open to debate as to whether he had a right to live in this way.

I never knew a man to whom in expenditure the question of dollars was of less interest nor one who so naturally surrounded himself with all that was richest, most convenient and artistic. He reached the climax of his abilities just as the financial world was flowing into great masses, and working in the midst of this, masses of wealth flowed towards him. They came quickly and increasingly. His mind was intensely occupied with many things. He did not have time nor probably

interest to enter into the philosophy of the use of wealth,—what proportion ought to be spent, what proportion to be given, or his obligations to the great mass of the people through some distribution of his property. Indeed, when one thinks of the short term of years in which Mr. Morgan lived in the way that I have described, one appreciates how natural it was for him to do very much as the rest of us do. When we have an increase of income, we naturally increase expenditure in various ways, private and public. We do not reason it out as to the exact proportion but in a rough way we try, taking things as they are, to do the right thing. Expenditure and wealth are all comparative, and while from a theoretical point of view Mr. Morgan might have given over his surplus income to somebody else to distribute, he did not himself have time to do it wisely. With a good conscience, he followed the traditions of his forebears and the habits of the best citizens. . . .

In the gathering of works of art, he doubtless took pleasure in acquisition. He liked to find the best and to know the best, and, given a man of his wealth, it is something to be grateful for that his fine taste prompted the selection of the finest. He well knew that practically every work of art that he bought was in time going back to the people. That the chief motive in the gathering of his collections was the love of acquisition, anyone who knew him would immediately deny. He had a love, almost a passion, for beautiful and interesting things for their own sake. As soon as the finest beauty and the real interest ceased, he dropped that subject, and it was on this account . . . that most of his collections were incomplete. Indeed, a remark which he dropped in Naples revealed, so it seemed to me, the principle which had guided him in the making of his collections.

Mrs. Burns [his sister] said to him the next day after our arrival, "Pierpont, aren't you going down to a certain dealer in Greek antiquities?" He answered, "No." "But," she said, "you have always gone there and bought and he has been courteous enough to send his car for your use." "No," he said, "I am not going there any more; I have done with Greek antiquities; I am at the Egyptian." This together with the remark . . . , that when he had collected every piece of French porcelain of the finest that could be found outside of the museums, he stopped, makes me feel that there was a principle which guided him in the gathering of such a variety of collections.

His active mind also pressed him to move from interest to interest; hence we find in his collections the finest in miniatures, the best in English portraits and landscapes, the richest in Limoges and porcelains and bronzes, the best of Caxtons, the most interesting of manuscripts. . . . The persistency with which he would follow up what really interested him was remarkable. I remember his telling me how he obtained

the Byron manuscripts. "I was told," he said, "in London, that the Byron manuscripts were in the possession of a lady, a relative of Byron, in Greece. Libraries in England were after them. I wanted them. I therefore, through the advice of an expert, engaged a man, gave him a letter of credit and told him to go to Greece and live [there] until he had gotten those manuscripts. Every once in a while, during several years, a volume would come which the relative had been willing to sell, until the whole was complete." [1]

1 Bishop William Lawrence, "Memoir of J. P. Morgan," *Pierpont Morgan as Collector and Patron,* Francis Henry Taylor, ed. (New York: Pierpont Morgan Library, 1957), pp. 21-28.

6

Realism

JOHN NEAL: LANDSCAPE AND PORTRAIT PAINTING, 1829

John Neal, drawing on his considerable familiarity with the history of art, published this lament on the state of portraiture and landscape painting in America in 1829. It was written before the American landscape school had turned toward a realistic representation of our countryside and when the elegant and flattering likenesses of Thomas Sully (1783-1872) had turned some American portraiture away from the stern factuality of our older artists. Neal's complaint that artists were imitating art and not nature recalls Stuart's remarks quoted earlier. This call for a return to straightforward realism was made at the height of the Romantic era, but Neal lived to see his demands fulfilled in later landscape painting, less poetic than Doughty's or Fisher's, and in the early paintings of Homer and Eakins.

Landscape and Portrait-Painting

We may as well acknowledge the truth. Painting is poetry now. People have done with nature—life is insipid, prose flat. The standard for landscape is no longer what we see outstretched before us, and on every side of us, with such amazing prodigality of shape and color. We have done with the trees of the forest and the wilderness, the broken-up and richly-ayed earth, overrun with wild-flowers and bravely handled herbage; weary of what we see on our right hand and on our left, whenever we go abroad with our hearts for a sketch-book; of the blue deep and the bluer sky—and of all the painting of that master who used to be looked up to as an authority in landscape—God.

His pictures are not colored like those of the old masters—there's no denying that; nor like any of the young masters—any may see that. Occasionally, to be sure, he does pretty well, *to put into language the doctrines of the craft,* comes pretty near to Hobbima and Ruysdael in the handling of his oak-branches, and the coloring of his ruder foliage with the light shining through; nor is he greatly inferior to Cuyp in his warm air and silent skies, or to Claude in his autumnal suns, wandering about, with great ships looming through a golden vapor; or to Vandervelt in his earlier sea-pieces. But then, what are his landscapes in general to those of the grand, the cultivated, the classical Poussin?—who spreads out the shadow of his own spirit upon the canvas, covering it with trees and skies and distances, altogether more beautiful and in better taste; what is his coloring to that of Titian, whose deep blue, and gorgeous yellow, and subdued crimson are never to be sufficiently admired; or what is his handling to the careless wash of Rubens, that giant in every-

thing, whose landscapes, like his lions, are the wonder of our age; as they ought to be, for they are transparent, and all run together like the dyes of a rich marble paper. Do you ever see anything of the sort in the Master to whom we allude? Never.

So too with the landscapes of Wilson (the English Claude); of Lutherbourg, and a few more, whom we acknowledge as the standards in landscape, how different are they in all that is required for a picture. Not that we never see in his work a resemblance—we would not say an imitation of parts that are known to distinguish these great modern masters; for it cannot be denied that his general air is like that of Wilson, that his mountains are not much inferior to those of Lutherbourg, and that his dwarf-willows are exceedingly like those of Paul Potter.

And so with Portraits—although he certainly improves, it cannot be denied that his faces are generally out of drawing. Seldom or never do you see a pair of *his* eyes that are perfectly alike, or a nose in the middle of the face. And always—always—we find something to wish for, sooner or later, something that anybody may improve, in the very best of his works. But how is it with the great masters of a gone-by age, or with the little masters of our day? Take them in the order they deserve to be placed in: Rembrandt, Ostade,* Titian, Vandyke, Velasquez, Raphael, Sir Joshua Reynolds, Rubens,† Gainsborough, Stewart, Bourdon, Sir Thomas Lawrence—how unlike to each other in a few things, yet how alike in everything else! And how little, save perhaps in the flesh-work, the tissues of the skin which we observe in Rembrandt, where the blood works through the shadow, and in Stewart wherever he enjoyed his subject; and occasionally in the pearly hue that overspreads the finer faces of Vandyke, almost like the quiet pale lustre of Guido,—how little is there in the works of the Deity himself, which bears a resemblance to the works of these our acknowledged masters and authorities in portrait-painting.

* * *

There is not a landscape nor a portrait painter alive, who dares to paint what he sees, *as he sees it;* nor probably a dozen with the power to see things as they are. They copy each other. They refer to each other; and think as they may, believe as they may, they dare not—they would starve perhaps if they did—they dare not judge for themselves against

> *We put him here for the sake of one picture, No. 618, of the Louvre, "Le maitre d'ecole au milieu de ses écoliers, et la ferule en main." Wilkie is largely indebted to this, we apprehend.
> † Rubens we put here also for the sake of one portrait, and only one. It is No. 711 of the same catalogue, and called thus: "Jeune homme peint en buste." It is a thing of wonderful beauty and simplicity, and what we should suppose the germ of Gainsborough to be.

the overpowering authority of the names above. At first they may—at first they do; but it is not for beginners to effect a revolution—mere boys, who give up, long before they have tempered their ignorant zeal with knowledge, or learned where the difficulty lies; thereby discouraging others from the trial, and setting up what may be regarded as beacons to the ambitious, the original and the extravagant. We know well what we say—it is a truth which no painter alive would gainsay. It is no light thing to be able to see color. Men have painted half their lives without ever having suspected the existence of the purple shadow that lurks under the yellowish-brown hair of a bright complexion, where it reposes on a clear forehead. But after seeing it, there is another difficulty. They are to paint it, not so that others may see it; but so that others may *not* see it. For such is the workmanship of nature. Now look at the purple shadow we speak of, as it appears under the management of Sir Thomas Lawrence. Anybody may see it—is that a touch of nature? Or is it a trick of art?

* * *

No wonder that we have landscape painters of extraordinary merit, whose pictures are never half so much like truth, as are the commonest daubings of the stage. Beautiful they are; and works of art they are. But they are not like the live-landscapes we see about us; and if they were, they would not sell. Do you doubt the truth of what we say? Were you at the last Athenaeum exhibition here? Do you remember the Ruysdael, just over the head of the stair-case, the leafing of which, and the very tone have passed over into a couple of Doughty's on the side of the hall. Did you see anybody stop to look at this picture, where you saw a thousand gathered before Doughty's or Fisher's? Yet the landscape of Ruysdael was true, theirs untrue; his plain prose, theirs poetry. Did you observe the Salvatore Rosa, a little farther along on the same side, one of the finest specimens of that master? Had you the valor to put faith in that? Were you gratified by the strength and robustness you saw there? Was it *natural* to you? Did you not feel astonished when you saw it, and were told the name of the author, and saw how unlike it was to any other *pictures* you had ever met with? Hundreds were astonished, if you were not. Yet Salvatore's landscape was brimful of truth. Now if poetry is what you want—you have nothing to fear. The people who buy pictures have no taste for anything else. They want the very elements of poetry in everything they buy—better trees and better skies, prettier women and more beautifully-colored men.[1]

[1] John Neal, "Landscape and Portrait Painting," *The Yankee and Boston Literary Gazette,* New Series, *I* (1829), 113-121.

GEORGE CALEB BINGHAM: THE IDEAL IN ART, 1879

That George Caleb Bingham (1811-1879) was neither an esthetician nor a philosopher is evident in this lecture he prepared during the last year of his life. As Robert Goldwater has suggested in his Artists on Art, *Bingham's remarks bear some affinity to Gustave Courbet's dicta that "an abstract object, invisible, non-existent, does not lie within the domain of painting" and that "if beauty is real and visible it contains its artistic expression within itself." Although Bingham did not know Courbet and in America had no academy to attack, his statements parallel those of Courbet in their opposition to the fine-spun theories of Allston and Emerson and to the idealism which had been present in much of American writing on art.*

The Ideal in Art

There are various and conflicting opinions as to what constitutes the ideal in Art. In the minds of those liberally endowed artists whose productions exhibit a wide range of thought, it seems to my judgment to be that general and much embracing idea necessarily derived from the love and study of nature in her varied and multitudinous aspects, as presented in form and color. It must, however, be necessarily limited by the taste of the artist, which may confine him to what is special rather than to what is general in nature. I say it may be limited and contracted by the taste of the artist. Artists permit themselves to be absorbed only by what they love. And as nature presents herself to them in a thousand phases, they may worship her in few or many. Such of her phases as take possession of their affections also take possession of their minds, and form thereon their ideal, it matters not whether it be animate or inanimate nature, or a portion of either. A Landseer is captivated by the faithfulness, habits and hairy texture of dogs, and makes them his specialty in Art, being kennelled in his mind, as it were, they exclude other subjects of Art and become the ideal which governs his pencil. When Sidney Smith was requested by a friend to sit to Landseer for his portrait he replied, *"is thy servant a dog that he should do this thing?"* His reply was significant of the apprehension justly entertained that the artist could not avoid giving to his portrait something of the expression which more properly belonged to his favorites of the canine species. Rosa Bonhier [sic], early in life, fell in love with the kine which furnishes us all, with the milk, butter and cheese which form so large a portion of the aliment which sustains our physical frames. In living with them and caressing them, their forms and habits took possession

of her mind as they had done of her heart, and formed that ideal, which makes her pictures of cattle far transcend in excellence those of Paul Potter or any of her predecessors.

I cannot believe that the ideal in Art, as is supposed by many, is a specific mental form existing in the mind of the artist more perfect than any prototype in nature, and that to be a great artist he must look within him for a model and close his eyes upon external nature. Such a mental form would be a fixed and determined idea, admitting of no variations, such as we find in diversified nature and in the works of artists most distinguished in their profession. An artist guided by such a form would necessarily repeat in every work exactly the same lines and the same expression.

To the beautiful belongs an endless variety. It is seen not only in symmetry and elegance of form, in youth and health, but is often quite as fully apparent in decrepit old age. It is found in the cottage of the peasant as well as in the palace of kings. It is seen in all the relations, domestic and municipal, of a virtuous people, and in all that harmonizes man with his Creator. The ideal of the great artist, therefore, embraces all of the beautiful which presents itself in form and color, whether characterized by elegance and symmetry or by any quality within the wide and diversified domain of the beautiful. Mere symmetry of form finds no place in the works of Rembrandt, Teniers, Ostade, and others of a kindred school. Their men and women fall immeasurably below that order of beauty which characterizes the sculptures of classic Greece. But they address themselves nonetheless to our love of the beautiful, and nonetheless tend to nourish the development and growth of those tastes which prepare us for the enjoyment of that higher life which is to begin when our mortal existence shall end.

All the thought which in the course of my studies, I have been able to give to the subject, has led me to conclude that the ideal in Art is but the impressions made upon the mind of the artist by the beautiful or Art subjects in external nature, and that our Art power is the ability to receive and retain these impressions so clearly and distinctly as to be able to duplicate them upon our canvas. So far from these impressions thus engraved upon our memory being superior to nature, they are but the creatures of nature, and depend upon her for existence as fully as the image in a mirror depends upon that which is before it. It is true that a work of Art emanating from these impressions may be, and generally is, tinged by some peculiarity belonging to the mind of the artist, just as some mirrors by a slight convex in the surface give reflections which do not exactly accord with the objects before them. Yet any obvious and radical departure from its prototypes in nature will justly condemn it as a work of Art.

I have frequently been told, in conversation with persons who have obtained their ideas of Art from books, that an artist should give to his productions something more than nature presents to the eye. That in painting a portrait for instance, he should not be satisfied with giving a true delineation of the form and features of his subject, with all the lines of his face which mark his individuality, but in addition to these should impart to his work the *soul* of his sitter. I cannot but think that this is exacting from an artist that which rather transcends the limits of his powers, great as they may be. As for myself, I must confess, that if my life and even my eternal salvation depended upon such an achievement, I would look forward to nothing better than death and everlasting misery, in that place prepared for the unsaved. According to all of our existing ideas of a soul, there is nothing material in its composition. The manufacture, therefore, of such a thing out of the earthen pigments which lie upon my palate would be a miracle entitling me to rank as the equal of the Almighty himself. Even if I could perform such a miracle, I would be robbing my sitter of the most valuable part of his nature and giving it to the work of my own hands. There are lines which are to be seen on every man's face which indicate to a certain extent the nature of the spirit within him. But these lines are not the spirit which they indicate any more than the sign above the entrance to a store is the merchandise within. These lines upon the face embody what artists term its expression, because they reveal the thoughts, emotions, and to some extent the mental and moral character of the man. The clear perception and practiced eye of the artist will not fail to detect these; and by tracing similar lines upon the portrait, he gives to it the expression which belongs to the face of his sitter, in doing this, so far from transferring to his canvas the soul of his subject, he merely gives such indications of a soul as appear in certain lines of the human face; if he gives them correctly, he has done all that Art can do.[1]

THOMAS EAKINS: ON HIS TEACHING METHODS

These two passages, based on interviews with Thomas Eakins (1844-1916), describe in the painter's own terms the revolutionary life-drawing methods he put into practice in his classes at the Pennsylvania Academy of Fine Arts. His insistence upon setting down the essentials of the figure directly with the brush reveals the method by which he

[1] George Caleb Bingham, "The Ideal in Art." Reprinted by permission of Dodd, Mead & Company from *George Caleb Bingham of Missouri* by Albert Christ-Janer. Copyright, 1940, by Dodd, Mead & Company.

established the fundamental power of his own paintings beneath their surface detail. The humanism which tempered his own empirical approach comes to light in his remarks on circus performers and the men who posed for Phidias. His disavowal of composition—"picture making" —as taught in more conventional schools is expressed in the second selection on the school. Very likely Eakins' single-minded emphasis upon figure painting may have been as great a cause of his removal from the Academy's teaching staff as his alleged improprieties, much more publicized, in posing nearly nude models before mixed classes of young men and women.

As Quoted by W. C. Brownell, 1879

Mr. Eakins, who is radical, prefers that the pupil should paint at once, and he thinks a long study of the antique detrimental. There is no conflict; for the instruction is nothing if not elastic, it appeals to the pupil's reason with candor, and avoids anything like rigid direction. But, as is natural with ambitious students, most of these take Mr. Eakins's advice. That advice is almost revolutionary, of course. Mr. Eakins's master, Gérôme, insists on preliminary drawing; and insistence on it is so universal that it was natural to ask an explanation.

"Don't you think a student should know how to draw before beginning to color?"

"I think he should learn to draw with color," was Mr. Eakins's reply. And then in answer to the stock objections he continued:

The brush is a more powerful and rapid tool than the point or stump. Very often, practically, before the student has had time to get his broadest masses of light and shade with either of these, he has forgotten what he is after. Charcoal would do better, but it is clumsy and rubs too easily for students' work. Still the main thing that the brush secures is the instant grasp of the grand construction of a figure. There are no lines in nature, as was found out long before Fortuny exhibited his detestation of them; there are only form and color. The least important, the most changeable, the most difficult thing to catch about a figure is the outline. The student drawing the outline of that model with a point is confused and lost if the model moves a hair's-breadth; already the whole outline has been changed, and you notice how often he has had to rub out and correct; meantime he will get discouraged and disgusted long before he has made any sort of portrait of the man. Moreover, the outline is not the man; the grand construction is. Once that is got, the details follow naturally. And as the tendency of the point or stump is, I think, to reverse this order, I prefer the brush. I don't at all share the old fear that the beauties of color will intoxicate the pupil, and cause him to neglect the form. I have never known anything of that kind to happen unless a student fancied he had mastered drawing before he began to paint. Certainly it is not likely to happen here. The first things to attend to in painting

the model are the movement and the general color. The figure must balance, appear solid and of the right weight. The movement once understood, every detail of the action will be an integral part of the main continuous action; and every detail of color auxiliary to the main system of light and shade. The student should learn to block up his figure rapidly, and then give to any part of it the highest finish without injuring its unity. To these ends, I haven't the slightest hesitation in calling the brush and an immediate use of it, the best possible means.

"All this quite leaves the antique out of consideration, does it not?"

Mr. Eakins did not say "the antique be hanged," because though he is a radical he is also contained and dispassionate; but he managed to convey such an impression:

I don't like a long study of casts, even of the sculptors of the best Greek period. At best, they are only imitations, and an imitation of imitations cannot have so much life as an imitation of nature itself. The Greeks did not study the antique: the "Theseus" and "Illyssus," and the draped figures in the Parthenon pediment were modeled from life, undoubtedly. And nature is just as varied and just as beautiful in our day as she was in the time of Phidias. You doubt if any such men as that Myron statue in the hall exist now, even if they ever existed? Well, they must have existed once or Myron would never have made that, you may be sure. And they do now. Did you ever notice, by the way, those circus tumblers and jumpers—I don't mean the Hercules? They are almost absolutely beautiful, many of them. And our business is distinctly to do something for ourselves, not to copy Phidias. Practically, copying Phidias endlessly dulls and deadens a student's impulse and observation. He gets to fancying that all nature is run in the Greek mold; that he must arrange his model in certain classic attitudes, and paint its individuality out of it; he becomes prejudiced, and his work rigid and formal. The beginner can at the very outset get more from the living model in a given time than from study of the antique in twice that period. That at least has been my own experience; and all my observation confirms it.

Here then are two things which distinguish the Philadelphia from the New York schools—immediate drawing with the brush and no prolonged study of the antique. Another is modeling, of which there is none at all done at either the Cooper Union or the National Academy, and which is not practiced at the League in direct connection with painting. When Mr. Eakins finds any of his pupils, men or women, painting flat, losing sight of the solidity, weight and roundness of the figure, he sends them across the hall to the modeling-room for a few weeks. There is now no professor of modeling, but, as modeling is not pursued for the end of sculpture but of painting, the loss is not deeply felt. And Mr. Eakins is frequently present to give advice and render assistance. Some twelve or fourteen students are in this room daily. It is large, high, and light. The same liberal provisions are made for pro-

curing models for it as are made for the classes in painting. A change
is made at least every fortnight, and the students make themselves
familiar with every variety of form. They model extremely well, as a
rule, I should say—though there are the same differences to be observed
here as in the painting classes. The same characteristics in other respects
are evident also. Nowhere is there any effort at anything but individual
portraiture—no attempt to make a Phidian statue from a scullion model.

<p style="text-align:center">* * *</p>

"And don't you find your interest becoming scientific in it. nature,
that you are interested in dissection as an end in itself, that curiosity
leads you beyond the point at which the æsthetic usefulness of the work
ceases? I don't see how you can help it."
Replies Mr. Eakins, smiling:

> No, we turn out no physicians and surgeons. About the philosophy of
> æsthetics, to be sure, we do not greatly concern ourselves, but we are con-
> siderably concerned about learning how to paint. For anatomy, as such,
> we care nothing whatever. To draw the human figure it is necessary to
> know as much as possible about it, about its structure and its movements,
> its bones and muscles, how they are made, and how they act. You don't
> suppose we pay much attention to the viscera, or study the functions of
> the spleen, I trust.

"But the atmosphere of the place, the hideousness of the objects!
I can't fancy anything more utterly—utterly—inartistic."

> Well, that's true enough. We should hardly defend it as a quickener of
> the æsthetic spirit, though there is a sense in which a study of the human
> organism is just that. If beauty resides in fitness to any extent, what can
> be more beautiful than this skeleton, or the perfection with which means
> and ends are reciprocally adapted to each other? But no one dissects
> to quicken his eye for, or his delight in, beauty. He dissects simply to
> increase his knowledge of how beautiful objects are put together to the
> end that he may be able to imitate them. Even to refine upon natural
> beauty—to idealize—one must understand what it is that he is idealizing;
> otherwise his idealization—I don't like the word, by the way—becomes
> distortion, and distortion is ugliness. This whole matter of dissection is
> not art at all, any more than grammar is poetry. It is work, and hard work,
> disagreeable work. No one, however, needs to be told that enthusiasm
> for one's end operates to lessen the disagreeableness of his patient work-
> ing toward attainment of it. In itself I have no doubt the pupils consider
> it less pleasant than copying the frieze of the Parthenon. But they are
> learning the niceties of animal construction, providing against mistakes
> in drawing animals, and they are, I assure you, as enthusiastic over their
> "hideous" work as any decorator of china at South Kensington could be
> over hers. As for their artistic impulse, such work does not affect it in any
> way whatever. If they have any when they come here they do not lose

it by learning how to exercise it; if not, of course, they will no more get it here than anywhere else.[1]

As Reported by Fairman Rogers, 1881

From time to time, athletes, trapeze-performers, and the like, have been secured. Originally, the number of male models was greater than that of female models, as they are rather more instructive as to muscular development; but because the male figure is more familiar to the male students, at least, than that of the female, through opportunities afforded in swimming and the like, for the past two years the sexes have been alternated so that the class sees the same number of each during the season. Rather simple poses, usually standing ones, are employed, as they seem to give the best practical results, and the mental comparison of the different models from week to week is more vivid in simple poses. Poses representing action, or those which depend upon several points of support, are difficult to keep, and confuse the student by constantly varying; but the model, in going in or out of the room, and moving about during the rests, shows how that particular body looks in action, and is carefully noticed by the students with that view. A proposition to use the last hour of each pose (not of each day) in noticing and perhaps sketching the action in various positions of the model whose conformation has become familiar during the work of the week, may be carried out in the future.

* * *

One peculiarity of the school, which has been somewhat unfavorably criticized, is that in one sense there is little variety in the instruction; that is, the student works first from casts which are almost universally of the nude human figure; he then enters the life class and continues to work from the nude human figure, usually in simple poses, and he works in the dissecting room also from the human figure. He does some work in the sketch class from a draped figure, and in the portrait class from the head and face; but the main strength is put upon the nude figure.

* * *

It may be considered somewhat narrow, but the difficulties of attaining that knowledge that is necessary to a successful career as a producer of pictures and sculpture, are so great, that the four or five

[1] W. C. Brownell, "The Art Schools of Philadelphia," *Scribner's Monthly Illustrated*, XVIII (1879), 737-750.

years of a professional life which are represented by the school work, have to be devoted to steady grinding application to that one thing. The objection that the school does not sufficiently teach the students picture-making, may be met by saying that it is hardly within the province of a school to do so. It is better learned outside, in private studios, in the fields, from nature, by reading, from a careful study of other pictures, of engravings, of art exhibitions; and, in the library, the print room and the exhibitions which are held in the galleries, all freely open to the student, the Academy does as much as it can in this direction. Loan collections of the best pictures obtainable, American and foreign, are among the most useful educators of this kind. It must not be supposed that broad culture is unnecessary; on the contrary, it is of the greatest importance, but it should be attained as far as possible before and after this particular period of work.[1]

WINSLOW HOMER: ON PAINTING IN THE OPEN AIR, 1881

These remarks, reported by a nineteenth century historian of American art in 1882, were made before Winslow Homer (1866-1910) turned for a time to melodramatic and anecdotal subject matter. They reflect, however, his lifelong preoccupation with the effects of light, color, and atmosphere. Although Homer had studied in Paris, his knowledge of French Impressionism could only have been slight, and his opinions, which so closely parallel those of the Impressionists, would seem to have grown naturally from his own observations.

Of Bouguereau . . . Mr. Homer says:

I wouldn't go across the street to see a Bouguereau. His pictures look false; he does not get the truth of that which he wishes to represent; his light is not out-door light; his works are waxy and artificial. They are extremely near being frauds. I prefer every time . . . a picture composed and painted out-doors. The thing is done without your knowing it. Very much of the work now done in studios should be done in the open air. This making studies and then taking them home to use them is only half right. You get composition, but you lose freshness; you miss the subtle and, to the artist, the finer characteristics of the scene itself. I tell you it is impossible to paint an out-door figure in studio-light with any degree of certainty. Out-doors you have the sky overhead giving one light; then the reflected light from whatever reflects; then the direct light of the sun; so that, in the blending and suffusing of these several luminations, there

[1] Fairman Rogers, "The Art Schools of the Pennsylvania Academy of Fine Arts," *The Penn Monthly,* XII (1881), 453-462.

is no such thing as a line to be seen anywhere. I can tell in a second if an out-door picture with figures has been painted in a studio. When there is any sunlight in it, the shadows are not sharp enough; and, when it is an overcast day, the shadows are too positive. Yet you see these faults constantly in pictures in the exhibitions, and you know that they are bad. Nor can they be avoided when such work is done indoors. By the nature of the case the light in a studio must be emphasized at some point or part of the figure; the very fact that there are walls around the painter which shut out the sky shows this. I couldn't even copy in a studio a picture made out-doors; I shouldn't know where the colors came from, nor how to reproduce them. I couldn't possibly do it. Yet an attempted copy might be more satisfactory to the public, because more like a made picture.[1]

JOHN W. BEATTY: RECOLLECTIONS OF
WINSLOW HOMER, 1923 OR 1924

John W. Beatty, painter, and director of the Department of Fine Arts of Carnegie Institute, Pittsburgh, was one of the few men who got Winslow Homer to talk about art. His "Recollections of an Intimate Friendship," based on notes made in 1903, were written in 1923 and 1924, and first published in Winslow Homer *by Lloyd Goodrich, 1944.*

It should be borne in mind that Homer was inarticulate about artistic matters, and that Beatty had a definite naturalistic viewpoint. That Homer did not actually paint nature "exactly as it appears" is proved by his work itself, which from the first showed selectivity, simplification, a gift for decorative values, and a conscious sense of design that grew stronger with the years.

LLOYD GOODRICH

The chief qualities which made up Homer's character were, I think, simplicity, earnestness, absolute honesty, concentration on his art and a straightforward manner of thinking and acting. These qualities account for the direct and forceful character of his paintings. When it came to representing the essential truth, as truth appeared to him in nature, he knew no deviation from a straight course; and truth to Homer finally, at the end of many years' study, appeared first and foremost in broad and commanding masses. He saw clearly and he saw broadly. He never emphasized unimportant details. Even his earliest paintings, and his drawings published in *Harper's Weekly* before he had fully

1 G. W. Sheldon, *Hours with Art and Artists* (1882), pp. 136-141.

committed himself to the use of color, exhibit the same breadth of vision. This quality was more and more developed throughout his career and reached its highest expression in his late watercolors.

In addition to breadth, he laid special stress upon the importance of securing the exact relationship between a few dominating values. Referring to this one day he said, "I have never tried to do anything but get the true relationship of values; that is, the values of dark and light and the values of color. It is wonderful," he added, "how much depends upon the relationship of black and white. Why, do you know, a black and white, if properly balanced, suggests color. The construction, the balancing of the parts is everything. You can make a black and white almost perfect and carry a little color—of course, if it is a figure picture that is important. But when I paint one of my simple seascapes, the question is the truth of the values."

Once when we were picking our way along the shore, over the shelving rocks he painted so often, I suddenly said, "Homer, do you ever take the liberty, in painting nature, of modifying the color of any part?" I recall his manner and expression perfectly. Arresting his steps for an instant, he firmly clenched his hand, and bringing it down with a quick action, exclaimed: "Never! Never! When I have selected the thing carefully, I paint it exactly as it appears."

Always he insisted upon this: the importance of getting the truth from nature.

When I asked him if he made a calculation for the difference in the strength of light out-of-doors and in a gallery, and as a result forced his color or strengthened his values to provide for the drop in tone under lower light, he said, "Certainly not. I try to paint truthfully what I see, and make no calculations"; but he promptly added, revealing his desire to consider fairly the suggestion, "I would not say that that is not a good and proper method to pursue. Yes, that might be a good and just method; but I have always thought that my pictures looked better when lowered in tone by the weaker light of a gallery or house."

One evening he asked me how I liked the watercolors in the cottage that he rented. I replied, "They seem to me to be very brilliant. I think you hit them hard, as the painters say. That is, it seems to me that, while preserving a perfect adjustment of values, you went even a little beyond the strength of nature, to the end that your pictures would not suffer when placed in a low light."

"No, never, never," said Homer. "I never try to make things stronger than they actually are in nature."

"Well," I said, "I do not doubt that you do this as you see the values, but you know perfectly well, if you would place a piece of canvas against the sky and literally match the color so that the canvas would

be like the sky, this piece of canvas would look several degrees lower in tone when placed in a home than it did in the strong outdoor light. At the end of a long life of experiment and labor," I said, "you probably unconsciously make the just allowance."

"Well, probably I do, probably I do."

He told me that he always painted direct from nature and in the open light of day. This was his almost invariable rule; but it did not mean that he never touched a canvas after taking it to his studio. "Of course," he said, "I go over them in the studio and put them in shape."

He said that when painting *The Fox Hunt* he took no chances on securing the exact color or the relationship between the color notes. He placed the skin of a fox over a barrel and put it in the snow near his studio.

Homer not only understood perfectly the importance of seeing aright, of selecting with discrimination, but also of securing the transient effect, the spirit of the moment. This was indicated by a letter in which he said, "You will be glad to hear that I am painting again. *I work hard every afternoon* from 4:30 to 4:40, that being the limit of the light that I represent, the title of my picture being *'Early Evening.'*" This shows that he was inspired by the very spirit of impressionism. I have never heard of him expressing any special interest in the impressionists, and think it probable that he arrived at this by himself. Born of an earlier age, trained, so far as he was trained at all, in a different school, he nevertheless grasped for himself a vital principle, that the momentary impression is of greater importance than mere details. To secure this he painted in the presence of nature and sometimes resorted to unusual means to try out a painting as it progressed; to discover whether or not he was securing the exact effect he desired. He said he would sometimes hang a canvas on the balcony outside of his studio, where he could study it from a distance of seventy-five feet. "I could see," he said, "the least thing that was out."

Although such remarks suggest that Homer approached nature in a very simple and direct manner, relying almost wholly upon his impression at the moment, it must not be assumed that he neglected any means in his pursuit of truth. He studied the principles of art, and especially the laws governing color harmony, with much interest.

At times in talking to him one felt that he painted his wonderful canvases without knowing his power, just as the strapping farmer boy turns over a great log without being conscious that he is doing anything remarkable. But at other times one was startled out of this position by some remark about the scientific study of the influence of complementary colors one upon another, or the relation of color notes in juxtaposition. For instance he said, "You can't get along without a knowledge of the

principles and rules governing the influence of one color upon another. A mechanic might as well try to get along without tools." But a little later, in the presence of nature, he would say, "There it is! You simply have to get it right."

I said, "Well, I don't see how you square this with your opinion of the importance of rules. If it is there, and you simply háve to get it with absolute truth, there it is, and what have you to do with the rules governing color? If you get it with justness and truth it is a law unto itself."

"Well, yes!" he said. "But for instance there is that stove. If you are going to paint it, you first draw the upright at one side. Then comes in your knowledge of perspective and you unconsciously are influenced by the rules as you work. You simply can't do without them."

"Not a parallel case," I replied. "Of course a knowledge of perspective helps you in the drawing, but we were not talking about drawing. We were talking about color, and taking you on your own ground, there it is, a definite quality of gray sky; beneath, a definite quality of greenish gray water; and the rocks. You simply, in the matter of color, have got to get it, and I don't see how rules apply."

"Well, yes, that's so," he said. "You simply have to get the truth of it, as you see it; but the knowledge of the influence of one color upon another is necessary anyhow. You can't do it unless you know when you put down one positive color what influence that color is going to have on the color next to it."

One day I picked up from his table a copy of Chevreul's well-known book on the laws of color, and without revealing my surprise, asked if he found it of value. He replied simply, "It is my Bible."

These incidents throw light on Homer's philosophy of art, establishing the fact that he was a thoughtful and thorough student, mentally alert and working with extreme precision. He was interested in every aid offered by science. In no other way can his power be accounted for; because if there is one universal law perfectly established, it is that success waits for those who are willing to pay the price in study and effort.

Sometimes he referred to months of hard work at this place or that, when he exhausted every known means to secure the desired end. In England he hired a garden with a great wall about it, and for a long period painted figures, posing them and working out every detail until he was satisfied he could do no more; then took his canvas and models to the seacoast, where, as he expressed it, "I would in a couple of hours, with the thing right before me, secure the truth of the whole impression."

"Homer," I once asked, "do you ever paint a picture with which

you are perfectly satisfied?" "The first picture I ever painted," he replied, "was the only one I considered perfect. I thought there never was such a man.

"I have learned two or three things in my years of experience," he said. "One is, never paint a blue sky," "Why?" I asked. "Why, because it looks like the devil, that's all. Another thing; a horizon is horrible—that straight line!"

Asked if he ever prepared canvases by underlaying with rich color, he said, "Never." Sometimes he scraped off old canvases and thought them very superior to paint on, but he never tried any but the most direct and simple methods.

I pressed him for a definition of what he considered the essential, the most important quality in painting, but he replied like one who had given little thought to distinctions or reasoning of this kind. I tried to reach his real judgment by asking if he did not think that beauty exists in nature actually and in fact had always existed, and must be discovered and revealed, simply and frankly. Quick as a flash he answered, "Yes, but the rare thing is to find a painter who knows a good thing when he sees it!" He added, "It is a gift to be able to see the beauties of nature."

Referring at another time to the power of seeing, he observed, "You must not paint everything you see. You must wait, and wait patiently until the exceptional, the wonderful effect or aspect comes. Then, if you have sense enough to see it—well," he quaintly added, "that is all there is to that."

This seemed to me to touch the very core of the question. The power to see, to comprehend the exceptional qualities existing in nature, is a gift possessed by few men and these few become the great masters. It is the first and highest requisite in the pursuit of art. Homer never wasted effort on unimportant things. He never painted simply for the purpose of correctly representing natural objects or scenes. He knew perfectly that only the exceptional, the dominant or characteristic, is important. His thought was to select with care and then to be prepared, to lie in wait, to stand ready to put forth a supreme effort when the moment should arrive, when the desired effect should come. This I believe was his constant attitude towards nature and art. To select with extreme care and to get the truth of nature direct from nature was his gospel.

Of equal importance was his sense of the value of simplicity. Building upon the power to delineate every detail with precision, he early learned to see broadly, to separate the essential character from the non-essential details. This was one of the most important factors

in his success. It is a quality of mind which separates the strong from
the weak in every walk of life. The narrow mind seizes upon details;
the large mind grasps the essentials. If Homer had become a lawyer
instead of a painter, this power to grasp essentials would have governed
in that relation as surely as it did in his relation to nature. He would
have become an able advocate because he would have seized upon the
basic facts in every case and concentrated his whole effort upon these.

Rarely did he represent in any of his late canvases more than
three or four dominant notes. In the *Northeaster,* as in many other paint-
ings, this quality of simplicity is remarkably exemplified. A few massive
rock forms combined with onrushing waves are made to give one a
tremendous sense of power and reality. Here we have Homer fully
abreast of if not in advance of his time; because if there is any one
outstanding characteristic of modern art it is simplicity.

In the Prout's Neck paintings the sense of irresistible force is the
dominating note. No word of less significance than power seems ade-
quate to describe them. We have all felt this quality when in the pres-
ence of Homer's works. He has expressed the power of the ocean better
than has any painter of the past or present. Standing before the *North-
easter,* one seems to feel the very weight and onrushing of the waves,
the very vibration of the earth. The late Dr. Gunsaulus, who owned
On a Lee Shore, expressed in a whimsical way the feeling here sug-
gested. He said that the picture, hung in his rather small library, gave
him the feeling that he might be washed out of his home at any mo-
ment.

In the noble group of paintings produced by Homer at Prout's
Neck, we probably have his highest achievement. They undoubtedly
form the foundation of his great reputation. Limited in subject, as they
were, they at once express the power of a great painter and the majesty
of the ocean. These remarkable pictures came one after another from
Homer's seclusion into the art world with startling effect. They breathed
a spirit of truth and sincerity which literally commanded respect. Dur-
ing these years a few great American painters were producing impor-
tant works, but these Prout's Neck paintings differed in content from
those with which art lovers were familiar and aroused profound admira-
tion among the few men who were capable of understanding them.

Then Homer turned from Prout's Neck to the Bahamas to seek
rest and recreation, and the result was the most amazing watercolors
ever produced in this country. Indeed, I think nothing like these latter
works, for directness and power, has been produced in the field of water-
color painting in our time. It would seem as if this power was only fully
realized when he was at play with color, when he had "given up the

business" and gone to the Bahamas in a spirit of pleasure-seeking and not of work. All his gifts of observation and concentration, and an astonishing freedom of touch, long walled up and controlled in the interest of producing what he probably considered more serious work, seemed to break forth with unbounded freedom. Free from anxiety, free also from interest in public exhibitions and purchasers, conscious of his power, he literally revelled in the simple ability to do the thing for the sake of doing it. It was in this mood that he wrote, "What is the use? The people are too stupid. They do not understand." He was now free, free to enjoy his art without thought of others.

And thus did one of our strongest painters begin and end his career—a career uneventful on the surface, even prosaic, but stirred all the while by deep currents of sincerity and power. Withdrawing from active affairs and from intercourse with his fellow painters, choosing rather to associate with his family and a few friends that he might the better serve his own purpose in the remaining years of his life, he made a contribution which is destined long to continue a milestone in the progress of our national art.[1]

HENRY JAMES: ON SOME EXHIBITIONS OF 1875

When Henry James (1843-1916) wrote this review he had already begun to spend most of his time abroad. His reaction to the paintings, most of them at the National Academy of Design's annual exhibition, is witty, sometimes condescending, and, in the case of the late luminaries of the Hudson River School, Moran and Church, less than enthusiastic. James had little admiration for the folksy, homespun aspects of American culture, but his comments on the young realists, Winslow Homer, Eastman Johnson, and Frank Duveneck, are less biting than might be expected; in fact, into his polished prose comes a note of reluctant admiration. His defense of the critic's role and his perceptive writing on these painters reflect his lifelong concern with painting and sculpture.

The standing quarrel between the painters and the *litterateurs* will probably never be healed. Writers will continue to criticize pictures from the literary point of view, and painters will continue to denounce their criticisms from the free-spoken atmosphere of the studio. Each party will, in a manner, to our sense, be in the right. If it is

[1] John W. Beatty, "Recollections of an Intimate Friendship (1923 or 1924)," in Lloyd Goodrich, *Winslow Homer* (New York: The Whitney Museum, 1944), pp. 220-226.

very proper that the critics should watch the painters, it is equally proper that the painters should watch the critics. We frankly confess it to be our own belief that even an indifferent picture is generally worth more than a good criticism; but we approve of criticism nevertheless. It may be very superficial, very incompetent, very brutal, very pretentious, very preposterous; it may cause an infinite amount of needless chagrin and gratuitous error; it may even blast careers and break hearts; but we are inclined to think that if it were suppressed at a stroke, the painters of our day would sadly miss it, decide that on the whole it had its merits, and at last draw up a petition to have it resuscitated. It makes them more patrons than it mars; it helps them to reach the public and the public to reach them. It talks a good deal of nonsense, but even its nonsense is a useful force. It keeps the question of art before the world, insists upon its importance, and makes it always in order. Many a picture has been bought, not because its purchaser either understood it or relished it—being incapable, let us say, of either of these subtle emotions—but because, for good or for ill, it had been made the subject of a certain amount of clever writing "in the papers." It may be said that not only does the painter have to live by his pictures, but in many cases the critic has to as well, and it is therefore in the latter gentleman's interest to foster the idea that pictures are indispensable things.

Of course what most painters urge is not that criticism is *per se* offensive, but that the criticism of the uninitiated, of those who mix things up, who judge sentimentally, fantastically, from the outside, by literary standards, is the impertinent and injurious thing. Painters, we think, complain of this so-called "literary" criticism more than any other artists—more than musicians, actors, or architects. There is probably more unmeaning verbiage, in the guise of criticism, poured forth upon music than upon all the other arts combined, and yet the melodious brotherhood take their injury, apparently, in a tolerably philosophic fashion. They seem to feel that it is about as broad as it is long, and that as they profit on the one side by the errors of the public, there is a rough reason in their losing, or even suffering, on the other. People in general had rather not take music at all than take it hard. The case is very much the same with the visitors of the galleries and studios. If they always had to show chapter and verse for their impressions and judgments, they would soon declare that the play is not worth the candle, that art is meant for one's entertainment; that a picture is a thing to take or to leave. "If one didn't look at you imaginatively," they say in many a case, "if one didn't lend you something of one's own, pray where would you be?" Art, at the present day, is being steadily

and rapidly vulgarized (we do not here use the word in the invidious sense); it appeals to greater numbers of people than formerly, and the gate of communication has had to be widened, perhaps in a rather barbarous fashion. The day may come round again when we shall all judge pictures as unerringly as the burghers of Florence in 1500; though it will hardly do so, we fear, before we have, like the Florentines, a native Michel Angelo or an indigenous Andrea del Sarto to exercise our wits upon. Meanwhile, as we are expected to exhibit a certain sensibility to the innumerable productions of our own period, it will not be amiss to excuse us for sometimes attempting to motive our impressions, as the French say, upon considerations not exclusively pictorial. Some of the most brilliant painters of our day, indeed, are themselves more literary than their most erratic critics; we have invented, side by side, the arts of picturesque writing and of erudite painting.

<p style="text-align: center">* * *</p>

Mr. Eastman Johnson, whom we mentioned just now in conjunction with Mr. Gray, is a painter who has constant merits, in which we may seek compensation for his occasional errors. His "Milton and his Daughters" is a very decided error, and yet it contains some very pretty painting. Like Mr. Gray, Mr. Johnson here seems to us to have attempted to paint an expensive picture cheaply. To speak of the work at all kindly, we must cancel the Milton altogether and talk only about the daughters. By thus defilializing these young ladies, and restoring them to their proper sphere as pretty Americans of the year 1875, one is enabled to perceive that their coloring is charming, and that though the sister with her back turned is rather flat, rather vaguely modelled, they form a very picturesque and richly-lighted group. One of Mr. Johnson's other pictures, a young country-woman buying a paper of pins from an old peddler, is a success almost without drawbacks. Mr. Johnson has the merit of being a real painter—of loving, for itself, the slow, caressing process of rendering an object. Of all our artists, he has most coquetry of manipulation. We don't know that he is ever really wasteful or trivial, for he has extreme discretion of touch; but it occasionally seems as if he took undue pleasure in producing effects that suggest a sort of lithographic stippling. The head of the woman, pretty as it is, in the picture just mentioned, is a case in point; her dress, and the wall beyond it, are even more so. But the old hawker, with his battered beaver hat, his toothless jaws and stubbly chin, is charmingly painted. The painting of his small wares and of the stove near him, with the hot white bloom, as it were, upon the iron, has a Dutch humility of subject, but also an almost Dutch certainty of touch. For the same

artist's lady in a black velvet dressing-gown, fastening in an earring, we did not greatly care, in spite of the desirable mahogany buffet against which she is leaning. Mr. Johnson will never be an elegant painter—or at least a painter of elegance. He is essentially homely.

* * *

Of Mr. Homer's three pictures we have spoken, but there would be a good deal more to say about them; not, we mean, because they are particularly important in themselves, but because they are peculiarly typical. A frank, absolute, sincere expression of any tendency is always interesting, even when the tendency is not elevated or the individual not distinguished. Mr. Homer goes in, as the phrase is, for perfect realism, and cares not a jot for such fantastic hair-splitting as the distinction between beauty and ugliness. He is a genuine painter; that is, to see, and to reproduce what he sees, is his only care; to think, to imagine, to select, to refine, to compose, to drop into any of the intellectual tricks with which other people sometimes try to eke out the dull pictorial vision—all this Mr. Homer triumphantly avoids. He not only has no imagination, but he contrives to elevate this rather blighting negative into a blooming and honorable positive. He is almost barbarously simple, and, to our eye, he is horribly ugly; but there is nevertheless something one likes about him. What is it? For ourselves, it is not his subjects. We frankly confess that we detest his subjects—his barren plank fences, his glaring, bald, blue skies, his big, dreary, vacant lots of meadows, his freckled, straight-haired Yankee urchins, his flat-breasted maidens, suggestive of a dish of rural doughnuts and pie, his calico sun-bonnets, his flannel shirts, his cowhide boots. He has chosen the least pictorial features of the least pictorial range of scenery and civilization; he has resolutely treated them as if they *were* pictorial, as if they were every inch as good as Capri or Tangiers; and, to reward his audacity, he has incontestably succeeded. It makes one feel the value of consistency; it is a proof that if you will only be doggedly literal, though you may often be unpleasing, you will at least have a stamp of your own. Mr. Homer has the great merit, moreover, that he naturally sees everything at one with its envelope of light and air. He sees not in lines, but in masses, in gross, broad masses. Things come already modelled to his eye. If his masses were only sometimes a trifle more broken, and his brush a good deal richer—if it had a good many more secrets and mysteries and coquetries, he would be, with his vigorous way of looking and seeing, even if fancy in the matter remained the same dead blank, an almost distinguished painter. In its suggestion of this blankness of fancy the picture of the young farmer flirting with the

pie-nurtured maiden in the wheat field is really an intellectual curiosity. The want of grace, of intellectual detail, of reflected light, could hardly go further; but the picture was its author's best contribution, and a very honest, and vivid, and manly piece of work. Our only complaint with it is that it is damnably ugly! We spoke just now of Mr. La Farge, and it occurs to us that the best definition of Mr. Homer to the initiated would be, that he is an elaborate contradiction of Mr. La Farge. In the Palace of Art there are many mansions!

* * *

We choose a wrong moment moreover for harboring evil thoughts of the Munich school, for we have lately had evidence that a great talent of the most honorable sort may flourish beneath its maternal wing. The good people of Boston have recently been flattering themselves that they have discovered an American Velasquez. In the rooms of the Boston Art Club hang some five remarkable portraits by Mr. Frank Duveneck of Cincinnati. This young man, who is not yet, we believe, in his twenty-fifth year, took his first steps in painting in the Bavarian capital, and it is hardly hyperbolical to say that these steps were, for a mere lad, giant strides. He came back a while since, if we are not mistaken, to his native city, where his genius was not highly appreciated, and where depressing obscurity was his portion, until æsthetic Boston held out a friendly hand. It is of course of supreme importance that Mr. Duveneck should not be talked about intemperately, though we shall be surprised if his head is not too firmly set upon his shoulders to be easily turned. We speak in reason when we say that the half dozen portraits in question have an extraordinary interest. They are all portraits of men—and of very ugly men; they have little grace, little finish, little elegance, none of the relatively superfluous qualities. But they have a most remarkable reality and directness, and Velasquez is in fact the name that rises to your lips as you look at them. It is very evident that in so far as there is any question of Velasquez in the matter, the analogy of Mr. Duveneck's talent with that of the great Spaniard is a natural, instinctive one. His models for the pictures in Boston are far from having the Spanish stateliness of aspect or the sixteenth century bravery of costume. One of them is a plain old agricultural character, we should say, of Quakerish rigidity and of an extremely plebeian type, seated squarely in a straw-bottomed arm-chair and staring out of the picture, at full length, with startling vividness. Another is a young man in a shabby coat and a slouched hat, holding a stump of a cigar, a fellow art student of the author, presumably—less remarkable than the first, yet full of rough simplicity and truth. A third is a head of a German

professor, most grotesquely hideous in feature and physiognomy, look-
ing a good deal, as to his complexion and eyeballs, as if he had just
been cut down after an unpractical attempt to hang himself. There
is little color in these things save a vigorous opposition of black and
white, or of shaded flesh-tints and heavy browns; yet they are strikingly
solid and definite. Their great quality, we repeat, is their extreme nat-
uralness, their unmixed, unredeemed reality. They are brutal, hard,
indelicate, and as the maximum of the artist's effort they would be
almost melancholy; but they contain the material of an excellent founda-
tion—a foundation strong enough to support a very liberal structure.
What does Mr. Duveneck mean to build upon it? He is most felicitously
young, and time will show. We frankly confess that we shall take it
hard if he fails to do something of the first degree of importance.

The Academy contained the usual proportion of landscapes, and
these landscapes contained the usual proportion of mild merit. The
average merit, as we say, was mild, but it was recognizable as merit.
We flourish as yet decidedly more in our handling of rocks and trees and
blue horizon-hills than in our dealings with heads and arms and legs.
At the Academy were a great many very pretty rocks and trees, a great
many charming wavelets and cloudlets. Some of the rocks were most
delectable—those, for instance, of Mr. Thomas Moran, in his picture of
certain geological eccentricities in Utah. The cliffs there, it appears, are
orange and pink, emerald green and cerulean blue; they look at a dis-
tance as if, in emulation of the vulgar liberties taken with the exposed
strata in the suburbs of New York, they had been densely covered with
bill-posters of every color of the rainbow. Mr. Moran's picture is, in
the literal sense of the word, a brilliant production. We confess it gives
a rather uncomfortable wrench to our prosy preconceptions of the con-
duct and complexion of rocks, even in their more fantastic moods; but
we remember that all this is in Utah, and that Utah is terribly far away.
We cannot help wishing that Mr. Moran would try his hand at some-
thing a little nearer home, so that we might have a chance to congratu-
late him, with a good conscience, not only upon his brilliancy, but
upon his fidelity. This is a satisfaction we were able to enjoy with
regard to Mr. Jervis McEntee, the author of the landscape which most
took our own individual fancy—a pond in a little scrubby, all but leafless
wood, on a gray autumn afternoon. There are some children playing
on the edge of it; a sort of blurred splinter of cold sunlight is peeping
out of the thick low clouds and touching the stagnant, shallow pool. It
is excellent in tone; it is a genuine piece of melancholy autumn; we felt
as if we were one of the children grubbing unæsthetically in the ugly
wood, breaking the lean switches, and kicking the brown leaves. There
are other things which would be worth mentioning if we were attempt-

ing to speak of the Exhibition in detail. It may seem disrespectful, from a certain point of view, to allude to such performances as Mr. Bierstadt's "California in Spring" and Mr. Cropsey's "Sidney Plains" as "details"; they take up much space on the walls; but they have taken little (and even that we grudge them) in our recollections. Mr. Church had two or three pictures at the Academy—small for him, and for him, too, rather feeble. But, in compensation, he had at the same time a large and elaborate landscape at Goupil's—a certain "Valley of Santa Isabel," in New Granada. We know of nothing that is a better proof of the essential impotence of criticism, in the last resort, than Mr. Church's pictures. One can't say what one means about them; the common critical formulas are too inflexible. It would be the part of wisdom perhaps to attempt and to desire to say nothing; simply to leave them to their tranquil destiny, which is apparently very honorable and comfortable. If you praise them very highly, you say more than you mean; if you denounce them, if, in vulgar parlance, you sniff at them, you say less. It is the kind of art which seems perpetually skirting the edge of something worse than itself, like a woman with a taste for florid ornaments who should dress herself in a way to make quiet people stare, and yet who should be really a very reputable person. As we looked at Mr. Church's velvety vistas and gem-like vegetation, at Goupil's, we felt honestly sorry that there was any necessity in this weary world for taking upon one's self to be a critic, for deeming it essential to a proper self-respect to be analytical. Why not accept this lovely tropic scene as a very pretty picture, and have done with it? A very pretty picture, surely, it was, and a very skillful, and laborious, and effective one. The valley of Santa Isabel melts away into the softest violet glow—the most cunning aërial perspective. The great, heavy, yellow tropic sun sinks down into the wine-colored mountains as if exhausted and athirst with his own prodigious heat, and his level rays come wandering forward down the mile-long gorges, and floating over the lustrous mountain lake in the middle distance, and flinging themselves in the flower-strewn grass in the foreground, in the most natural fashion in the world—natural, we mean, when nature is in her theatrical, her demonstrative, her exhibitory moods. Certainly if we were able to handle a brush, we should not use it, in some places (especially in our mysterious, deep-toned boskages, and our rich, multitudinous leafage), exactly as Mr. Church does; but his own brush is an extremely accomplished one, and we should be poorly set to work to quarrel with the very numerous persons who admire its brilliant feats.[1]

[1] Henry James, "On Some Pictures Lately Exhibited," *The Galaxy*, XX (July, 1875), 89-97.

HAMLIN GARLAND: IMPRESSIONISM, 1894

These excerpts from what John Rewald has termed the "first all-out defense of Impressionism in English," appeared in Crumbling Idols *(1894) by the American novelist, Hamlin Garland (1860-1940). His essay was based on the examples of international Impressionism he had seen at the World's Columbian Exposition in Chicago in 1893, seven years after the successful Impressionist show Durand-Ruel brought to New York in 1886. Garland sees Impressionism not as a passive and scientifically precise method, but as a vigorous, individualistic, and buoyant style ideally suited to capture local variations. Thus for him it becomes a rallying point for the new and particularly for those personal and local values which Garland was seeking to establish in his own prose.*

Impressionism

Every competent observer who passed through the art palace at the Exposition was probably made aware of the immense growth of impressionistic or open-air painting. If the Exposition had been held five years ago, scarcely a trace of the blue-shadow idea would have been seen outside the work of Claude Monet, Pisarro, and a few others of the French and Spanish groups.

To-day, as seen in this wonderful collection, impressionism as a principle has affected the younger men of Russia, Norway, Sweden, Denmark, and America as well as the *plein air* school of Giverney. Its presence is put in evidence to the ordinary observer in the prevalence of blue or purple shadows, and by the abundance of dazzling sun-light effects.

This growth of an idea in painting must not be confounded with a mere vogue. It is evolutionary, if not destructive, in the eyes of the old-school painters, at least. To the younger men it assumes almost as much importance as the law of gravity. With them it is the true law of light and shade.

It may be worth while to consider, quite apart from technical terms, the principles upon which this startling departure from the conventional manner is based.

The fundamental idea of the impressionists, as I understand it, is that a picture should be a unified impression. It should not be a mosaic, but a complete and of course momentary concept of the sense of sight. It should not deal with the concepts of other senses (as touch), nor with judgments; it should be the stayed and reproduced effect of a single section of the world of color upon the eye. It should not be a number of

pictures enclosed in one frame, but a single idea impossible of sub-division without loss.

They therefore strive to represent in color an instantaneous effect of light and shade as presented by nature, and they work in the open air necessarily. They are concerned with atmosphere always. They know that the landscape is never twice alike. Every degree of the progress of the sun makes a new picture. They follow the most splendid and allur-ing phases of nature, putting forth almost superhuman effort to catch impressions of delight under which they quiver.

They select some moment, some center of interest,—generally of the simplest character. This central object they work out with great care, but all else fades away into subordinate blur of color, precisely as in life. We look at a sheep, for example, feeding under a tree. We see the sheep with great clearness, and the tree and the stump, but the fence and hill outside the primary circle of vision are only obscurely perceived. The meadow beyond is a mere blur of yellow-green. This is the natural arrangement. If we look at the fence or the meadow, an-other picture is born.

It will thus be seen that these men are veritists in the best sense of the word. They are referring constantly to nature. If you look care-fully at the Dutch painters and the English painters of related thought, you will find them working out each part of the picture with almost the same clearness. Their canvases are not single pictures, they are mosaics of pictures, packed into one frame. Values are almost equal everywhere.

This idea of impressionism makes much of the relation and inter-play of light and shade,—not in black and white, but in color. Im-pressionists are, above all, colorists. They cannot sacrifice color for multiple lines. They do not paint leaves, they paint masses of color; they paint the *effect* of leaves upon the eye.

They teach that the retina perceives only plane surfaces. The eye takes note, in its primary impressions, of masses rather than lines. This idea affects the painting of groups; and the most advanced painter never loses the unity of light effects, no matter how tempting a subject may be, nor how complex.

<p style="text-align:center">* * *</p>

The point to be made here is this, the atmosphere and coloring of Russia is not the atmosphere of Holland. The atmosphere of Nor-way is much clearer and the colors more vivid than in England. One school therefore cannot copy or be based upon the other without loss. Each painter should paint his own surroundings, with nature for his

teacher, rather than some Dutch master, painting the never-ending mists and rains of the sea-level.

This brings me to my settled conviction that art, to be vital, must be local in its subject; its universal appeal must be in its working out,— in the way it is done. Dependence upon the English or French groups is alike fatal to fresh, individual art.

The impressionist is not only a local painter, in choice of subject he deals with the present. The impressionist is not an historical painter, he takes little interest in the monks and brigands of the Middle Ages.

* * *

He does not feel that America is without subjects to paint because she has no castles and donjon keeps. He loves nature, not history. His attitude toward nature is a personal one. He represents the escape from childish love of war and the glitter of steel.

* * *

The impressionist does not paint Cherubs and Loves and floating iron chains. He has no conventional pictures, full of impossible juxta-positions. He takes fresh, vital themes, mainly out-of-door scenes. He aims always at freshness and vigor.

The impressionist is a buoyant and cheerful painter. He loves the open air, and the mid-day sun. He has little to say about the "mystery" and "sentiment" of nature. His landscapes quiver with virile color. He emphasizes (too often over-emphasizes) his difference in method, by choosing the most gorgeous subjects. At his worst, the impressionist is daring in his choice of subject and over-assertive in his handling. Nat-urally, in his reaction he has swung back across the line too far.

This leads Monet to paint the same haystack in twenty different lights, in order to emphasize the value of color and atmosphere over mere subject. It leads Dodge McKnight to paint water "till it looks as if skinned," as one critic said. It led Bunker to paint the radiant meadows of June, and leads Remington to paint the hot hollows between hills of yellow sand, over which a cobalt, cloudless sky arches.

* * *

It is blind fetichism, timid provincialism, or commercial greed which puts the works of "the masters" above the living, breathing artist. Such is the power of authority that people who feel no answering thrill from some smooth, dim old paintings are afraid to say they do not care for them for fear someone will charge them with stupidity or ignorance.

The time is coming when the tyranny of such criticism will be overthrown. There is no exclusive patent on painting. There are just as faithful artists to-day as ever lived, and much more truthful than any past age could have been. Day by day the old sinks an inch. The same questions face the painter that face the novelist or the sculptor. Has the last word been said? Did the masters utter the last word? Are there no new kingdoms of art? It is the age-worn demand of the old that the new shall conform.

The old masters saw nature in a certain way,—right or wrong it does not matter; youth must conform. They saw nature in a somber fashion, therefore youth must be decorous. Youth, in impressionism, to-day is saying, "I have nothing to do with Constable or Turner. Their success or failure is nothing to me, as an artist. It is my own impression of nature I am to paint, not theirs. I am to be held accountable to nature, not to the painters of a half century ago."

* * *

The iconoclast is a necessity. He it is who breaks out of the hopeless circle of traditional authority. His declaration of independence is a disturbance to those who sleep on the bosom of the dead prophets. The impressionist is unquestionably an iconoclast, and the friends of the dead painters are properly alarmed. Here, as everywhere, there are the two parties,—the one standing for the old, the other welcoming the new. A contest like that between realism and romanticism is not playful, it is destructive.

To a man educated in the school of Munich, the pictures, both of the Norwegians and of the Giverney group of Frenchmen and all other pictures with blue and purple shadows, are a shock. They are not merely variants, they are flags of anarchy; they leave no middle ground, apparently. If they are right, then all the rest are wrong. By contrast the old is slain.

Not merely this, but to the connoisseur who believes that Corot, Rousseau, or Millet touched the highest point of painting, these impressionists are intruders, "they come in unbidden; they are ribald when they are not absurd." It is the same old fight between authority and youth, between the individual and the mass. "We do not welcome change, we conservatives. It discredits our masters and confuses us with regard to works we have considered to be mountain-peaks of endeavor."

As a matter of fact, they are justified in taking a serious view of the situation. The change in method indicated by vivid and fearless coloring, indicates a radical change in attitude toward the physical universe. It stands for an advance in the perceptive power of the human

eye. Mercifully, for youth, the world of human kind and physical nature forever offers new phases for discovery, for a new work of art; just as new subtleties of force lure minds like Edison's into the shadow, so to the young and unfettered artists new worlds of art beckon.

Let the critic who thinks this a vogue or fad, this impressionist view of nature, beware. It is a discovery, born of clearer vision and more careful study,—a perception which was denied the early painters, precisely as the force we call electricity was an ungovernable power a generation ago.

The dead must give way to the living. It may be sad, but it is the inexorable law, and the veritist and the impressionist will try to submit gracefully to the method of the iconoclasts who shall come when they in their turn are old and sad.

For the impressionists rank themselves with those who believe the final word will never be spoken upon art. That they have added a new word to painting, no competent critic will deny. It has made nature more radiantly beautiful, this new word. Like the word of a lover, it has exalted the painter to see nature irradiated with splendor never seen before. Wherever it is most originally worked out, it makes use of a fundamental principle in an individual way, and it has brought painting abreast of the unprejudiced perception of the lover of nature. The principle is as broad as air, its working out should be individual.[1]

ROBERT HENRI: THE NEW YORK EXHIBITION OF INDEPENDENT ARTISTS, 1910

The essential message of Robert Henri's (1865-1929) teaching has been described by John Sloan as the "importance of life as the primary motive of art." These excerpts from Henri's review of the New York Exhibition of Independent Artists of 1910 present his ideas in more concise form than his Art Spirit *and offer additional comments on some of his many protégés among the Eight, Sloan, Glackens, and Shinn, and their associates, Bellows, Coleman, and Myers, who shared their views that art should be concerned with the vital experience of contemporary life. The exhibition was a monument to Henri's teaching and extraordinary influence and marked an extension of the pictorial revolution inaugurated with the exhibition of the Eight, two years earlier, a revolt against the devitalized standards of the National Academy. Henri's teaching, informal and undogmatic, was precisely that kind of communication*

[1] Hamlin Garland, *Crumbling Idols, Twelve Essays on Art and Literature* (Chicago, 1894), pp. 121-141.

in which Greenough and Jarves had long before seen a hope for art in America.

Freedom to think and to show what you are thinking about, that is what the exhibition stands for. Freedom to study and experiment and to present the results of such essay, not in any way being retarded by the standards which are the fashion of the time, and not to be exempted from public view because of such individuality or strangeness in the manner of expression. What such an exhibition desires is all the new evidence, all the new opinions that the artists have, and then their work must either succeed by its integrity or fail from the lack of it. We want to know the ideas of young men. We do not want to coerce them into accepting ours. Every art exhibit should hear from the young as well as the old, and in this one we want to present the independent personal evidence which each artist has to make and which must become a record of their time and a proof of the advancement of human understanding.

This is called an independent exhibition because it is a manifestation of independence in art and of the absolute necessity of such independence. It does not mean that it is an independent organization, but that it is made up of the independent points of view of men who are investigating. What such an exhibition should show is the work of those who are pushing forward, who need and deserve recognition, who must have encouragement, who should receive praise for every step of their advance. They deserve it because they are thinking. The world should stand and watch their progress, not to criticize, but to be criticized by these essays. When we walk into such an exhibition we may expect to see things which we will not understand, but we should not express instantly the first idea which comes into our minds, because that idea is more apt than not to be an exclamation at the shock we receive at seeing something different from what we had expected. All important steps forward in the world have been received by critics and by the public generally as something ridiculous, impossible—until they were accepted and lauded.

As I see it, there is only one reason for the development of art in America, and that is that the people of America learn the means of expressing themselves in their own time and in their own land. In this country we nave no need of art as a culture; no need of art as a refined and elegant performance; no need of art for poetry's sake, or any of these things for their own sake. What we do need is art that expresses the *spirit* of the people of today. What we want is to meet young people who are expressing this spirit and listen to what they have to tell us. Those of us who are old should be anxious to be told

the things by those who are to advance beyond us, and we should not hate to see them in their progress. We should rejoice that a building is rising on the foundation that we have helped and are still helping to erect. I personally want to see things advance. I want to see work done better by others than I have found possible in my life. I want to see progress. It should be impossible to have any feeling of jealousy toward those who are young and who are to accomplish the future.

It is necessary for the people in this country to understand *what* art is, to understand *why* it is, to understand that it is the expression of the temperament of our people, that it is the development of the imagination which in the end must affect not only the production of painting, of sculpture, of poems, music, architecture, but every phase of our daily existence. If art is real it must come to affect every action in our lives, every product, every necessary thing. It is, in fact, the understanding of what is needed in life, and then the pursuit of the best means to produce it. It is not learning how to do something which people will call art, but rather inventing something that is absolutely necessary for the progress of our existence. Our artists must be philosophers; they must be creators; they must be experimenters; they must acquire a knowledge of fundamental law in order that those who seek them and listen to them may learn that there are great laws controlling all existence, that through the understanding of these laws they may live in greater simplicity, greater happiness and greater beauty. Art cannot be separated from life. It is the expression of the greatest need of which life is capable, and we value art not because of the skilled product, but because of its revelation of a life's experience. The artists who produce the most satisfactory art are in my mind those who are absorbed in the civilization in which they are living. Take, for instance, Rockwell Kent. He is interested in everything, in political economy, in farming, in every phase of industrial prosperity. He cannot do without this interest in his art. The very things that he portrays on his canvas are the things that he sees written in the great organization of life and his painting is a proclamation of the rights of man, of the dignity of man, of the dignity of creation. It is his belief in God. It is what art should mean.

Another is John Sloan, with his demand for the rights of man, and his love of the people; his keen observation of the people's folly, his knowledge of their virtues and his surpassing interest in all things. I have never met Sloan but what he had something new to tell me of some vital thing in life that interested him, and which probably was eventually typified in his work.

William Glackens is in this exhibition, as usual, unique in mind, unique in his appreciation of human character, with an element of

humor, an element of criticism, always without fear. He shows a wonderful painting of a nude that has many of the qualities that you notice in the neo-impressionist movement. But Glackens seems to me to have attained a greater beauty and a more fundamental truth. There is something rare, something new in the thing that he has to say. At first it may shock you a little, perhaps a great deal; you question, but you keep looking; you grow friendly toward his art; you come back and you get to feel toward the things that you have criticized as you do toward the defects in the face of a person whom you have grown to like very much. They become essential to you in the whole, and the whole with Glackens is always so much alive, so much the manifestation of a temperament intensely sincere and intensely brave.

A man whose work is beautiful because he is close to life is Jerome Myers. He is also a dreamer; he works close to the little people in this world of New York. He is a lover of people and in his pictures he tells you what he knows of humanity's ways. You don't stop to question his technique, although that is good enough, too, but in studying his paintings you study the soul of the man and his knowledge of the world and the breadth of his kindness.

Not one of these men will talk to you of their technique or of any organization they are interested in, or of any effort to form a society. They will tell you that they want independence for their ideas, independence for every man's idea. Why, this country was founded with the idea of independence, with the idea of man's right for freedom. We do not think much about this, and yet it was the first idea that caused people to fight under the leadership of such a man as Patrick Henry.

* * *

What a mistake we have made in life in seeking for the finished product. A thing that is finished is dead. That is why the student interests me so. He is in the process of growth. He is experimenting; he is testing all his powers; he has no thought of any finished product in his expression. A thing that has the greatest expression of life itself, however roughly it may be expressed, is in reality the most finished work of art. A finished technique without relation to life is a piece of mechanics, it is not a work of art. Some of the things that may hold one's attention in this present exhibition are possibly the very slight sketches.

* * *

I do not wish to convey the idea that this exhibition was planned for the work of young people; at least, for those who are young in

their abilities as artists, because most of the exhibitors are not young people. A few of them are older than some very old artists that I know. Take the picture, for instance, of Julius Golz, the painter of Blackwell's Island and the East River. What force and power is in this man's work. He seems to be the only man who has ever painted the East River, that wonderful snowswept fence against that absolutely deep and tragic water and then beyond, Blackwell's Island, and all done without a particle of sentimentality. As a canvas it stands as a striking piece of realism and yet in the hanging it is associated with and is a most natural accompaniment to the painting of Arthur Davies, the great imaginator. Side by side with the work of these two men is the painting showing the tenderness and bravery and the imagination of Homer Boss, and down the line is John Sloan's "Clown," a wonderful piece of work.

I want to speak again of John Sloan, of his painting of the backs of houses, old Twenty-second Street houses, with the boys on the roof startling the pigeons into flight. It is a human document of the lives of the people living in those houses. You feel the incidents in the windows, the incidents in the construction of the houses, the incidents in the wear and tear on them; in fact, the life of that neighborhood is all shown in the little line of houses, yellow and red houses, warm in the sunlight. And the quality of the sunlight is that of a caress; the houses, the atmosphere are steeped in its warmth.

These are some of the things that it seems to me a person will see at the Independent Exhibition of pictures. Those who are looking for exhibitions of culture in some set form or fashion in art will probably not see these things, because of the prejudice of their point of view, because they are really looking in different directions. They are looking for the signs of the acquirement of the fashion in art of the day; they are not looking for the thoughts, the feelings, the life of a man; they are not searching for a personal record in a man's work. They seek an accomplishment in a trade.

*　　*　　*

There are some prize fights in this exhibition, the work of George Bellows, which are full also of their own kind of beauty, strength, energy, declaration of physical grace. Their value is in Bellows' appreciation of what is interesting in this phase of life, and the work has its own beauty.

Everett Shinn is there, too, with his distinct whimsical humor. He has done some marvelous work. He is full of enthusiastic interest in life, and his works are full of the beauty of this enthusiasm. He

likes the show; he understands its pleasures, and he makes you see and understand every phase of it. And his most serious work is presented with a sparkle of never-failing exquisite whimsicality. His way of seeing never fails in interest.

Of Ernest Lawson there is the love of the vibration of light, his enjoyment of life as it is, his power to see the poetry in it, his desire to express all the romance of Nature without adding to it, finding enough romance in the thing as it exists,—a greater romance than any human mind could imagine.

Glenn O. Coleman is another man to be remembered. He is represented in this exhibition by a canvas done in simple breadth, rich and deeply impersonal in color; the very spirit of an old New York street seeping in rain. Edith Dimock is represented by a series of most original delightfully humorous water-color drawings—such criticisms of the manners and appearance of people is there yet with the amusement they evoke the heart also warms toward them. Walt Kuhn's work is full of rugged vigor. Margaret Eckerson shows a Rodin-like head. But in the exhibition of sculpture we turn first and last to Borglum's Lincoln,—the Great Independent. A distinctly new painter of snow, possessed of great virility, is Edward Keith, Jr. There is a spirit of youth in the way Stella Elmendorf has painted her flowers. They are presented as youth sees growing things, strong, courageous and sympathetic. In Amy Londoner's pictures there is a rare specialization through color and a very personal note of humor. Maurice Prendergast's work shows, as always, the happy vibration of light which suggests the vitality of life itself. The entire third floor of this exhibition is given up to a presentation of drawings by modern American artists, probably the best collection of this line of work ever shown in New York.

I have been asked if this Independent Exhibition will become a permanent organization. I have not the slightest doubt but what the *idea* will go on, but I personally have no interest whatever in forming it into a society, and if an institution were formed and I were to become a member of it, I would probably be the first man to secede from it, because I can see no advantage to art in the existence of art societies. The thing that interests me in this is the idea of it, the idea of independence, the idea of encouragement of independence and individuality in study and the giving of an opportunity for greater freedom in exhibitions.[1]

[1] Robert Henri, "The New York Exhibition of Independent Artists," *The Craftsman, XVIII,* No. 2 (1910), 160-172.

7

Modernism:
Early Phases

JAMES ABBOT McNEILL WHISTLER: THE GENTLE ART OF MAKING ENEMIES, 1890

In his Gentle Art of Making Enemies *the expatriate American painter James Abbot McNeill Whistler (1834-1903) included these excerpts from the court proceedings of 1878 in his libel suit against John Ruskin. Whistler was awarded a farthing in damages, but public sentiment so strongly favored Ruskin that Whistler was forced into bankruptcy. The trial, marked by considerable hilarity and the sallies of Whistler's pugnacious wit, was a rather dubious attempt to prove at law the viability of a work of art,* Nocturne in Black and Gold—The Falling Rocket. *Reproduced from the same volume is Whistler's defense of his own art, which, very close to being a defense of abstract painting, stands as one of the major statements of the modern point of view in painting.*

The Action

In the Court of Exchequer Division on Monday, before Baron Huddleston and a special jury, the case of Whistler *v.* Ruskin came on for hearing. In this action the plaintiff claimed £1000 damages.

Mr. Serjeant Parry and Mr. Petheram appeared for the plaintiff; and the Attorney-General and Mr. Bowen represented the defendant.

Mr. Serjeant Parry, in opening the case on behalf of the plaintiff, said that Mr. Whistler had followed the profession of an artist for many years, both in this and other countries. Mr. Ruskin, as would be probably known to the gentlemen of the jury, held perhaps the highest position in Europe and America as an art critic, and some of his works, were, he might say, destined to immortality. He was, in fact, a gentleman of the highest reputation. In the July number of *Fors Clavigera* there appeared passages in which Mr. Ruskin criticized what he called "the modern school," and then followed the paragraph of which Mr. Whistler now complained, and which was: "For Mr. Whistler's own sake, no less than for the protection of the purchaser, Sir Coutts Lindsay ought not to have admitted works into the gallery in which the ill-educated conceit of the artist so nearly approached the aspect of wilful imposture. I have seen, and heard, much of cockney impudence before now; but never expected to hear a coxcomb ask two hundred guineas for flinging a pot of paint in the public's face." That passage, no doubt, had been read by thousands, and so it had gone forth to the world that Mr. Whistler was an ill-educated man, an impostor, a cockney pretender, and an impudent coxcomb.

Mr. Whistler, cross-examined by the Attorney-General, said: "I

have sent pictures to the Academy which have not been received. I believe that is the experience of all artists. . . . The nocturne in black and gold is a night piece, and represents the fireworks at Cremorne."

"Not a view of Cremorne?"

"If it were called a view of Cremorne, it would certainly bring about nothing but disappointment on the part of the beholders. (*Laughter.*) It is an artistic arrangement. It was marked two hundred guineas."

"Is not that what we, who are not artists, would call a stiffish price?"

"I think it very likely that that may be so."

"But artists always give good value for their money, don't they?"

"I am glad to hear that so well established. (*A laugh.*) I do not know Mr. Ruskin, or that he holds the view that a picture should only be exhibited when it is finished, when nothing can be done to improve it, but that is a correct view; the arrangement in black and gold was a finished picture, I did not intend to do anything more to it."

"Now, Mr. Whistler. Can you tell me how long it took you to knock off that nocturne?"

. . . "I beg your pardon?" (*Laughter.*)

"Oh! I am afraid that I am using a term that applies rather perhaps to my own work. I should have said, How long did you take to paint that picture?"

"Oh, no! permit me, I am too greatly flattered to think that you apply, to work of mine, any term that you are in the habit of using with reference to your own. Let us say then how long did I take to—'knock off,' I think that is it—to knock off that nocturne; well, as well as I remember, about a day."

"Only a day?"

"Well, I won't be quite positive; I may have still put a few more touches to it the next day if the painting were not dry. I had better say then, that I was two days at work on it."

"Oh, two days! The labor of two days, then, is that for which you ask two hundred guineas!"

"No;—I ask it for the knowledge of a lifetime." (*Applause.*)

"You have been told that your pictures exhibit some eccentricities?"

"Yes; often." (*Laughter.*)

"You send them to the galleries to incite the admiration of the public?"

"That would be such vast absurdity on my part, that I don't think I could." (*Laughter.*)

"You know that many critics entirely disagree with your views as to these pictures?"

"It would be beyond me to agree with the critics."

"You don't approve of criticism then?"

"I should not disapprove in any way of technical criticism by a man whose whole life is passed in the practice of the science which he criticises; but for the opinion of a man whose life is not so passed I would have as little regard as you would, if he expressed an opinion on law."

"You expect to be criticised?"

"Yes; certainly. And I do not expect to be affected by it, until it becomes a case of this kind. It is not only when criticism is inimical that I object to it, but also when it is incompetent. I hold that none but an artist can be a competent critic."

"You put your pictures upon the garden wall, Mr. Whistler, or hang them on the clothes line, don't you—to mellow?"

"I do not understand."

"Do you not put your paintings out into the garden?"

"Oh! I understand now. I thought, at first, that you were perhaps again using a term that you are accustomed to yourself. Yes; I certainly do put the canvases into the garden that they may dry in the open air while I am painting, but I should be sorry to see them 'mellowed.'"

"Why do you call Mr. Irving 'an arrangement in black'?" (*Laughter.*)

Mr. Baron Huddleston: "It is the picture and not Mr. Irving that is the arrangement."

A discussion ensued as to the inspection of the pictures, and incidentally Baron Huddleston remarked that a critic must be competent to form an opinion, and bold enough to express that opinion in strong terms if necessary.

The Attorney-General complained that no answer was given to a written application by the defendant's solicitors for leave to inspect the pictures which the plaintiff had been called upon to produce at the trial. The Witness replied that Mr. Arthur Severn had been to his studio to inspect the paintings, on behalf of the defendant, for the purpose of passing his final judgment upon them and settling that question for ever.

Cross-examination continued: "What was the subject of the nocturne in blue and silver belonging to Mr. Grahame?"

"A moonlight effect on the river near old Battersea Bridge."

"What has become of the nocturne in black and gold?"

"I believe it is before you." (*Laughter.*)

The picture called the nocturne in blue and silver, was now produced in Court.

"That is Mr. Grahame's picture. It represents Battersea Bridge by moonlight."

Baron Huddleston: "Which part of the picture is the bridge?" (*Laughter.*)

His Lordship earnestly rebuked those who laughed. And witness explained to his Lordship the composition of the picture.

"Do you say that this is a correct representation of Battersea Bridge?"

"I did not intend it to be a 'correct' portrait of the bridge. It is only a moonlight scene and the pier in the center of the picture may not be like the piers at Battersea Bridge as you know them in broad daylight. As to what the picture represents that depends upon who looks at it. To some persons it may represent all that is intended; to others it may represent nothing."

"The prevailing color is blue?"

"Perhaps."

"Are those figures on the top of the bridge intended for people?"

"They are just what you like."

"Is that a barge beneath?"

"Yes. I am very much encouraged at your perceiving that. My whole scheme was only to bring about a certain harmony of color."

"What is that gold-colored mark on the right of the picture like a cascade?"

"The 'cascade of gold' is a firework."

A second nocturne in blue and silver was then produced.

Witness: "That represents another moonlight scene on the Thames looking up Battersea Reach. I completed the mass of the picture in one day."

The Court then adjourned. During the interval the jury visited the Probate Court to view the pictures which had been collected in the Westminster Palace Hotel.

After the Court had re-assembled the "Nocturne in Black and Gold" was again produced, and Mr. Whistler was further cross-examined by the Attorney-General: "The picture represents a distant view of Cremorne with a falling rocket and other fireworks. It occupied two days, and is a finished picture. The black monogram on the frame was placed in its position with reference to the proper decorative balance of the whole."

"You have made the study of Art your study of a lifetime. Now do you think that anybody looking at that picture might fairly come to the conclusion that it had no peculiar beauty?"

"I have strong evidence that Mr. Ruskin did come to that conclusion."

"Do you think it fair that Mr. Ruskin should come to that conclusion?"

"What might be fair to Mr. Ruskin I cannot answer."

"Then you mean, Mr. Whistler, that the initiated in technical matters might have no difficulty in understanding your work. But do you think now that you could make *me* see the beauty of that picture?"

The witness then paused, and examining attentively the Attorney-General's face and looking at the picture alternately, said, after apparently giving the subject much thought, while the Court waited in silence for his answer:

"No! Do you know I fear it would be as hopeless as for the musician to pour his notes into the ear of a deaf man. (*Laughter.*)

"I offer the picture, which I have conscientiously painted, as being worth two hundred guineas. I have known unbiassed people express the opinion that it represents fireworks in a night-scene. I would not complain of any person who might simply take a different view."

The Court then adjourned.

* * *

Nature contains the elements, in color and form, of all pictures, as the keyboard contains the notes of all music.

But the artist is born to pick, and choose, and group with science, these elements, that the result may be beautiful—as the musician gathers his notes, and forms his chords, until he brings forth from chaos glorious harmony.

To say to the painter, that Nature is to be taken as she is, is to say to the player, that he may sit on the piano.

That Nature is always right, is an assertion, artistically, as untrue, as it is one whose truth is universally taken for granted. Nature is very rarely right, to such an extent even, that it might almost be said that Nature is usually wrong: that is to say, the condition of things that shall bring about the perfection of harmony worthy of a picture is rare, and not common at all.

This would seem, to even the most intelligent, a doctrine almost blasphemous. So incorporated with our education has the supposed aphorism become, that its belief is held to be part of our moral being, and the words themselves have, in our ear, the ring of religion. Still, seldom does Nature succeed in producing a picture.

* * *

As music is the poetry of sound, so is painting the poetry of sight, and the subject-matter has nothing to do with harmony of sound or of color.

The great musicians knew this. Beethoven and the rest wrote

music—simply music; symphony in this key, concerto or sonata in that.

On F or G they constructed celestial harmonies—as harmonies—as combinations, evolved from the chords of F or G and their minor correlatives.

This is pure music as distinguished from airs—commonplace and vulgar in themselves, but interesting from their associations, as, for instance, "Yankee Doodle," or "Partant pour la Syrie."

Art should be independent of all clap-trap—should stand alone, and appeal to the artistic sense of eye or ear, without confounding this with emotions entirely foreign to it, as devotion, pity, love, patriotism, and the like. All these have no kind of concern with it and that is why I insist on calling my works "arrangements" and "harmonies."

Take the picture of my mother, exhibited at the Royal Academy as an "Arrangement in Grey and Black." Now that is what it is. To me it is interesting as a picture of my mother; but what can or ought the public to care about the identity of the portrait?

The imitator is a poor kind of creature. If the man who paints only the tree, or flower, or other surface he sees before him were an artist, the king of artists would be the photographer. It is for the artist to do something beyond this: in portrait painting to put on canvas something more than the face the model wears for that one day; to paint the man, in short, as well as his features; in arrangement of colors to treat a flower as his key, not as his model.[1]

ALBERT PINKHAM RYDER: PARAGRAPHS FROM THE STUDIO OF A RECLUSE, 1905

The haunted marines, brooding landscapes, and symbolic pictures of Albert Pinkham Ryder (1847-1917) are part of a continuing strain of romanticism in American painting, but as he describes the revelation which launched his unique style and his attempts to seize by the simplest forms the first vision of an idea, Ryder reveals himself to be closely akin to contemporary French symbolism and thereby related to the main-stream of modern painting.

The artist should fear to become the slave of detail. He should strive to express his thought and not the surface of it. What avails a storm cloud accurate in form and color if the storm is not therein? A daub of white will serve as a robe to Miranda if one feels the shrinking

[1] James Abbot McNeill Whistler, *The Gentle Art of Making Enemies* (New York, 1890), pp. 2-10, 127-128, 143.

timidity of the young maiden as the heavens pour down upon her their vials of wrath.

It is the first vision that counts. The artist has only to remain true to his dream and it will possess his work in such a manner that it will resemble the work of no other man—for no two visions are alike, and those who reach the heights have all toiled up the steep mountains by a different route. To each has been revealed a different panorama.

Imitation is not inspiration, and inspiration only can give birth to a work of art. The least of a man's original emanation is better than the best of a borrowed thought. In pure perfection of technique, coloring and composition, the art that has already been achieved may be imitated, but never surpassed. Modern art must strike out from the old and assert its individual right to live through Twentieth Century impressionism and interpretation. The new is not revealed to those whose eyes are fastened in worship upon the old. The artist of today must work with his face turned toward the dawn, steadfastly believing that his dream will come true before the setting of the sun.

The canvas I began ten years ago I shall perhaps complete today or tomorrow. It has been ripening under the sunlight of the years that come and go. It is not that a canvas should be worked at. It is a wise artist who knows when to cry "halt" in his composition, but it should be pondered over in his heart and worked out with prayer and fasting.

Art is long. The artist must buckle himself with infinite patience. His ears must be deaf to the clamor of his insistent friends who would quicken his pace. His eyes must see naught but the vision beyond. He must await the season of fruitage without haste, without worldly ambitions, without vexation of spirit. An inspiration is no more than a seed that must be planted and nourished. It gives growth as it grows to the artist, only as he watches and waits with his highest effort.

* * *

Nature is a teacher who never deceives. When I grew weary with the futile struggle to imitate the canvases of the past, I went out into the fields, determined to serve nature as faithfully as I had served art. In my desire to be accurate I became lost in a maze of detail. Try as I would, my colors were not those of nature. My leaves were infinitely below the standard of a leaf, my finest strokes were coarse and crude. The old scene presented itself one day before my eyes framed in an opening between two trees. It stood out like a painted canvas—the deep blue of a midday sky—a solitary tree, brilliant with the green of early summer, a foundation of brown earth and gnarled roots. There was no detail to vex the eye. Three solid masses of form and color—sky, foliage

and earth—the whole bathed in an atmosphere of golden luminosity. I threw my brushes aside; they were too small for the work in hand. I squeezed out big chunks of pure, moist color and taking my palette knife, I laid on blue, green, white and brown in great sweeping strokes. As I worked I saw that it was good and clean and strong. I saw nature springing into life upon my dead canvas. It was better than nature, for it was vibrating with the thrill of a new creation. Exultantly I painted until the sun sank below the horizon, then I raced around the fields like a colt let loose, and literally bellowed for joy.[1]

THE ARMORY SHOW, 1913

The International Exhibition of Modern Art of 1913, popularly known as the Armory Show, brought for the first time before a wide American public in New York, Chicago, and Boston the work of the great French moderns. Thus, with the aid of the publicity suggested in Walt Kuhn's (1877-1949) enthusiastic letter, the intention of Arthur B. Davies (1862-1928) as it was expressed in the introduction to the exhibition catalogue was amply fulfilled. Whether the show succeeded as well in bringing a new spirit to American art, as Kuhn hoped, is much less certain. Many Americans had already come under the spell of the new European painting, and many others would undoubtedly have followed without benefit of the events at the Armory. The show also served to sharpen the hostility of other American painters such as the conservative muralist Kenyon Cox (1856-1919) who was their spokesman. As to the response of the public at large, the honest bewilderment of the distinguished layman, Theodore Roosevelt, is perhaps the most accurate guide. One definite result of the show was the effects it had upon American collectors, many of whom, following John Quinn's example, began to acquire works of the French artists so brilliantly represented. Paradoxically among the Americans most damaged by this shift in taste were the organizers of the Exhibition—all but one of the Eight were involved—whose realism suddenly seemed old fashioned.

Walt Kuhn: Letter to Walter Pach, 1912

Dear Pach:

I should have written you before this but Davies and myself have been on the jump every minute since we landed. Today I gave the

[1] A. P. Ryder, "Paragraphs from the Studio of a Recluse," *Broadway Magazine, XIV* (September, 1905), 10-11.

papers the list of European stuff which we know of definitely. It will be like a bomb shell, the first news since our arrival.

You have no idea how eager everybody is about this thing and what a tremendous success it's going to be. Everybody is electrified when we quote the names, etc. The outlook is great, and after having figured up the likely income we stand to come out ahead of the game as far as money goes. The articles appearing from now on will increase the desire to help by the money'd "classes." We owe you a tremendous lot for your indispensable help and advice, but you know that we are all in the same boat for this great chance to make the American think. I feel as though I had crowded an entire art education into these few weeks. Chicago has officially asked for the show, and of course we accepted.

I am very anxious to get a "thumb nail" biography of *all* the important men. Will you see what you can get for me, every little bit helps, anything of interest. The papers are also interested in portrait-photos of the men themselves. Everything you can send me in this line will be of enormous help in securing good press notices. I have planned a press campaign to run from now right through the show, and then some—a snapshot of the Duchamp-Villon brothers in their garden, for instance will help me get a special article on them. I await your story on them, also Redon. We are going to feature Redon big (BIG!). You see the fact that he is so little known will mean a still bigger success in publicity.

John Quinn, our lawyer and biggest booster, is strong for plenty of publicity, he says the New Yorkers are worse than rubes, and must be told. All this is not to my personal taste, I'd rather stay home and work hard at my pictures shoving in some of the things I have learned, but we are all in deep water now and have got to paddle—Don't disappoint me on this—Our show must be talked about all over the U.S. before the doors open.

* * *

We have a great opportunity in this show, and must try to make it truly wonderful and get all the people there, which owing to the extremely short duration of the show is very hard, and can only be done through the press. So don't ignore my plea for minor information, it may be undignified but it brings the desired result. We want this old show of ours to mark the starting point of the new spirit in art, at least as far as America is concerned.

I feel that it will show its effect even further and make the big wheel turn over both hemispheres.[1]

[1] From a letter from Walt Kuhn to Walter Pach, December 12, 1912.

Frederick James Gregg: Preface to the Catalogue for the International Exhibition of Modern Art, 1913

Mr. Arthur B. Davies, President of the Association of American Painters and Sculptors, gave out the following statement on the last day of December, 1912:

> On behalf of the Executive Committee, I desire to explain the general attitude of the Association and especially in regard to the International Exhibition to be held in this city in February and March.
>
> This is not an institution but an association. It is composed of persons of varying tastes and predilections, who are agreed on one thing, that the time has arrived for giving the public here the opportunity to see for themselves the results of new influences at work in other countries in an art way.
>
> In getting together the works of the European Moderns, the Society has embarked on no propaganda. It proposes to enter on no controversy with any institution. Its sole object is to put the paintings, sculptures, and so on, on exhibition so that the intelligent may judge for themselves by themselves.
>
> Of course controversies will arise, just as they have arisen under similar circumstances in France, Italy, Germany and England. But they will not be the result of any stand taken by this Association as such; on the other hand we are perfectly willing to assume full responsibility for providing the opportunity to those who may take one side or the other.
>
> Any individual expression of opinion contrary to the above is at variance with the official resolutions of this Association.

The wide publicity given to the above in the public press all over the country showed to what an extent it was accepted as a definite and precise expression of the policy and the aims of the Association in its relation to the art of Europe and to the American public. That policy and those aims remain unchanged.

Anything that can be said further must be but an amplification of the statement. The foreign paintings and sculptures here shown are regarded by the committee of the Association as expressive of the forces which have been at work abroad of late, forces which cannot be ignored because they have had results.

The American artists exhibiting here, consider the exhibition as of equal importance for themselves as for the lay public. The less they find their work showing signs of the developments indicated in the Europeans, the more reason they will have to consider whether or not painters and sculptors here have fallen behind through escaping the incidence through distance and for other reasons of the forces that have manifested themselves on the other side of the Atlantic.

Art is a sign of life. There can be no life without change, as there

can be no development without change. To be afraid of what is different or unfamiliar, is to be afraid of life. And to be afraid of life is to be afraid of truth, and to be a champion of superstition. This exhibition is an indication that the Association of American Painters and Sculptors is against cowardice even when it takes the form of amiable self satisfaction.[1]

Theodore Roosevelt: A Layman's View of an Art Exhibition, 1913

The recent "International Exhibition of Modern Art" in New York was really noteworthy. Messrs. Davies, Kuhn, Gregg, and their fellow-members of the Association of American Painters and Sculptors have done a work of very real value in securing such an exhibition of the works of both foreign and native painters and sculptors. Primarily their purpose was to give the public a chance to see what has recently been going on abroad. No similar collection of the works of European "moderns" has ever been exhibited in this country. The exhibitors are quite right as to the need of showing to our people in this manner the art forces which of late have been at work in Europe, forces which cannot be ignored.

This does not mean that I in the least accept the view that these men take of the European extremists whose pictures are here exhibited. It is true, as the champions of these extremists say, that there can be no life without change, no development without change, and that to be afraid of what is different or unfamiliar is to be afraid of life. It is no less true, however, that change may mean death and not life, and retrogression instead of development. Probably we err in treating most of these pictures seriously. It is likely that many of them represent in the painters the astute appreciation of the power to make folly lucrative which the late P. T. Barnum showed with his faked mermaid. There are thousands of people who will pay small sums to look at a faked mermaid; and now and then one of this kind with enough money will buy a Cubist picture, or a picture of a misshapen nude woman, repellent from every standpoint.

In some ways it is the work of the American painters and sculptors which is of most interest in this collection, and a glance at this work must convince anyone of the real good that is coming out of the new movements, fantastic though many of the developments of these new movements are. There was one note entirely absent from the exhibition, and that was the note of the commonplace. There was not a touch of simpering, self-satisfied conventionality anywhere in the exhibition. Any

[1] Frederick James Gregg, "Preface to the Catalog for the International Exhibition of Modern Art, 1913."

sculptor or painter who had in him something to express and the power of expressing it found the field open to him. He did not have to be afraid because his work was not along ordinary lines. There was no stunting or dwarfing, no requirement that a man whose gift lay in new directions should measure upon or down to stereotyped and fossilized standards.

For all this there can be only hearty praise. But this does not in the least mean that the extremists whose paintings and pictures were represented are entitled to any praise, save, perhaps, that they have helped to break fetters. Probably in any reform movement, any progressive movement, in any field of life, the penalty for avoiding the commonplace is a liability to extravagance. It is vitally necessary to move forward and to shake off the dead hand, often the fossilized dead hand, of the reactionaries; and yet we have to face the fact that there is apt to be a lunatic fringe among the votaries of any forward movement. In this recent art exhibition the lunatic fringe was fully in evidence, especially in the rooms devoted to the Cubists and the Futurists, or Near-Impressionists. I am not entirely certain which of the two latter terms should be used in connection with some of the various pictures and representations of plastic art—and, frankly, it is not of the least consequence. The Cubists are entitled to the serious attention of all who find enjoyment in the colored puzzle pictures of the Sunday newspapers. Of course there is no reason for choosing the cube as a symbol, except that it is probably less fitted than any other mathematical expression for any but the most formal decorative art. There is no reason why people should not call themselves Cubists, or Octagonists, Parallelopipedonists, or Knights of the Isosceles Triangle, or Brothers of the Cosine, if they so desire; as expressing anything serious and permanent, one term is as fatuous as another. Take the picture which for some reason is called *A naked man going down stairs.* There is in my bath-room a really good Navajo rug which, on any proper interpretation of the Cubist theory, is a far more satisfactory and decorative picture. Now if, for some inscrutable reason, it suited somebody to call this rug a picture of, say, *A well-dressed man going up a ladder,* the name would fit the facts just about as well as in the case of the Cubist picture of the *Naked man going down stairs.* From the standpoint of terminology each name would have whatever merit inheres in a rather cheap straining after effect; and from the standpoint of decorative value, of sincerity, and of artistic merit, the Navajo rug is infinitely ahead of the picture.[1]

1 Theodore Roosevelt, "A Layman's Views of an Art Exhibition," *The Outlook,* March 9, 1913, pp. 718-720.

Kenyon Cox: The Modern Spirit in Art, 1913

It is proper to begin an account of the extraordinary exhibition of modern art recently held in New York with an acknowledgment that it is well such an exhibition should be held and that, therefore, the thanks of the public are due to the gentlemen who got it together. We have heard a great deal about the Post-Impressionists and the Cubists; we have read expositions of their ideas and methods which have had a plausible sound in the absence of the works to be explained; we have had some denunciation and ridicule, some enthusiastic praise, and a great deal of half-frightened and wholly puzzled effort to understand what, it was taken for granted, must have some real significance; but we have not heretofore had an opportunity of seeing the things themselves—the paintings and sculpture actually produced by these men. Now the things are quite indescribable and unbelievable. Neither the praises of their admirers, the ridicule of their opponents, nor the soberest attempt at impartial description can give any idea of them. No reproduction can approach them. They must be seen to be believed possible, and therefore it is well that they should have been seen. From this point of view my only regret is that the Association of American Painters and Sculptors did not see fit to include some representation of the Futurists in their exhibition, that the whole thing might be done once for all. In a case of necessity one may be willing to take a drastic emetic and may even humbly thank the medical man for the efficacy of the dose. The more thorough it is the less chance is there that it may have to be repeated.

Of course I cannot pretend to have approached the exhibition entirely without prejudice. One cannot have studied and practised an art for forty years without the formation of some opinions—even of some convictions. But I remembered the condemnation of Corot and Millet by Gérôme and Cabanel; I remembered the natural conservatism of middle age; I took to heart the admonition of the preface to the catalogue, that "to be afraid of what is different or unfamiliar is to be afraid of life." I meant to make a genuine effort to sort out these people, to distinguish their different aims and doctrines, to take notes and to analyze, to treat them seriously if disapprovingly. I cannot do it. Nor can I laugh. This thing is not amusing; it is heartrending and sickening. I was quoted the other day as having said that the human race is rapidly approaching insanity. I never said it, but if I were convinced that this is really "modern art" and that these men are representative of our time, I should be constrained to believe it.

In recollecting the appalling morning I spent in this place certain personalities do, however, define themselves and certain tendencies make

themselves clear. It is no time for squeamishness or for standing upon "professional courtesy," and such persons as I may mention I shall treat quite frankly—in that respect, at least, I may follow their own example. Fortunately there is little necessity of dwelling upon the American part of the show. It contains some good work by artists who must wonder at the galley aboard which they find themselves, some work with real merit by men who have aided in the launching of the galley, and a great deal of bad work which, however, seldom reaches the depths of badness attainable by Frenchmen and Germans. But this work, good, bad, and indifferent, is either perfectly well known or is so paled by comparison that it needs no mention. Some of it is silly, but little of it is dangerous. There is one American, however, who must be spoken of because he has pushed the new doctrines to a conclusion in some respects more logical and complete than have any of the foreigners. In the wildest productions of Picabia or Picasso there is usually discernible, upon sufficiently painstaking investigation, some faint trace of the natural objects which are supposed to have inspired them; and even when this disappears the title remains to show that such objects have existed. It has remained for Mr. Marsden Hartley to take the final step and to arrange his lines and spots purely for their own sake, abandoning all pretense of representation or even of suggestions. He exhibits certain rectangles of paper covered with a maze of charcoal lines which are catalogued simply as Drawing No. 1, Drawing No. 2, and so forth.

This, I say, is the logical end, for the real meaning of this Cubist movement is nothing else than the total destruction of the art of painting—that art of which the dictionary definition is "the art of representing, by means of figures and colors applied on a surface, objects presented to the eye or to the imagination." Two years ago I wrote: "We have reached the edge of the cliff and must turn back or fall into the abyss." Deliberately and determinedly these men have stepped over the edge. Now the total destruction of painting as a representative art is a thing which a lover of painting could hardly envisage with entire equanimity, yet one may admit that such a thing might take place and yet an art remain that should have its own value. A Turkish rug or a tile from the Alhambra is nearly without representative purpose, but it has intrinsic beauty and some conceivable human use. The important question is what it is proposed to substitute for this art of painting which the world has cherished since there were men definitely differentiated from beasts. They have abolished the representation of nature and all forms of recognized and traditional decoration; what will they give us instead? And here is the difference between Mr. Hartley and his Parisian brothers. His "drawings" are purely nugatory. If one finds it impossible to imagine the kind of human being that could take any

pleasure in them one is free to admit that there is nothing especially disgusting about them. But one cannot say as much for the works of the Frenchmen. In some strange way they have made their work revolting and defiling. To have looked at it is to have passed through a pathological museum where the layman has no right to go. One feels that one has seen not an exhibition, but an exposure.

Of course the work of these artistic anarchists formed only a part of the exhibition. A serious attempt was made to get together a representative showing of the artists whom they consider their forerunners, and a number of the smaller galleries contained what might be considered a series of illustrations of Meier-Graefe. A good many critics who find the latest manifestations of the "modern" spirit quite intolerable are yet able to maintain a complacent satisfaction in these earlier exemplifications of it and even, by contrast, to increase their pleasure in work which seems relatively sane and wholesome. I wish I could feel, as they do, that there is a sudden dislocation with the appearance of Matisse and that everything before him falls naturally into its place as a continuation of the great tradition. I wish I were not forced to see that the easy slope to Avernus began as far back as the sixties of the last century. The lack of discipline and the exaltation of the individual have been the destructive forces of modern art, and they began their work long ago. For a time the persistence of earlier ideals and the possession by the revolutionaries of the very training which they attacked as unnecessary saved the art from entire dissolution. Now all discipline has disappeared, all training is proclaimed useless, and individualism has reached the pitch of sheer insanity or triumphant charlatanism.

* * *

Believing, as I do, that there are still commandments in art as in morals, and still laws in art as in physics, I have no fear that this kind of art will prevail, or even that it can long endure. But it may do a good deal of harm while it lasts. It may dazzle the young students of art with the prospect of an easily attained notoriety which they cannot distinguish from fame, and prevent their acquiring any serious training during the years when, if ever, such training must be acquired; it may so debauch criticism that it shall lose what little authority or usefulness it still retains; it may corrupt public taste and stimulate an appetite for excitement that is as dangerous as the appetite for any other poisonous drug; finally, it may juggle out of the pockets of the gullible a few dollars that will be far more wasted than if they were thrown into the sea. To the critics it is useless to speak. How shall we instruct our self-

appointed instructors? The students and the public may possibly listen, and for them I have a few words of earnest advice.

To the student I would say: Distrust all short cuts to art or to glory. No work worth doing was ever done without long preparation and continuous endeavor. The success that is attained in a month will be forgotten in a year. To the public I would say: Do not allow yourselves to be blinded by the sophistries of the foolish dupes or the self-interested exploiters of all this charlatanry. Remember that it is for you that art is created, and judge honestly for yourselves whether this which calls itself art is useful to you or to the world. You are not infallible, but your instincts are right in the main, and you are, after all, the final judges. If your stomach revolts against this rubbish it is because it is not fit for human food. Let no man persuade you to stuff yourselves with it.[1]

ARTHUR B. DOVE: LETTER TO ARTHUR JEROME EDDY, 1912

Arthur B. Dove (1880-1946) was one of those American painters who prior to the Armory Show had already proceeded to draw his own conclusions from the new European painting. In this letter of 1912 he explains to Arthur Jerome Eddy his Based on Leaf Forms and Spaces, *a picture which Eddy had purchased at a Chicago exhibition of Dove's work. Although Eddy was enthusiastic about Cubism and wrote the first American book on the subject, the approach Dove describes is more involved with a reduction and simplification of natural forms than with the elaborate analytical methods of the Cubists. Dove was less philosophically inclined and more deliberate in his painting methods than Wassily Kandinsky (1866-1944), the Russian abstractionist, but the two independently reached startlingly similar results in 1910. A series of small abstract paintings of that year by Dove were the first such works painted by an American and perhaps the first painted anywhere.*

My dear Mr. Eddy:

You have asked me to "explain as I would talk to any intelligent friend, the idea behind the picture," or in other words, "what I am driving at."

First of all this is not propaganda, there has been too much of that written on Modern Art already. It is simply an explanation of *my own means* in answer to the above question.

<hr>

1 Kenyon Cox, "The Modern Spirit in Art, Some Reflections Inspired by the Recent International Exhibition," *Harper's Weekly*, March 15, 1913, p. 10.

In as much as the means continually changes as one learns, perhaps the best way to make it understood would be to state the different steps which have been taken up to the present time. After having come to the conclusion that there were a few principles existent in all good art from the earliest examples we have, through the masters to the present, I set about it to analyze these principles as they occurred in works of art and in nature.

One of these principles which seemed the most evident was the choice of the simple motif. This same law held in nature, a few forms and a few colors sufficed for the creation of an object. Consequently I gave up my more disorderly methods (impressionism). In other words I gave up trying to express an idea by stating innumerable little facts, the statement of facts having no more to do with the art of painting than statistics with literature. . . .

The first step was to choose from nature a motif in color and with that motif to paint from nature, the forms still being objective.

The second step was to apply this same principle to form, the actual dependence upon the object (representation) disappearing, and the means of expression becoming purely subjective. After working for some time in this way, I no longer observed in the old way, and, not only began to think subjectively but also to remember certain sensations purely through their form and color, that is, by certain shapes, planes of light, or character lines determined by the meeting of such planes.

With the introduction of the line motif the expression grew more plastic and the struggle with the means became less evident.[1]

[1] Arthur B. Dove, "Letter to Arthur Jerome Eddy," in Frederick S. Wight, *Arthur Dove* (Berkeley: University of California Press, 1958), pp. 36-37.

8

Modernism:
Dissent and
Variations

THOMAS HART BENTON: ON REGIONALISM, 1951

Thomas Hart Benton (1889-), along with Grant Wood (1892-1942) and John Steuart Curry (1897-1946), was a leader of American Regionalism. These pages from the 1951 edition of his An Artist in America *are a retrospective summary of that movement and reveal its fundamental nativist, popularist, and anti-urban orientation. Benton's comments are marked by a note of bitterness toward the museum officials and university professors who, with their European aesthetics, remained hostile to this attempt to paint America in images intelligible to all Americans. But Benton understands that the movement reflected a national mood of self-preoccupation, which began with the collapse of Wilsonian idealism and ended with the rise of the internationalist sentiments which were ushered in by the Second World War, and he thereby touches upon deeper causes for the movement's decline than the hostility of the art establishment. This perspective does not soften his scorn for the new wave of abstraction which the post-War years brought. After all, he had been through it a generation earlier and returned.*

Here as I approach the end of my public adventures, I must go back a little and pick up an association which was for a time very much involved in them. I have neglected to mention the two artists whose names during the days of success were always connected with mine. John Steuart Curry and Grant Wood rose along with me to public attention in the thirties. They were very much a part of what I stood for and made it possible for me in my lectures and interviews to promote the idea that an indigenous art with its own aesthetics was a growing reality in America. Without them, I would have had only personal grounds to stand on for my pronouncements.

We were, the three of us, pretty well along before we ever became acquainted or were linked under the now famous name of Regionalism. We were different in our temperaments and many of our ideas, but we were alike in that we were all in revolt against the unhappy effects which the Armory show of 1913 had had on American painting. We objected to the new Parisian aesthetics which was more and more turning art away from the living world of active men and women into an academic world of empty pattern. We wanted an American art which was not empty, and we believed that only by turning the formative processes of art back again to meaningful subject matter, in our cases specifically American subject matter, could we expect to get one.

A book like this, devoted so much to personal happenings, is hardly one in which to deal extensively with the ideas underlying our Regionalism so I shall reserve a detailed study of that for another writing. The term was, so to speak, wished upon us. Borrowed from a group of southern writers who were interested in their regional cultures, it was applied to us somewhat loosely, but with a fair degree of appropriateness. However, our interests were wider than the term suggests. They had their roots in that general and country-wide revival of Americanism which followed the defeat of Woodrow Wilson's universal idealism at the end of World War One and which developed through the subsequent periods of boom and depression until the new internationalisms of the second World War pushed it aside. This Americanist period had many facets, some dark, repressive and suggestive of an ugly neo-fascism, but on the whole it was a time of general improvement in democratic idealism. After the break of 1929 a new and effective liberalism grew over the country and the battles between that liberalism and the entrenched moneyed groups, which had inherited our post Civil War sociology and were in defense of it, brought out a new and vigorous discussion of the intended nature of our society. This discussion and the political battles over its findings, plus a new flood of historical writing concentrated the thirties on our American image. It was this countrywide concentration more probably than any of our artistic efforts which raised Wood, Curry and me to prominence in the national scene. We symbolized aesthetically what the majority of Americans had in mind—America itself. Our success was a popular success. Even where some American citizens did not agree with the nature of our images, instanced in the objections to my state-sponsored murals in Indiana and Missouri, they understood them. What ideological battles we had were in American terms and were generally comprehensible to Americans as a whole. This was exactly what we wanted. The fact that our art was arguable in the language of the street, whether or not it was liked, was proof to us that we had succeeded in separating it from the hothouse atmospheres of an imported and, for our country, functionless aesthetics. With that proof we felt that we were on the way to releasing American art from its subservience to borrowed forms. In the heyday of our success, we really believed we had at last succeeded in making a dent in American aesthetic colonialism.

However, as later occurrences have shown, we were well off the beam on that score. As soon as the second World War began substituting in the public mind a world concern for the specifically American concerns which had prevailed during our rise, Wood, Curry and I found the bottom knocked out from under us. In a day when the problems of America were mainly exterior, our interior images lost public sig-

nificance. Losing that, they lost the only thing which could sustain them because the critical world of art had, by and large, as little use for our group front as it had for me as an individual. The coteries of high-brows, of critics, college art professors and museum boys, the tastes of which had been thoroughly conditioned by the new aesthetics of twentieth-century Paris, had sustained themselves in various subsidized ivory towers and kept their grip on the journals of aesthetic opinion all during the Americanist period. These coteries, highly verbal but not always notably intelligent or able to see through momentarily fashionable thought patterns, could never accommodate our popularist leanings. They had, as a matter of fact, a vested interest in aesthetic obscurity, in highfalutin symbolisms and devious and indistinct meanings. The entertainment of these obscurities, giving an appearance of superior discernment and extraordinary understanding, enabled them to milk the wealthy ladies who went in for art and the college and museum trustees of the country for the means of support. Immediately after it was recognized that Wood, Curry and I were bringing American art out into a field where its meanings had to be socially intelligible to justify themselves and where aesthetic accomplishment would depend on an effective representation of cultural ideas, which were themselves generally comprehensible, the ivory tower boys and girls saw the danger to their presumptions and their protected positions. They rose with their supporting groups of artists and highbrowish disciples to destroy our menace.

As I have related, I profited greatly by their fulminations and so, for a while, did Wood and Curry. However, in the end they succeeded in destroying our Regionalism and returning American art to that desired position of obscurity, and popular incomprehensibility which enabled them to remain its chief prophets. The Museum of Modern Art, the Rockefeller-supported institution in New York, and other similar culturally rootless artistic centers, run often by the most neurotic of people, came rapidly, as we moved through the war years, to positions of predominant influence over the artistic life of our country. As the attitudes of these cultist groups were grounded on aesthetic events which had occurred or were occurring in cultures overseas their ultimate effect was to return American art to the imitative status from which Wood, Curry and I had tried to extricate it. The younger artists of America were left, in this situation, only with an extenuating function. The sense of this humiliating state of affairs led many of them, and notably some of the most talented of my old students, to a denial of all formal values and they began pouring paint out of cans and buckets just to see what would happen or tieing pieces of wire to sticks and smacking them around in the air in the name of a new mobility. This

American contribution to "modern" aesthetics, though it suggests the butler trying to outdo his master's manners, received wide applause in our cultist circles and it went out from there to the young ladies colleges and to the small-town art schools and into the minds of all those thousands of amateurs over the land who took themselves to be artists. These latter saw immediately the wonderful opportunities for their own ego advancement which this "free expression" afforded and embraced it enthusiastically.

Now all this anarchic idiocy of the current American art scene cannot be blamed solely on the importation of foreign ideas about art or on the existence in our midst of institutions which represent them. It is rather that our artists have not known how to deal with these. In other fields than art, foreign ideas have many times vastly benefited our culture. In fact few American ideas are wholly indigenous, nor in fact are those of any other country, certainly not in our modern world. But most of the imported ideas which have proved of use to us were able to become so by intellectual assimilation. They were thoughts which could be thought of. The difficulty in the case of aesthetic ideas is that intellectual assimilation is not enough—for effective production. Effective aesthetic production depends on something beyond thought. The intellectual aspects of art are not art nor does a comprehension of them enable art to be made. It is in fact the over-intellectualization of modern art and its separation from ordinary life intuitions which have permitted it, in this day of almost wholly collective action, to remain psychologically tied to the "public be damned" individualism of the last century and thus in spite of its novelties to represent a cultural lag.

Art has been treated by most American practitioners as if it were a form of science where like processes give like results all over the world. By learning to carry on the processes by which imported goods were made, the American artist assumed that he would be able to end with their expressive values. This is not perhaps wholly his fault because a large proportion of the contemporary imports he studied were themselves laboratory products, studio experiments in process, with pseudo-scientific motivations which suggested that art was, like science, primarily a process evolution. This put inventive method rather than a search for the human meaning of one's life at the center of artistic endeavor and made it appear that aesthetic creation was a matter for intellectual rather than intuitive insight. Actually this was only illusory and art's modern flight from representation to technical invention has only left it empty and stranded in the back waters of life. Without those old cultural ties which used to make the art of each country so expressive of national and regional character, it has lost not only its social purpose but its very techniques for expression.

It was against the general cultural inconsequence of modern art and the attempt to create by intellectual assimilation, that Wood, Curry and I revolted in the early twenties and turned ourselves to a reconsideration of artistic aims. We did not do this by agreement. We came to our conclusions separately but we ended with similar convictions that we must find our aesthetic values, not in thinking, but in penetrating to the meaning and forms of life as lived. For us this meant, as I have indicated, American life and American life as known and felt by ordinary Americans. We believed that only by our own participation in the reality of American life, and that very definitely included the folk patterns which sparked it and largely directed its assumptions, could we come to forms in which Americans would find an opportunity for genuine spectator participation. This latter, which we were, by the example of history, led to believe was a corollary, and in fact, a proof of real artistic vitality in a civilization, gave us that public-minded orientation which so offended those who lived above, and believed that art should live above, "vulgar" contacts. The philosophy of our popularism was rarely considered by our critics. It was much easier, especially after international problems took popular press support away from us, to dub us conventional chauvinists, fascists, isolationists or just ignorant provincials, and dismiss us.

When we were left to the mercies of the art journals, the professors and the museum boys, we began immediately to lose influence among the newly budding artists and the young students. The band wagon practitioners, and most artists are unhappily such, left our regionalist banner like rats from a sinking ship and allied themselves with the now dominant internationalisms of the high-brow aesthetes. The fact that these internationalisms were for the most part emanations from cultural events occurring in the bohemias of Paris and thus as local as the forms they deserted never once occurred to any of our band wagon fugitives.

Having long been separated from my teaching contacts, I did not immediately notice the change of student attitude which went with our loss of public attention. But Wood and Curry still maintaining their university positions were much affected and in the course of time under the new indifference, and sometimes actual scorn of the young, began feeling as if their days were over.

It was one of the saddest experiences of my life to watch these two men, so well known and, when compared with most artists, enormously successful, finish their lives in ill health and occasional moods of deep despondency. After the time we came to be publicly associated in the early thirties, we had for all our differences developed a close personal friendship and this loss of self-confidence by my friends was

disturbing to me. It was, as a matter of fact, sort of catching and I had more than a few low moments of my own.

Wood and Curry, and particularly Curry, were oversensitive to criticism. They lacked that certain core of inner hardness, so necessary to any kind of public adventure, which throws off the opinions of others when these set up conflicts within the personality. Thus to the profound self doubts, which all artists of stature experience, was added in these two an unhappy over-susceptibility to the doubts of others. Such a susceptibility in times of despondency or depression is likely to be disastrous. It was most emphatically so for Wood and Curry.

Small men catch the weaknesses of their famous brothers very quickly and in the universities where Wood and Curry taught, there were plenty of these to add their tormenting stings to the mounting uncertainties of my two companions. Oddly enough, although Rita and I tried hard, our friendly encouragements never seemed to equal the discouragements which Wood's and Curry's campus brothers worked up to annoy them. Wood was pestered almost from the beginning of his university career by departmental highbrows who could never understand why an Iowa small towner received world attention while they, with all their obviously superior endowments, received none at all.

By the time we moved over into the forties, both Wood and Curry were in a pretty bad way physically and even psychologically. They had their good moments but these seemed to be rare and shortlived. In the end, what with worry over his weighty debts and his artistic self doubts, Wood came to the curious idea of changing his identity. Wood was a man of many curious and illusory fancies and when I went to see him in 1942 as he lay dying of a liver cancer in an Iowa hospital, he told me that when he got well he was going to change his name, go where nobody knew him and start all over again with a new style of painting. This was very uncanny because I'm sure he knew quite well he would never come out of that hospital alive. It was as if he wanted to destroy what was in him and become an empty soul before he went out into the emptiness of death. So far as I know Grant had no God to whom he could offer a soul with memories.

John Curry died slowly in 1946 after operations for high blood pressure and a general physical failure had taken his big body to pieces little by little. He made a visit to Martha's Vineyard the Autumn before he died. Sitting before the fire on a cold grey day when a nor'easter was building up seas outside, I tried to bolster his failing spirits.

"John," I ventured, "You must feel pretty good now, after all your struggles, to know that you have come to a permanent place in American art. It's a long way from a Kansas farm to fame like yours."

"I don't know about that," he replied, "maybe I'd have done better

to stay on the farm. No one seems interested in my pictures. Nobody thinks I can paint. If I *am* any good, I lived at the wrong time."

This is the way my two famous associates came to their end.[1]

STUART DAVIS: TWO STATEMENTS ON HIS PAINTING, 1940, 1943

Stuart Davis (1894-1964), Georgia O'Keeffe, Charles Sheeler, and Charles Demuth all based their art on one or another phase of European modernism, but all of them gave their own personal interpretations to their borrowed forms and bent them to the description of specifically American scenery. O'Keeffe, Sheeler, and Demuth favored the crisp architectural forms of rural, industrial, or urban America. Davis, who remained closer to the brilliantly colored, flat, and precisely painted forms of Synthetic Cubism, in these excerpts describes his allegiance to the vibrant, dynamic quality of twentieth century America which he painted with unfailing verve.

An artist who has traveled on a steam train, driven an automobile, or flown in an airplane doesn't feel the same way about form and space as one who has not. An artist who has used telegraph, telephone, and radio doesn't feel the same way about light and color as one who has not. An artist who has lived in a democratic society has a different view of what a human being really is than one who has not. These new experiences, emotions, and ideas are reflected in modern art, but not as a copy of them. They are coordinated by the artist and established as a real order in the materials of art. Art changes the person who sees it, and these changes are reflected in other fields of social action. The Renaissance artist and the modern artist are alike in that they both organize their experience into a real and coherent order in the materials of art. But this order is always unique, acted upon by, and in turn reacting upon, the society of its time. The real order of art is not an ideal order, or system of beauty, because an ideal order would be timeless, and art exists in time.[2]

*　　*　　*

It has been often said, even by proponents of those pictures known in aesthetic slang as Cubist and Abstract, that they have no subject

[1] Thomas Hart Benton, *An Artist in America,* new and revised edition (University of Kansas City Press, 1951), 314-321.

[2] Stuart Davis, "Is There a Revolution in the Arts?" *Bulletin of America's Town Meeting of the Air, V,* No. 19 (February 19, 1940), 12-13.

matter. Such a statement is equivalent to saying that life has no subject matter. On the contrary, modern pictures deal with contemporary subject matter in terms of art. The artist does not exercise his freedom in a non-material world. Science has created a new environment, in which new forms, lights, speeds, and spaces, are a reality. The perspectives and chiaroscuro of the Renaissance are no longer physically with us, even though their ghosts linger in many of the best modern works.

In my own case, I have enjoyed the dynamic American scene for many years past, and all of my pictures (including the ones I painted in Paris), are referential to it. They all have their originating impulse in the impact of the contemporary American environment. And it is certainly a fact that the relevant art, literature, and music of other times and places are among the most cherished realities of that environment. I mention this last point only because there is a continuing trend by strong groups in American art who, in this way or that, have sought to deny it.

Some of the things which have made me want to paint, outside of other paintings, are: American wood and iron work of the past; Civil War and skyscraper architecture; the brilliant colors on gasoline stations, chain-store fronts, and taxicabs; the music of Bach; synthetic chemistry; the poetry of Rimbaud; fast travel by train, auto, and aeroplane which brought new and multiple perspectives; electric signs; the landscape and boats of Gloucester, Mass.; 5 & 10 cent store kitchen utensils; movies and radio; Earl Hines hot piano and Negro jazz music in general, and the like. In one way or another the quality of these things plays a role in determining the character of my paintings. Not in the sense of describing them in graphic images, but by predetermining an analogous dynamics in the design, which becomes a new part of the American environment. Paris School, Abstraction, Escapism? Nope, just Color-Space Compositions celebrating the resolution in art of stresses set up by some aspects of the American scene.[1]

ALEXANDER CALDER: WHAT ABSTRACT ART MEANS TO ME, 1951

The mobiles of Alexander Calder (1898-), inspired as he states here by the abstractions of the Dutch painter, Piet Mondrian and by the shapes of the Spaniard Juan Miró, are perhaps the best-known works of modern American sculpture. Both in their source of inspiration and in the breadth of their meaning described here by the artist,

1 Stuart Davis, "The Cube Root," *Art News,* XLI (February 1, 1943), 33-34. Reprinted and reproduced, by permission, from the copyright owner, *Art News,* published monthly at 4 East 53rd Street, New York 22, N. Y.

they belong to the international mainstream of twentieth century art which Benton sought to reject in his Regionalism.

My entrance into the field of abstract art came about as the result of a visit to the studio of Piet Mondrian in Paris in 1930.

I was particularly impressed by some rectangles of color he had tacked on his wall in a pattern after his nature.

I told him I would like to make them oscillate—he objected. I went home and tried to paint abstractly—but in two weeks I was back again among plastic materials.

I think that at that time and practically ever since, the underlying sense of form in my work has been the system of the Universe, or part thereof. For that is a rather large model to work from.

What I mean is that the idea of detached bodies floating in space, of different sizes and densities, perhaps of different colors and temperatures, and surrounded and interlarded with wisps of gaseous condition, and some at rest, while others move in peculiar manners, seems to me the ideal source of form.

I would have them deployed, some nearer together and some at immense distances.

And great disparity among all the qualities of these bodies, and their motions as well.

A very exciting moment for me was at the planetarium—when the machine was run fast for the purpose of explaining its operation: a planet moved along a straight line, then suddenly made a complete loop of 360° off to one side, and then went off in a straight line in its original direction.

I have chiefly limited myself to the use of black and white as being the most disparate colors. Red is the color most opposed to both of these—and then, finally, the other primaries. The secondary colors and intermediate shades serve only to confuse and muddle the distinctness and clarity.

When I have used spheres and discs, I have intended that they should represent more than what they just are. More or less as the earth is a sphere, but also has some miles of gas about it, volcanoes upon it, and the moon making circles around it, and as the sun is a sphere—but also is a source of intense heat, the effect of which is felt at great distances. A ball of wood or a disc of metal is rather a dull object without this sense of something emanating from it.

When I use two circles of wire intersecting at right angles, this to me is a sphere—and when I use two or more sheets of metal cut into shapes and mounted at angles to each other, I feel that there is a solid form, perhaps concave, perhaps convex, filling in the dihedral angles

between them. I do not have a definite idea of what this would be like. I merely sense it and occupy myself with the shapes one actually sees.

Then there is the idea of an object floating—not supported—the use of a very long thread, or a long arm in cantilever as a means of support seems to best approximate this freedom from the earth.

Thus what I produce is not precisely what I have in mind—but a sort of sketch, a man-made approximation.

That others grasp what I have in mind seems unessential, at least as long as they have something else in theirs.[1]

ADOLPH GOTTLIEB AND MARK ROTHKO: LETTER TO THE NEW YORK TIMES, 1943

The new spirit of internationalism which was fostered by the 1939 War appears in this manifesto written to Edwin A. Jewell, art critic of The New York Times *in 1943. In rebellion against the "corn belt academy" which Benton and the Regionalists of the thirties represented to them, Mark Rothko (1903-) and Adolph Gottlieb (1903-) took a stand for freedom of the imagination and the universality of ancient mythological themes. Such subjects appeared as a transitional phase during the War years in the work of Pollock and in that of the writers before each of them moved toward nonobjective painting in the years immediately following World War II. But the major points of this letter, including the assertion that "there can be no such thing as good painting about nothing," remained valid tenets of the post-War school of abstraction in which both signatories were active participants.*

To the artist the workings of the critical mind is one of life's mysteries. That is why, we suppose, the artist's complaint that he is misunderstood, especially by the critic, has become a noisy commonplace. It is therefore an event when the worm turns and the critic quietly, yet publicly, confesses his "befuddlement," that he is "nonplused" before our pictures at the federation show. We salute this honest, we might say cordial, reaction toward our "obscure" paintings, for in other critical quarters we seem to have created a bedlam of hysteria. And we appreciate the gracious opportunity that is being offered us to present our views.

We do not intend to defend our pictures. They make their own

[1] Alexander Calder, "What Abstract Art Means to Me," *The Museum of Modern Art Bulletin*, XVIII, No. 3 (Spring, 1951), 8.

defense. We consider them clear statements. Your failure to dismiss or disparage them is *prima facie* evidence that they carry some communicative power.

We refuse to defend them not because we cannot. It is an easy matter to explain to the befuddled that "The Rape of Persephone" is a poetic expression of the essence of the myth; the presentation of the concept of seed and its earth with all its brutal implications; the impact of elemental truth. Would you have us present this abstract concept, with all its complicated feelings, by means of a boy and girl lightly tripping?

It is just as easy to explain "The Syrian Bull" as a new interpretation of an archaic image, involving unprecedented distortions. Since art is timeless, the significant rendition of a symbol, no matter how archaic, has as full validity today as the archaic symbol had then. Or is the one 3,000 years old truer?

* * *

. . . these easy program notes can help only the simple-minded. No possible set of notes can explain our paintings. Their explanation must come out of a consummated experience between picture and onlooker. The point at issue, it seems to us, is not an "explanation" of the paintings, but whether the intrinsic ideas carried within the frames of these pictures have significance. We feel that our pictures demonstrate our aesthetic beliefs, some of which we, therefore, list:

1. To us art is an adventure into an unknown world, which can be explored only by those willing to take the risks.

2. This world of the imagination is fancy-free and violently opposed to common sense.

3. It is our function as artists to make the spectator see the world our way—not his way.

4. We favor the simple expression of the complex thought. We are for the large shape because it has the impact of the unequivocal. We wish to reassert the picture plane. We are for flat forms because they destroy illusion and reveal truth.

5. It is a widely accepted notion among painters that it does not matter what one paints as long as it is well painted. This is the essence of academism. There is no such thing as good painting about nothing. We assert that the subject is crucial and only that subject-matter is valid which is tragic and timeless. That is why we profess spiritual kinship with primitive and archaic art.

Consequently, if our work embodies these beliefs it must insult anyone who is spiritually attuned to interior decoration; pictures for the home; pictures for over the mantel; pictures of the American scene;

social pictures; purity in art; prize-winning potboilers; the National Academy, the Whitney Academy, the Corn Belt Academy; buckeyes; trite tripe, and so forth.[1]

JACKSON POLLOCK: TWO STATEMENTS ON HIS PAINTING, 1944, 1947

In the first of these two statements Jackson Pollock (1912-1956), one of the leaders of American Abstract Expressionism, reveals the importance he attached to the presence in New York during World War II of leading European modernists. It was in part through them and especially through the influence of the Surrealists among them, that Pollock rejected so violently the possibility of an isolated American painting and developed the methods described in 1947 in the second selection.

My work with [Thomas Hart] Benton was important as something against which to react very strongly, later on; in this, it was better to have worked with him than with a less resistant personality who would have provided a much less strong opposition. At the same time, Benton introduced me to Renaissance art. . . .

I accept the fact that the important painting of the last hundred years was done in France. American painters have generally missed the point of modern painting from beginning to end. (The only American master who interests me is Ryder.) Thus the fact that good European moderns are now here is very important, for they bring with them an understanding of the problems of modern painting. I am particularly impressed with their concept of the source of art being the Unconscious. This idea interests me more than these specific painters do, for the two artists I admire most, Picasso and Miró, are still abroad. . . .

The idea of an isolated American painting, so popular in this country during the thirties, seems absurd to me just as the idea of creating a purely American mathematics or physics would seem absurd. . . . And in another sense, the problem doesn't exist at all; or, if it did, would solve itself. An American is an American and his painting would naturally be qualified by that fact, whether he wills it or not. But the basic problems of contemporary painting are independent of any country.[2]

[1] Mark Rothko and Adolph Gottlieb, Letter to *The New York Times*, Sunday, June 13, 1943, Section 2, p. 9.
[2] Jackson Pollock, *Arts and Architecture*, LXI (February, 1944), 14-15.

I continue to get further away from the usual painter's tools such as easel, palette, brushes, and the like. I prefer sticks, trowels, knives and dripping fluid paint or a heavy impasto with sand, broken glass and other foreign matter added.

When I am *in* my painting, I'm not aware of what I'm doing. It is only after a sort of "get acquainted" period that I see what I have been about. I have no fears about making changes, destroying the image, and so forth, because the painting has a life of its own. I try to let it come through. It is only when I lose contact with the painting that the result is a mess. Otherwise there is pure harmony, an easy give and take, and the painting comes out well.[1]

HAROLD ROSENBERG: THE AMERICAN ACTION PAINTERS, 1952

Harold Rosenberg (1906-), a critic of the modern movement in painting and literature, closely observed the rise of Abstract Expressionism which, in the years after World War II, brought for the first time world-wide recognition to a whole school of American painting. Artists continue to argue over his interpretation of the movement and the term, action painting, *which he introduced in the article here reprinted in full. His account of the methods of the Abstract Expressionists may in fact overemphasize their concept of the empty canvas as an arena of action in which the effects of accident and chance are welcomed, but his description of their involvement with the act of painting, though perhaps excessively systematic, is such that the article has become and will undoubtedly remain a major point of departure for all future discussions of this predominantly New York development.*

> *"J'ai fait des gestes blanc parmi les solitudes."*
> APOLLINAIRE

> "The American will is easily satisfied
> in its efforts to realize itself in knowing itself."
> WALLACE STEVENS

What makes any definition of a movement in art dubious is that it never fits the deepest artists in the movement—certainly not as well as, if successful, it does the others. Yet without the definition something

[1] Jackson Pollock, "My Painting," *Possibilities,* Winter, 1947-1948, p. 79. Published by George Wittenborn, Inc.

essential in those best is bound to be missed. The attempt to define is like a game in which you cannot possibly reach the goal from the starting point but can only close in on it by picking up each time from where the last play landed.

MODERN ART? OR AN ART OF THE MODERN?

Since the War every twentieth-century style in painting is being brought to profusion in the United States: thousands of "abstract" painters—crowded teaching courses in Modern Art—a scattering of new heroes—ambitions stimulated by new galleries, mass exhibitions, reproductions in popular magazines, festivals, appropriations.

Is this the usual catching up of America with European art forms? Or is something new being created? . . . For the question of novelty, a definition would seem indispensable.

Some people deny that there is anything original in the recent American painting. Whatever is being done here now, they claim, was done thirty years ago in Paris. You can trace this painter's boxes of symbols to Kandinsky, that one's moony shapes to Miró or even back to Cézanne.

Quantitatively, it is true that most of the symphonies in blue and red rectangles, the wandering pelvises and birdbills, the line constructions and plane suspensions, the virginal dissections of flat areas that crowd the art shows are accretions to the "School of Paris" brought into being by the fact that the mode of production of modern masterpieces has now been all too clearly rationalized. There are styles in the present displays which the painter could have acquired by putting a square inch of a Soutine or a Bonnard under a microscope. . . . All this is training based on a new conception of what art is, rather than original work demonstrating what art is about to become.

At the center of this wide practicing of the immediate past, however, the work of some painters has separated itself from the rest by a consciousness of a function for painting different from that of the earlier "abstractionists," both the Europeans themselves and the Americans who joined them in the years of the Great Vanguard.

This new painting does not constitute a School. To form a School in modern times not only is a new painting consciousness needed but a consciousness of that consciousness—and even an insistence on certain formulas. A School is the result of the linkage of practice with terminology—different paintings are affected by the same words. In the American vanguard the words, as we shall see, belong not to the art but to the individual artists. What they think in common is represented only by what they do separately.

GETTING INSIDE THE CANVAS

At a certain moment the canvas began to appear to one American painter after another as an arena in which to act—rather than as a space in which to reproduce, re-design, analyze or "express" an object, actual or imagined. What was to go on the canvas was not a picture but an event.

The painter no longer approached his easel with an image in his mind; he went up to it with material in his hand to do something to that other piece of material in front of him. The image would be the result of this encounter.

It is pointless to argue that Rembrandt or Michelangelo worked in the same way. You don't get Lucrece with a dagger out of staining a piece of cloth or spontaneously putting forms into motion upon it. She had to exist some place else before she got on the canvas, and the paint was Rembrandt's means for bringing her here. Now, everything must have been in the tubes, in the painter's muscles and in the cream-colored sea into which he dives. If Lucrece should come out she will be among us for the first time—a surprise. To the painter, she *must* be a surprise. In this mood there is no point in an act if you already know what it contains.

"B. is not modern," one of the leaders of this mode said to me the other day. "He works from sketches. That makes him Renaissance."

Here the principle, and the difference from the old painting, is made into a formula. A sketch is the preliminary form of an image the *mind* is trying to grasp. To work from sketches arouses the suspicion that the artist still regards the canvas as a place where the mind records its contents—rather than itself the "mind" through which the painter thinks by changing a surface with paint.

If a painting is an action, the sketch is one action, the painting that follows it another. The second cannot be "better" or more complete than the first. There is just as much significance in their difference as in their similarity.

Of course, the painter who spoke had no right to assume that the other had the old mental conception of a sketch. There is no reason why an act cannot be prolonged from a piece of paper to a canvas. Or repeated on another scale and with more control. A sketch can have the function of a skirmish.

Call this painting "abstract" or "Expressionist" or "Abstract-Expressionist," what counts is its special motive for extinguishing the object, which is not the same as in other abstract or Expressionist phases of modern art.

The new American painting is not "pure art," since the extrusion

of the object was not for the sake of the aesthetic. The apples weren't brushed off the table in order to make room for perfect relations of space and color. They had to go so that nothing would get in the way of the act of painting. In this gesturing with materials the aesthetic, too, has been subordinated. Form, color, composition, drawing, are auxiliaries, anyone of which—or practically all, as has been attempted, logically, with unpainted canvases—can be dispensed with. What matters always is the revelation contained in the act. It is to be taken for granted that in the final effect, the image, whatever be or be not in it, will be a *tension*.

DRAMAS OF AS IF

A painting that is an act is inseparable from the biography of the artist. The painting itself is a "moment" in the adulterated mixture of his life—whether "moment" means, in one case, the actual minutes taken up with spotting the canvas or, in another, the entire duration of a lucid drama conducted in sign language. The act-painting is of the same metaphysical substance as the artist's existence. The new painting has broken down every distinction between art and life.

It follows that anything is relevant to it. Anything that has to do with action—psychology, philosophy, history, mythology, hero worship. Anything but art criticism. The painter gets away from Art through his act of painting; the critic can't get away from it. The critic who goes on judging in terms of schools, styles, form, as if the painter were still concerned with producing a certain kind of object (the work of art), instead of living on the canvas, is bound to seem a stranger.

Some painters take advantage of this stranger. Having insisted that their painting is an act, they then claim admiration for the act as art. This turns the act back toward the aesthetic in a petty circle. If the picture is an act, it cannot be justified *as an act of genius* in a field whose whole measuring apparatus has been sent to the devil. Its value must be found apart from art. Otherwise the "act" gets to be "making a painting" at sufficient speed to meet an exhibition date.

Art—relation of the painting to the works of the past, rightness of color, texture, balance, and so forth—comes back into painting by way of psychology. As Stevens says of poetry, "it is a process of the personality of the poet." But the psychology is the psychology of creation. Not that of the so-called psychological criticism that wants to "read" a painting for clues to the artist's sexual preferences or debilities. The work, the act, translates the psychologically given into the intentional, into a "world"—and thus transcends it.

With traditional aesthetic references discarded as irrelevant, what gives the canvas its meaning is not psychological data but *role*, the way

the artist organizes his emotional and intellectual energy as if he were in a living situation. The interest lies in the kind of act taking place in the four-sided arena, a dramatic interest.

Criticism must begin by recognizing in the painting the assumptions inherent in its mode of creation. Since the painter has become an actor, the spectator has to think in a vocabulary of action: its inception, duration, direction—psychic state, concentration and relaxation of the will, passivity, alert waiting. He must become a connoisseur of the gradations between the automatic, the spontaneous, the evoked.

"It's Not That, It's Not That, It's Not That"

With a few important exceptions, most of the artists of this vanguard found their way to their present work by being cut in two. Their type is not a young painter but a re-born one. The man may be over forty, the painter around seven. The diagonal of a grand crisis separates him from his personal and artistic past.

Many of the painters were "Marxists" (W.P.A. unions, artists' congresses)—they had been trying to paint Society. Others had been trying to paint Art (Cubism, Post-Impressionism)—it amounts to the same thing.

The big moment came when it was decided to paint. . . . Just to paint. The gesture on the canvas was a gesture of liberation, from Value—political, aesthetic, moral.

If the war and the decline of radicalism in America had anything to do with this sudden impatience, there is no evidence of it. About the effects of large issues upon their emotions, Americans tend to be either reticent or unconscious. The French artist thinks of himself as a battleground of history; here one hears only of private Dark Nights. Yet it is strange how many segregated individuals came to a dead stop within the past ten years and abandoned, even physically destroyed, the work they had been doing. A far-off watcher, unable to realize that these events were taking place in silence, might have assumed they were being directed by a single voice.

At its center the movement was away from rather than towards. The Great Works of the Past and the Good Life of the Future became equally nil.

The refusal of Value did not take the form of condemnation or defiance of society, as it did after World War I. It was diffident. The lone artist did not want the world to be different, he wanted his canvas to be a world. Liberation from the object meant liberation from the "nature," society and art already there. It was a movement to leave behind the self that wished to choose his future and to nullify its promissory notes to the past.

With the American, heir of the pioneer and the immigrant, the foundering of Art and Society was not experienced as a loss. On the contrary, the end of Art marked the beginning of an optimism regarding himself as an artist.

The American vanguard painter took to the white expanse of the canvas as Melville's Ishmael took to the sea.

On the one hand, a desperate recognition of moral and intellectual exhaustion; on the other, the exhilaration of an adventure over depths in which he might find reflected the true image of his identity.

Painting could now be reduced to that equipment which the artist needed for an activity that would be an alternative to both utility and idleness. Guided by visual and somatic memories of paintings he had seen or made—memories which he did his best to keep from intruding into his consciousness—he gesticulated upon the canvas and watched for what each novelty would declare him and his art to be.

Based on the phenomenon of conversion the new movement is, with the majority of the painters, essentially a religious movement. In every case, however, the conversion has been experienced in secular terms. The result has been the creation of private myths.

The tension of the private myth is the content of every painting of this vanguard. The act on the canvas springs from an attempt to resurrect the saving moment in his "story" when the painter first felt himself released from Value—myth of past self-recognition. Or it attempts to initiate a new moment in which the painter will realize his total personality—myth of future self-recognition.

Some formulate their myth verbally and connect individual works with its episodes. With others, usually deeper, the painting itself is the exclusive formulation, it is a Sign.

The revolution against the given, in the self and in the world, which since Hegel has provided European vanguard art with theories of a New Reality, has re-entered America in the form of personal revolts. Art as action rests on the enormous assumption that the artist accepts as real only that which he is in the process of creating. "Except the soul has divested itself of the love of created things . . ." The artist works in a condition of open possibility, risking, to follow Kierkegaard, the anguish of the aesthetic, which accompanies possibility lacking in reality. To maintain the force to refrain from settling anything, he must exercise in himself a constant No.

APOCALYPSE AND WALLPAPER

The most comfortable intercourse with the void is mysticism, especially a mysticism that avoids ritualizing itself.

Philosophy is not popular among American painters. For most,

thinking consists of the various arguments that TO PAINT is something different from, say, to write or to criticize: a mystique of the particular activity. Lacking verbal flexibility, the painters speak of what they are doing in a jargon still involved in the metaphysics of *things:* "My painting is not Art; it's an Is." "It's not a picture of a thing; it's the thing itself." "It doesn't reproduce Nature; it is Nature." "The painter doesn't think; he knows." And so forth. "Art is not, not not not not . . ." As against this, a few reply, art today is the same as it always has been.

Language has not accustomed itself to a situation in which the act itself is the "object." Along with the philosophy of TO PAINT appear bits of Vedanta and popular pantheism.

In terms of American tradition, the new painters stand somewhere between Christian Science and Whitman's "gangs of cosmos." That is, between a discipline of vagueness by which one protects oneself from disturbance while keeping one's eyes open for benefits; and the discipline of the Open Road of risk that leads to the farther side of the object and the outer spaces of the consciousness.

What made Whitman's mysticism serious was that he directed his "cosmic 'I'" towards a Pike's-Peak-or-Bust of morality and politics. He wanted the ineffable in *all* behavior—he wanted it *to win the streets.*

The test of any of the new paintings is its seriousness—and the test of its seriousness is the degree to which the act on the canvas is an extension of the artist's total effort to make over his experience.

A good painting in this mode leaves no doubt concerning its reality as an action and its relation to a transforming process in the artist. The canvas has "talked back" to the artist not to quiet him with Sibylline murmurs or to stun him with Dionysian outcries but to provoke him into a dramatic dialogue. Each stroke had to be a decision and was answered by a new question. By its very nature, action painting is painting in the medium of difficulties.

Weak mysticism, the "Christian Science" side of the new movement, tends in the opposite direction, toward *easy* painting—never so many unearned masterpieces! Works of this sort lack the dialectical tension of a genuine act, associated with risk and will. When a tube of paint is squeezed by the Absolute, the result can only be a Success. The painter need keep himself on hand solely to collect the benefits of an endless series of strokes of luck. His gesture completes itself without arousing either an opposing movement within itself nor his own desire to make the act more fully his own. Satisfied with wonders that remain safely inside the canvas, the artist accepts the permanence of the commonplace and decorates it with his own daily annihilation. The result is an apocalyptic wallpaper.

The cosmic "I" that turns up to paint pictures but shudders and

departs the moment there is a knock on the studio door brings to the artist a megalomania which is the opposite of revolutionary. The tremors produced by a few expanses of tone or by the juxtaposition of colors and shapes purposely brought to the verge of bad taste in the manner of Park Avenue shop windows are sufficient cataclysms in many of these happy overthrows of Art. The mystical dissociation of painting as an ineffable event has made it common to mistake for an act the mere sensation of having acted—or of having been acted upon. Since there is nothing to be "communicated," a unique signature comes to seem the equivalent of a new plastic language. In a single stroke the painter exists as a Somebody—at least on a wall. That this Somebody is not he seems beside the point.

Once the difficulties that belong to a real act have been evaded by mysticism, the artist's experience of transformation is at an end. In that case what is left? Or to put it differently: What is a painting that is not an object nor the representation of an object nor the analysis or impression of it nor whatever else a painting has ever been—and which has also ceased to be the emblem of a personal struggle? It is the painter himself changed into a ghost inhabiting The Art World. Here the common phrase, "I have bought an O" (rather than a painting by O) becomes literally true. The man who started to remake himself has made himself into a commodity with a trademark.

Milieu: the Busy No-Audience

We said that the new painting calls for a new kind of criticism, one that would distinguish the specific qualities of each artist's act.

Unhappily for an art whose value depends on the authenticity of its mysteries, the new movement appeared at the same moment that Modern Art *en masse* "arrived" in America: Modern architecture, not only for sophisticated homes, but for corporations, municipalities, synagogues; Modern furniture and crockery in mail-order catalogues; Modern vacuum cleaners, can openers; beer-ad "mobiles"—along with reproductions and articles on advanced painting in big-circulation magazines. *Enigmas for everybody.* Art in America today is not only nouveau, it's news.

The new painting came into being fastened to Modern Art and without intellectual allies—in literature everything had found its niche.

From this isolated liaison it has derived certain superstitions comparable to those of a wife with a famous husband. Superiorities, supremacies even, are taken for granted. It is boasted that modern painting in America is not only original but an "advance" in world art (at the same time that one says "to hell with world art").

Everyone knows that the label Modern Art no longer has any rela-

tion to the words that compose it. To be Modern Art a work need not be either modern nor art; it need not even be a work. A three thousand-year-old mask from the South Pacific qualifies as Modern and a piece of wood found on a beach becomes Art.

When they find this out, some people grow extremely enthusiastic, even, oddly enough, proud of themselves; others become infuriated.

These reactions suggest what Modern Art actually is. It is not a certain kind of art object. It is not even a Style. It has nothing to do either with the period when a thing was made nor with the intention of the maker. It is something that someone has had the power to designate as psychologically, aesthetically or ideologically relevant to our epoch. The question of the driftwood is: *Who* found it?

Modern Art in America represents a revolution of taste—and serves to identify power of the caste conducting that revolution. Responses to Modern Art are primarily responses to claims to social leadership. For this reason Modern Art is periodically attacked as snobbish, Red, immoral, and the like, by established interests in Society, politics, the church. Comedy of a revolution that restricts itself to weapons of taste—and which at the same time addresses itself to the masses: Modern-design fabrics in bargain basements, Modern interiors for office girls living alone, Modern milk bottles.

Modern art is educational, not with regard to art but with regard to life. You cannot explain Mondrian's painting to people who don't know anything about Vermeer, but you can easily explain the social importance of admiring Mondrian and forgetting about Vermeer.

Through Modern Art the expanding caste of professional enlighteners of the masses—designers, architects, decorators, fashion people, exhibition directors—informs the populace that a supreme Value has emerged in our time, the Value of the NEW, and that there are persons and things that embody that Value. This Value is a completely fluid one. As we have seen Modern Art does not have to be actually new; it only has to be new to *somebody*—to the last lady who found out about the driftwood—and to win neophytes is the chief interest of the caste.

Since the only thing that counts for Modern Art is that a work shall be NEW, and since the question of its newness is determined not by analysis but by social power and pedagogy, the vanguard painter functions in a milieu utterly indifferent to the content of his work.

Unlike the art of nineteenth-century America, advanced paintings today are not bought by the middle class. Nor are they by the populace. Considering the degree to which it is publicized and feted, vanguard painting is hardly bought at all. It is *used* in its totality as material for educational and profit-making enterprises: color reproductions, design adaptations, human-interest stories. Despite the fact that more people

see and hear about works of art than ever before, the vanguard artist has an audience of nobody. An interested individual here and there, but no audience. He creates in an environment not of people but of functions. His paintings are employed not wanted. The public for whose edification he is periodically trotted out accepts the choices made for it as phenomena of The Age of Queer Things.

An action is not a matter of taste.

You don't let taste decide the firing of a pistol or the building of a maze.

As the Marquis de Sade understood, even experiments in sensation, if deliberately repeated, presuppose a morality.

To see in the explosion of shrapnel over No Man's Land only the opening of a flower of flame, Marinetti had to erase the moral premises of the act of destruction—as Molotov did explicitly when he said that Fascism is a matter of taste. Both M's were, of course, speaking the driftwood language of the Modern Art International.

Limited to the aesthetics, the taste bureaucracies of Modern Art cannot grasp the human experience involved in the new action paintings. One work is equivalent to another on the basis of resemblances of surface, and the movement as a whole a modish addition to twentieth-century picture making. Examples in every style are packed side by side in annuals and in the heads of newspaper reviewers like canned meats in a chain store—all standard brands.

To counteract the obtuseness, venality and aimlessness of the Art World, American vanguard art needs a genuine audience—not just a market. It needs understanding—not just publicity.

In our form of society, audience and understanding for advanced painting have been produced, both here and abroad, first of all by the tiny circle of poets, musicians, theoreticians, men of letters, who have sensed in their own work the presence of the new creative principle.

So far, the silence of American literature on the new painting all but amounts to a scandal.[1]

LAWRENCE GOWING: PAINT IN AMERICA, 1958

These passages by the British painter and art historian Lawrence Gowing appeared in a review of a book on American art, but they represent primarily one foreign observer's reaction to the peculiarly

[1] Harold Rosenberg, "The American Action Painters," *Art News*, LI (December, 1952), 22-23, 48-50. Reprinted and reproduced, by permission, from the copyright owner, *Art News*, published monthly at 4 East 53rd Street, New York 22, N. Y.

American quality of our post-War abstraction. Generally our critics have hailed the creation in America of the major post-War develop-ment in Western painting and rightly pointed to its acknowledged development from the major European pictorial innovations of the twentieth century. In their justifiable pride they have perhaps exces-sively ignored the special American complexion which it also bears. But, as seen by critics abroad, the huge, space-hungry canvases of the Amer-icans, their apparently bold and brutal execution, and their configura-tions of shape seem uniquely derived from the physical appearance of the American landscape and what Americans have built upon it. "No other art is likely to be born again in just this way, in the American shape. The paint in its pot is different."

Nothing attracts like an idea. When artistic Europe saw itself fall-ing for American abstract painting and, enraptured, plunged delib-erately head over heels, what captivated it was not any visible picture or painter but the American idea. The tributes that European painters paid and are paying to paint itself, to the automatic splash and trickle of it, and the glamor of its crude nature as it comes from the tin, are tributes in fact to the logical necessity of a certain line of thought.

The infatuation has proceeded almost independent of its real object. The idea of American painting has worked an extraordinary liberation, a liberation from ideas about painting, which has a partic-ular force for the self-conscious painter in Europe. But it is doubtful if there is a painter in Europe who loves many real American pictures. It is not easy here even to know many, and books like this one, with good reproductions of large numbers of good examples of both fashion-able and other kinds, are needed. At present, when a representative collection of American pictures is imported, it is not much enjoyed. There seem to be too many pictures, or too few by too many artists, or the wrong ones (even when they are the best). The size of the ges-tures they make looks out of scale. *Something* is always wrong. In Europe one might suppose that the American achievement consisted in nothing so much as its idea, in the cynical realism with which it has boiled down the aesthetic of the age. Here in Europe the paint to which painting is reduced embodies a principle--a faith pursued to its fatalistic ex-tremity (and the fatalism is chic)—but not much else.

Seen in America, American painting embodies something very different. Quite another meaning fills it. The program and the line of talk are seen to serve something else, which no one has been able to imitate or export.

In any art anywhere there is something more radical than the idea. There is a visual substance older than the intention, older than

the skills and devices: it is there before style can be there. The essential base of art is in the place before there is an artist; understanding art, we comprehend both together—the common substance and the specific expression. Just as it was possible once for Europe to borrow the Corinthian order whole, from curling head to foot, without understanding the Renaissance in the least, for lack of its Italian substance, so now the flourishes of the American style travel everywhere, but without the meaning which they derive from the imaginative landscape of a specific community at a certain time.

To know anything about this art (about any art, perhaps) one must know almost everything. One may start anywhere. Look, for example, at the paint itself in its most famous manifestations—at the indispensable strand of white paint in Jackson Pollock's net, or the white strips in the painting of Bradley Tomlin. Grasping the substance that this one color possesses in its own world, we have to reconstruct elements which are there effortlessly assumed and retrieve something immemorial (of which perhaps no American will tell us). First, as always, we have to share senses of structure and material which are native to the place; we have to recognize the abstracted physique of forms and qualities which are everywhere supplied by building.

* * *

If we can make the adjustment, the conception of building takes on a new and specific meaning. In America the idea of structure envisages a broad assembly of slender parts, standing squarely, but with a quality of light attentiveness, independent but aware. The construction balances vertical against horizontal, major upright members against the delicate level ruling of boarded surfaces. In the balance there is the most lively serenity: it is recognizably embodied in the color, the white paint.

All this formal meaning—the counterpart of a certain human stance and frame of mind—is contained in American white paint. It was there almost from the start, in the broad American canvases of Copley, in their sharp white planes with thin overlapping edges and the level grooves of human features, the signs of an incomparably sharp and level vision. Copley raises to great art the qualities of whiteness and strip-like straightness and thinness—the qualities of linen and straight looks from lined faces—which make beautiful the symbolic presentations (very near to the common base of art) of the journeymen-portraitists who were also house-painters.

The other implication of architectural whiteness, the balance of vertical against horizontal, and the togate stoicism of mood, was sim-

ilarly fixed in painting at the outset, in the early style of Benjamin West who carried an essential quality of Pennsylvania, naively preserved within him, to Rome and London. It remains the strongest of all the country's patterns, and unimaginably stronger in America than in any other place or style. The frame of horizontal and vertical which building makes, now more than ever, is communicated to every structure, every visible system of intervals, every surface. Its meaning, its regular reference, is communicated to forms which are not rectangular at all but freely curving and capricious, the freer for the presence of the frame. The clapboard frame house (any house, old or new, of those around almost any town) sets up a rhythm which extends beyond it, sideways and also upward, among the trees (typically, the house is built among trees, wood among wood). The rhythms catch hold among the branches; trunks and limbs are claimed in order by the same system. (The trees take on a special, different look: no doubt they are different; no doubt they originally gave some of their special character to building.) The white-painted building imparts its order high into the threading arabesque, and the clear grey of sun-brightened bark which is the natural accompaniment of white in America and American painting (the random symmetry produced involuntarily and invariably by Pollock never looks arbitrary again after this), and out into the sky. The sky is the far, continental sky, which the European never sees, with its distant, extreme blue. Wherever there is white paint, this color too is in mind. When the colors come together, with their peculiar, fluorescent-seeming sharpness, in the canvases of Bradley Tomlin, the combination is immediately recognized.

The whiteness of building and paint is enriched with still further associations. Their whiteness is also the white of paper. The black and white of print, and its characteristic forms, contribute to the white and black of painting. The bold, bad letter-forms (as they look in Europe, where graphic style is fixed in a shape as clearly *cut* as De Tocqueville's marble) have a serious force which here we can hardly read, the force of a communal ideal in which independence and ungoverned enterprise are inseparable. (There is more of American art on the reverse of a one-dollar bill than in any European commentary.) The broad letter, with its fat vertical stroke balanced, naturally, against thin horizontals, forms the concentrated basis of a new style, resting, as style does anywhere, on the style of the society. The natural graphic consistency of America, the unity of free, disparate shapes—the consistency of the clustering proliferation of signs over any sidewalk—belongs to a country in which the natural consistency and unity is simply the new, unknown consistency of human behavior let loose in an immense and empty space. This style is cut, not as marble is but in the manner that

sheet-metal is cut, in the same sharp manner as the cluster of signs—the metal arrows pointing with internal fluorescent light to this or that, metal sea-food, dry goods and the curling metal signatures of soft drinks —are cut out against the continental sky. Seen in place, the cut shapes of Stuart Davis call to mind, never the *papiers collés* of Matisse but their own grand, fluorescent source. Seen there, it is precisely the serif-like terminations to Bradley Tomlin's strips of paint that give them the quality of characters spelling out the consistency of natural disorder and representing with material realism a real place.

In some such way the resources of painting snowball, accumulating meaning and depositing it in the raw material of art. All this, and more, is contained in the white of American painters. It is already in the tin, when they buy it. It is on the canvas before they touch it. To reconstruct in Europe the artistic substance of America may be hardly possible: its connection with our own is often slight. Its antecedents are no more than half European: its birth and rebirth are wholly American. No other art is likely to be born again in just this way, in the American shape. The paint in its pot is different.

Why did the American idea not occur to anyone before? It did: it was in the air in Europe for a quarter of a century. It required to be filled with the unique American substance, the material poetry of the country, to gain its present force.[1]

[1] Lawrence Gowing, "Paint in America," *The New Statesman,* May 24, 1958, pp. 699-700.